Put any picture you want on any state book cover. Makes a great gift. Go to www.america24-7.com/customcover

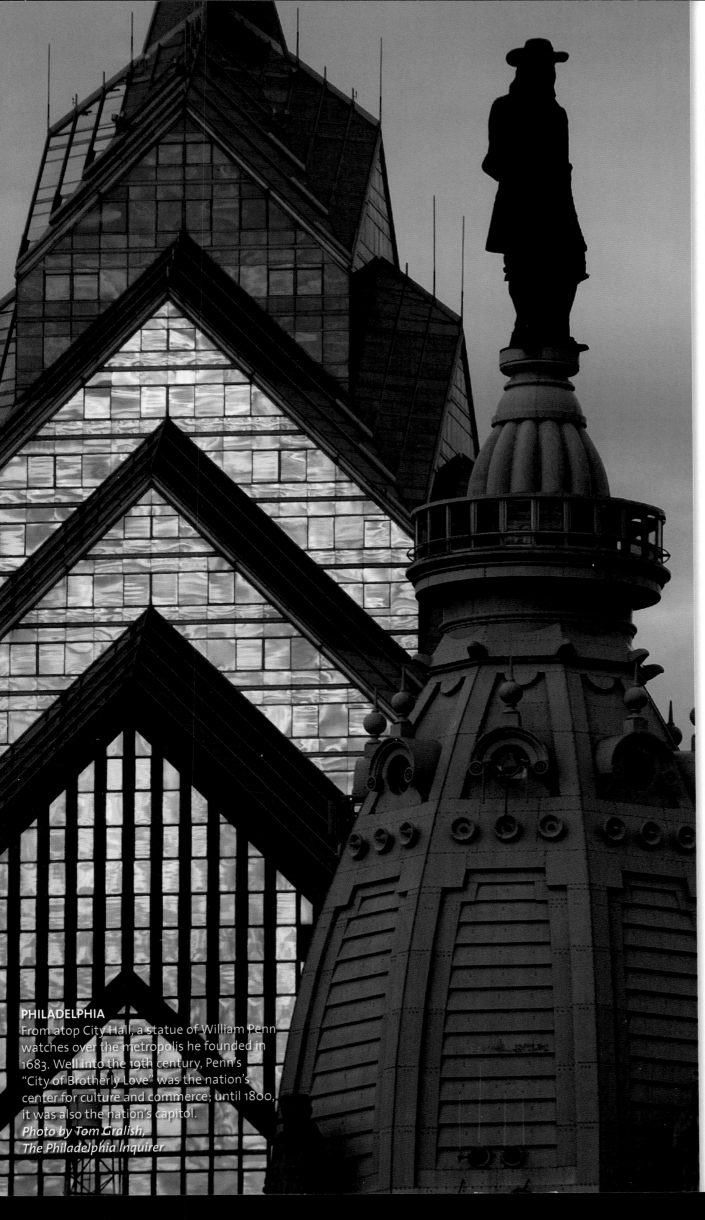

PHILADELPHIA
From atop City Hall, a statue of William Penn watches over the metropolis he founded in 1683. Well into the 19th century, Penn's "City of Brotherly Love" was the nation's center for culture and commerce; until 1800, it was also the nation's capitol.
Photo by Tom Gralish,
The Philadelphia Inquirer

Pennsylvania 24/7 is the sequel to *The New York Times* bestseller *America 24/7* shot by tens of thousands of digital photographers across America over the course of a single week. We would like to thank the following sponsors, the wonderful people of Pennsylvania, and the talented photojournalists who made this book possible.

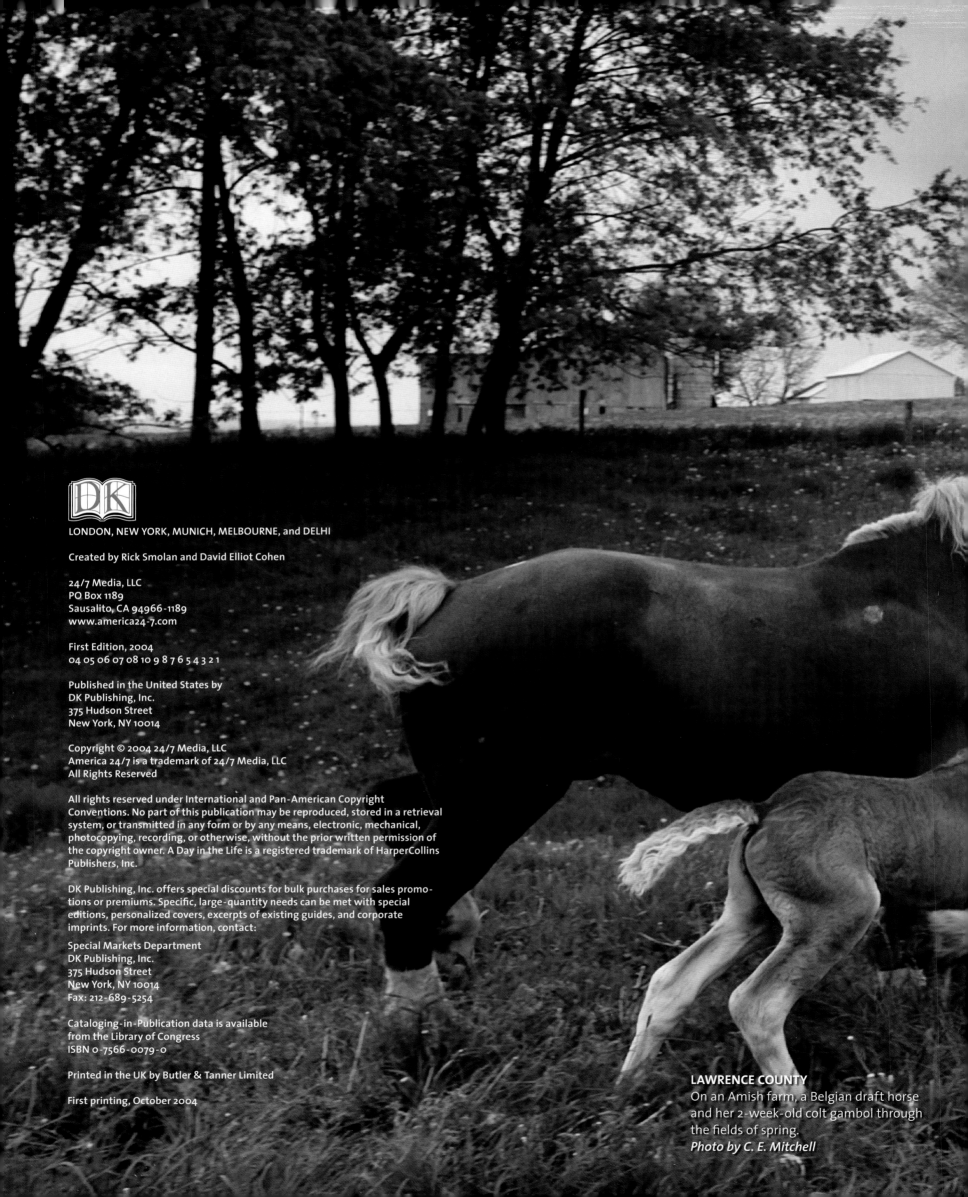

DK

LONDON, NEW YORK, MUNICH, MELBOURNE, and DELHI

Created by Rick Smolan and David Elliot Cohen

24/7 Media, LLC
PO Box 1189
Sausalito, CA 94966-1189
www.america24-7.com

First Edition, 2004
04 05 06 07 08 10 9 8 7 6 5 4 3 2 1

Published in the United States by
DK Publishing, Inc.
375 Hudson Street
New York, NY 10014

DK Publishing, Inc. offers special discounts for bulk purchases for sales promo-
tions or premiums. Specific, large-quantity needs can be met with special
editions, personalized covers, excerpts of existing guides, and corporate
imprints. For more information, contact:

Special Markets Department
DK Publishing, Inc.
375 Hudson Street
New York, NY 10014
Fax: 212-689-5254

Cataloging-in-Publication data is available
from the Library of Congress
ISBN 0-7566-0079-0

Printed in the UK by Butler & Tanner Limited

First printing, October 2004

LAWRENCE COUNTY
On an Amish farm, a Belgian draft horse
and her 2-week-old colt gambol through
the fields of spring.
Photo by C. E. Mitchell

PENNSYLVANIA 24/7

24 Hours. 7 Days.
Extraordinary Images of
One Week in Pennsylvania.

Created by Rick Smolan and David Elliot Cohen

DK Publishing

About the America 24/7 Project

A hundred years hence, historians may pose questions such as: What was America like at the beginning of the third millennium? How did life change after 9/11 and the ensuing war on terrorism? How was America affected by its corporate scandals and the high-tech boom and bust? Could Americans still express themselves freely?

To address these questions, we created *America 24/7*, the largest collaborative photography event in history. We invited Americans to tell their stories with digital pictures. We asked them to shoot a visual memoir of their lives, families, and communities.

During one week in May 2003, more than 25,000 professionals and amateurs shot more than a million pictures. These images, sent to us via the Internet, compose a panoramic yet highly intimate view of Americans in celebration and sadness; in action and contemplation; at work, home, and school. The best of these photographs, more than 6,000, are collected in 51 volumes that make up the *America 24/7* series: the landmark national volume *America 24/7*, published to critical acclaim in 2003, and the 50 state books published in 2004.

Our decision to make *America 24/7* an all-digital project was prompted by the fact that in 2003 digital camera sales overtook film camera sales. This techno-logical evolution allowed us to extend the project to a huge pool of photographers. We were thrilled by the response to our challenge and moved by the insight offered into American life. Sometimes, the amateurs outshot the pros—even the Pulitzer Prize winners.

The exuberant democracy of images visible throughout these books is a revela-tion. The message that emerges is that now, more than ever, America is a supersized idea. A dreamspace, where individuals and families from around the world are free to govern themselves, worship, read, and speak as they wish. Within its wide margins, the polyglot American nation manages to encompass an inexplicably complex yet workable whole. The pictures in this book are dedicated to that idea.

—*Rick Smolan and David Elliot Cohen*

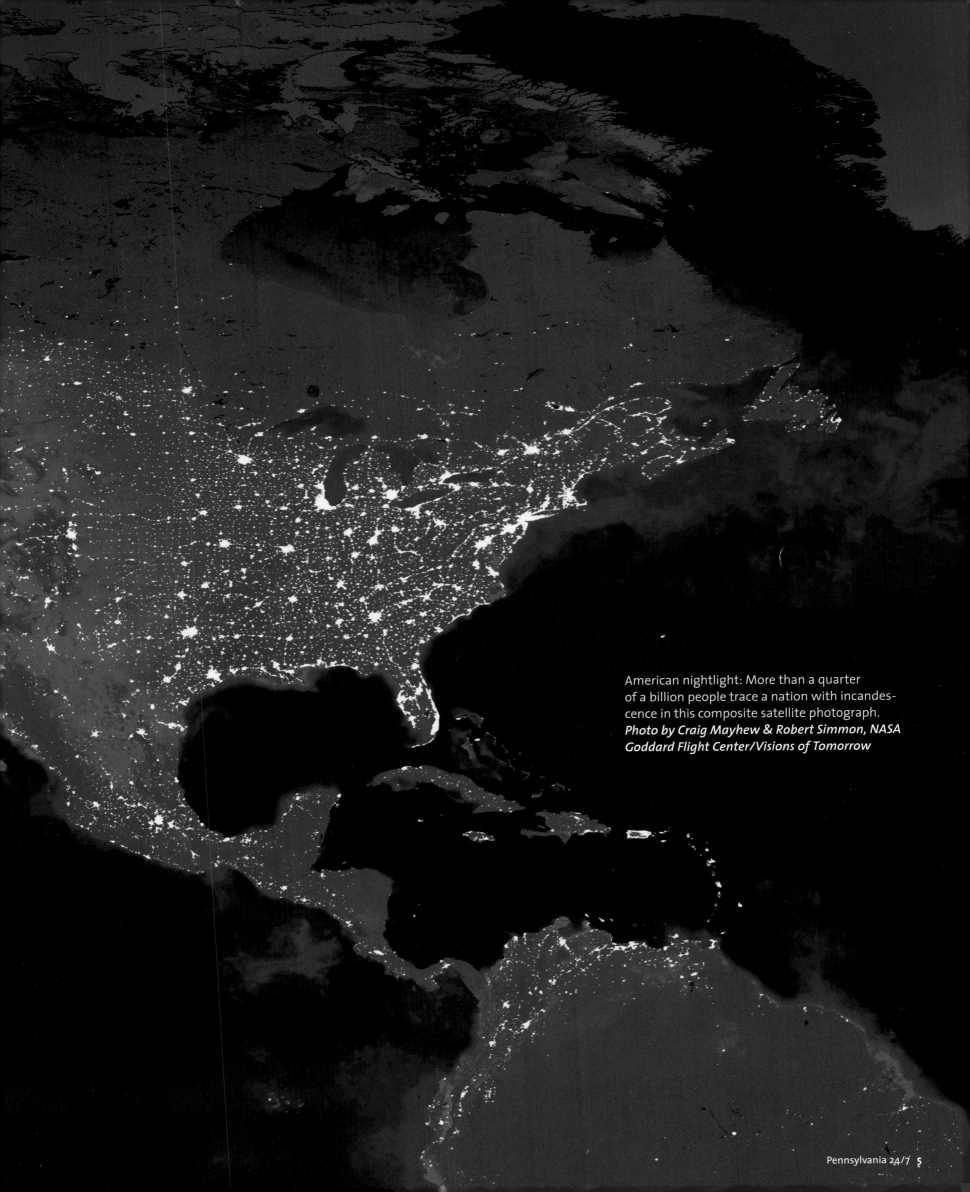

American nightlight: More than a quarter of a billion people trace a nation with incandescence in this composite satellite photograph.
Photo by Craig Mayhew & Robert Simmon, NASA Goddard Flight Center/Visions of Tomorrow

In Penn's Woods

By Dennis Roddy

When William Penn's sons needed to grow their colony westward, they struck a deal with the native tribes: They would lay down their money for whatever land a man could travel in a day and a half. The Indians assumed they meant a man walking. The Penns hired a group of runners who, by the time they dropped from exhaustion, had begun a land grab that 40 years and two wars later would push the border beyond the Alleghenies.

It was a state made for the robber barons who followed. Pennsylvanians poked tunnels through rock, carved canals in the soil and, when nothing else worked, came up with a railroad that pulled canal boats on flatbeds up mountains and then simply dropped them down the other side. Penn's boys wanted space, and succeeding generations found ways to fill it.

James Carville famously cracked that my state is "Pittsburgh and Philadelphia separated by Alabama," but it is better described as a promiscuous assemblage united by its differences, hewing to the political far-middle until, at places such as Independence Hall or Valley Forge, they feel pushed too far by the hand of authority and speak truth to power, often through the medium of gunpowder. I mean, we once had an armed rebellion about a whisky tax.

Our fights often are not over large things, but small things that matter in big ways. The state budget is six months overdue as I write this. That's nothing. The legislature has argued just as bitterly—and for years—about the official state dance. One faction demands a polka. The rural center wants square dancing.

PHILADELPHIA
The original Liberty Bell, cast by White-chapel Foundry in England, was so brittle that it cracked the first time it was rung in 1752. Philadelphia iron founders John Pass and John Stow recast it using a ratio of three parts copper to one part tin. But the attempt to soften the bell failed, and it fractured a second time in the early 1800s.
Photo by Tom Gralish,
The Philadelphia Inquirer

Our internal boundaries are often less geographic and more phonetic. Depending on your region, you can "redd up the room"—a Scots-Irish expression used in the west; "outen the light"—a legacy of German-speaking Amish who settled the center; or drink some "worter"—a Philadelphia tradition born of tossing stray r's into words that don't have them.

Between Pittsburgh, my wife's hometown, and Johnstown, the resilient little mill town in which I was born, there exists what I call "the scrapple line." Scrapple is a mixture of cornmeal and parts of the pig that stubborn German farmers refuse to surrender to the scrap pile. It is formed into blocks and wrapped in packages that are mercifully spare in content details. It's best served fried with maple syrup and minus discussion.

Search as you will, scrapple will not turn up on menus east of the Ohio border until you reach the Summit Diner in Somerset County. From there on, you are in scrapple country. Bon appétit and phone your cardiologist.

Between Pittsburgh and Philadelphia, a sandwich is a political state-ment. In the last election for governor, the Republican from Pittsburgh and the Democrat, a former Philadelphia mayor, argued over which is better: a Philly cheesesteak or a Primanti's sandwich, which is meat, coleslaw, and French fries all scrunched between two impossibly thick slices of Italian bread.

The Democrat from Philly won the governorship and we get along fine with him. He's a moderate, after all. But, if it's all the same, I'll take my sandwich with the French fries inside. Maybe with a glass of worter.

DENNIS RODDY, *a columnist for the* PITTSBURGH POST-GAZETTE, *has covered politics and other disasters in Pennsylvania for 30 years.*

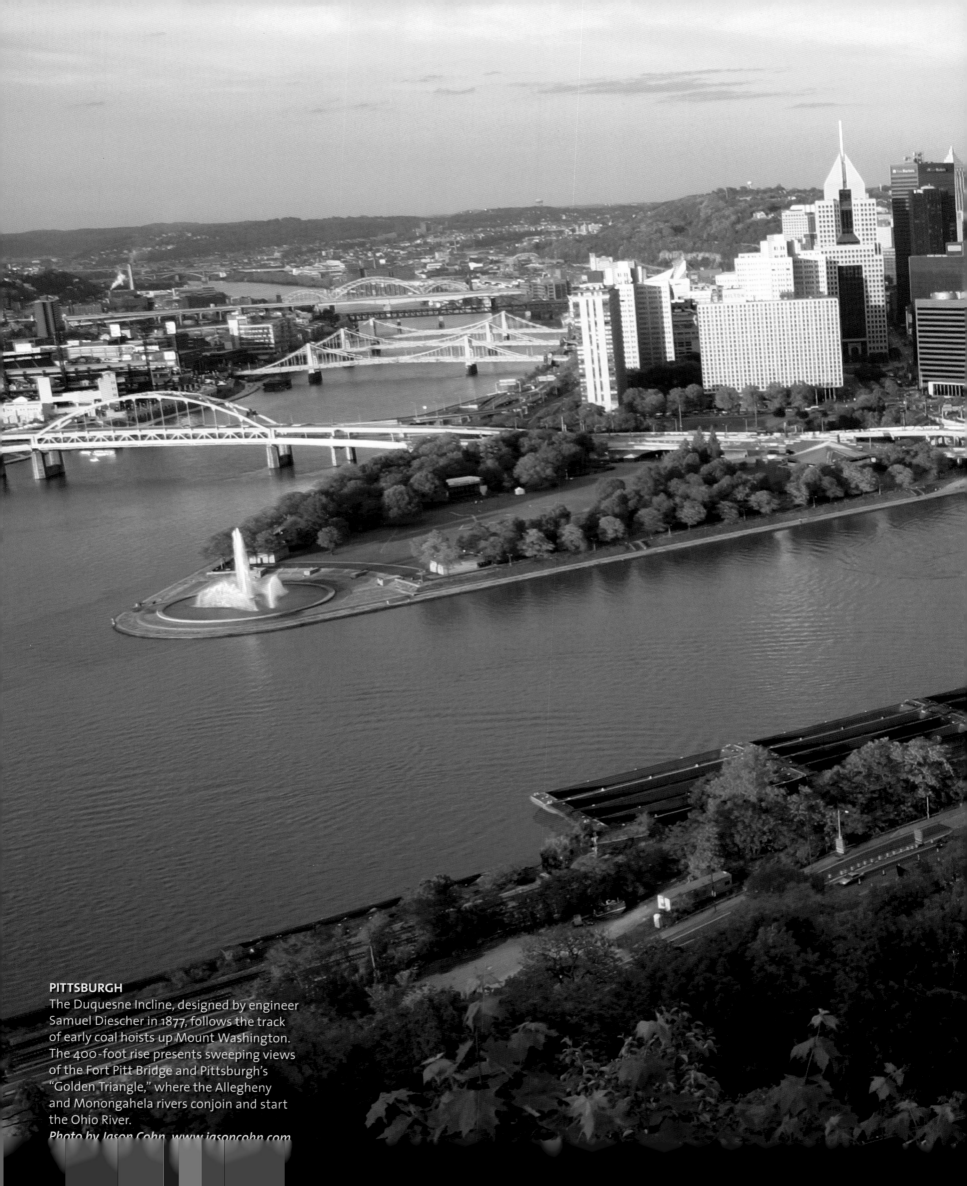

PITTSBURGH
The Duquesne Incline, designed by engineer
Samuel Diescher in 1877, follows the track
of early coal hoists up Mount Washington.
The 400-foot rise presents sweeping views
of the Fort Pitt Bridge and Pittsburgh's
"Golden Triangle," where the Allegheny
and Monongahela rivers conjoin and start
the Ohio River.
Photo by Jason Cohn, www.jasoncohn.com

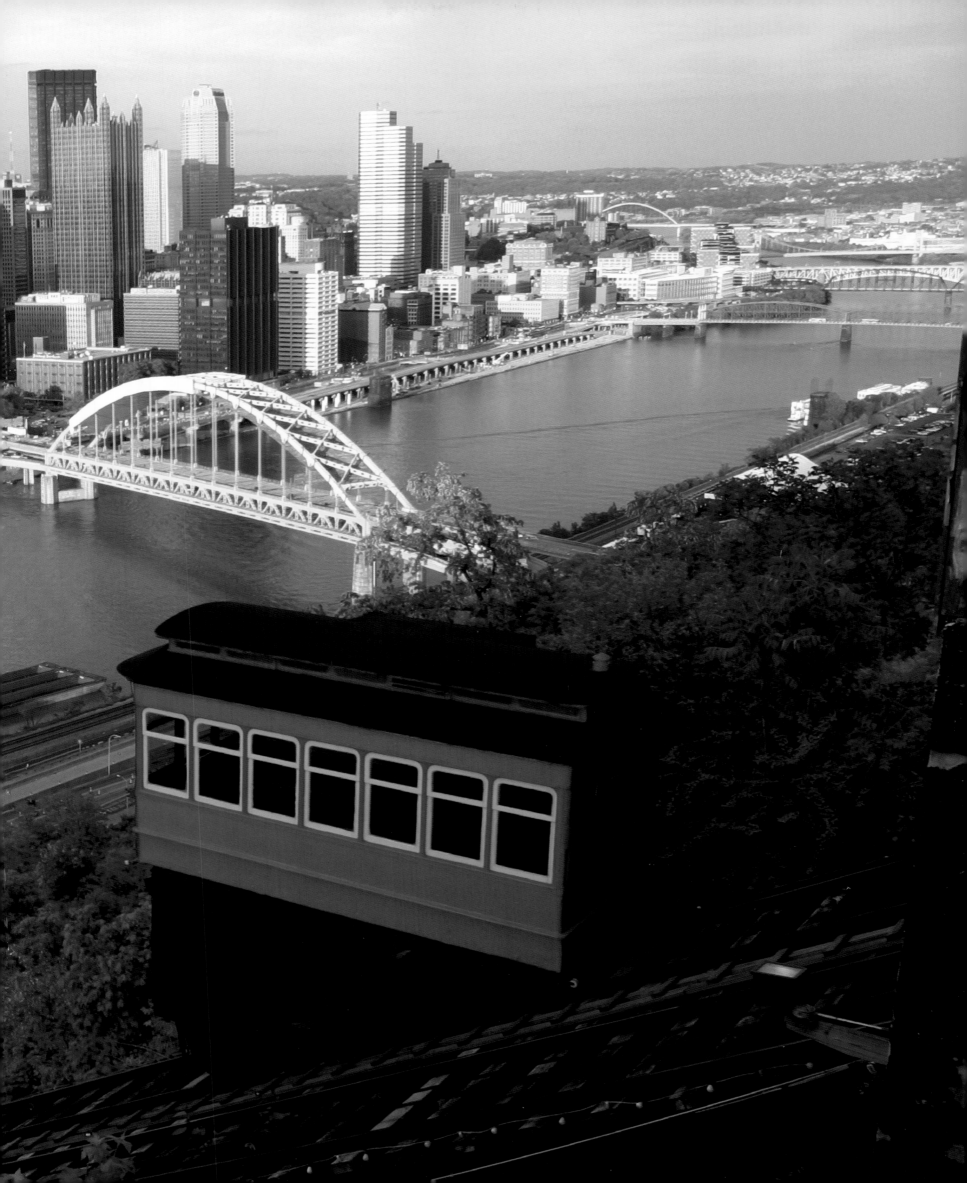

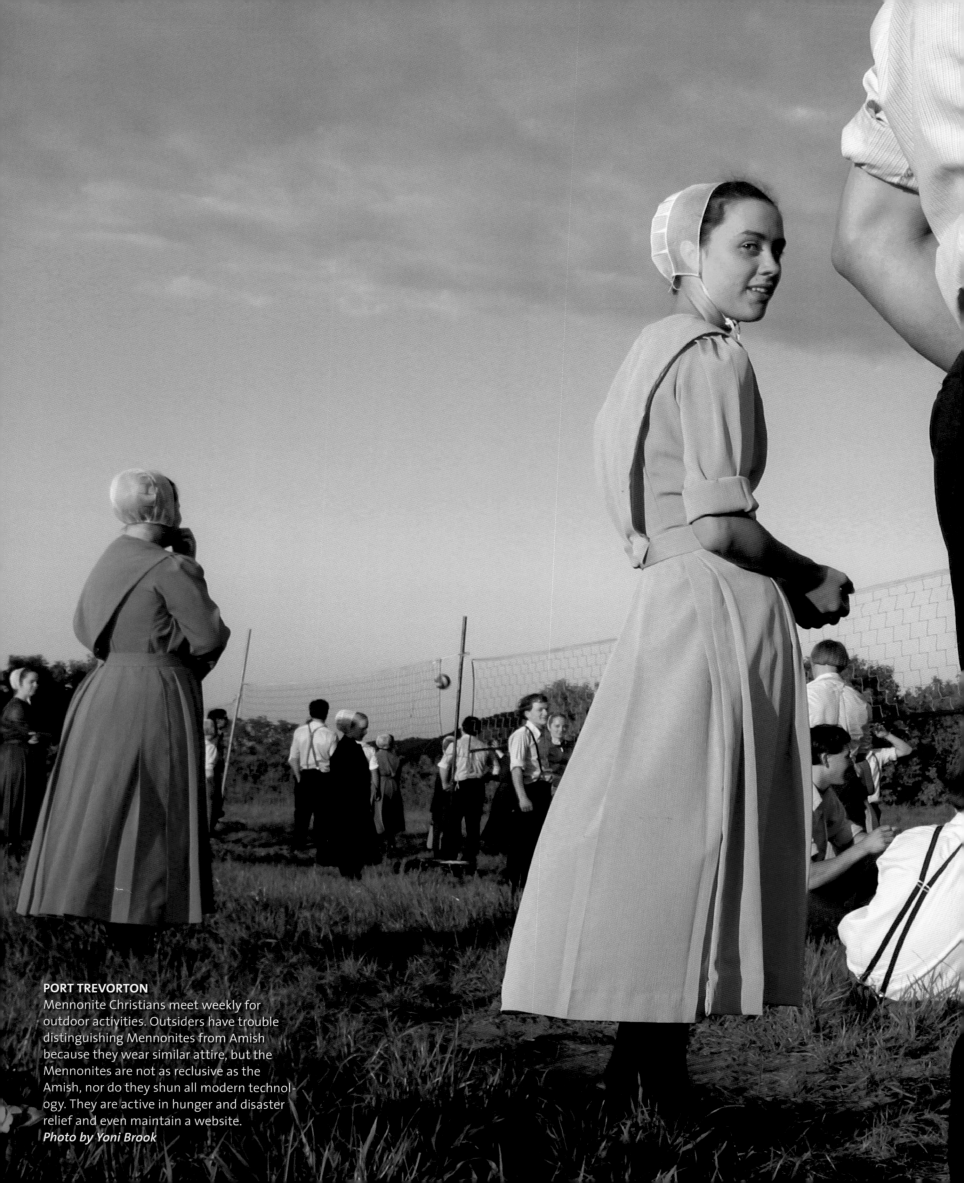

PORT TREVORTON
Mennonite Christians meet weekly for outdoor activities. Outsiders have trouble distinguishing Mennonites from Amish because they wear similar attire, but the Mennonites are not as reclusive as the Amish, nor do they shun all modern technology. They are active in hunger and disaster relief and even maintain a website.
Photo by Yoni Brook

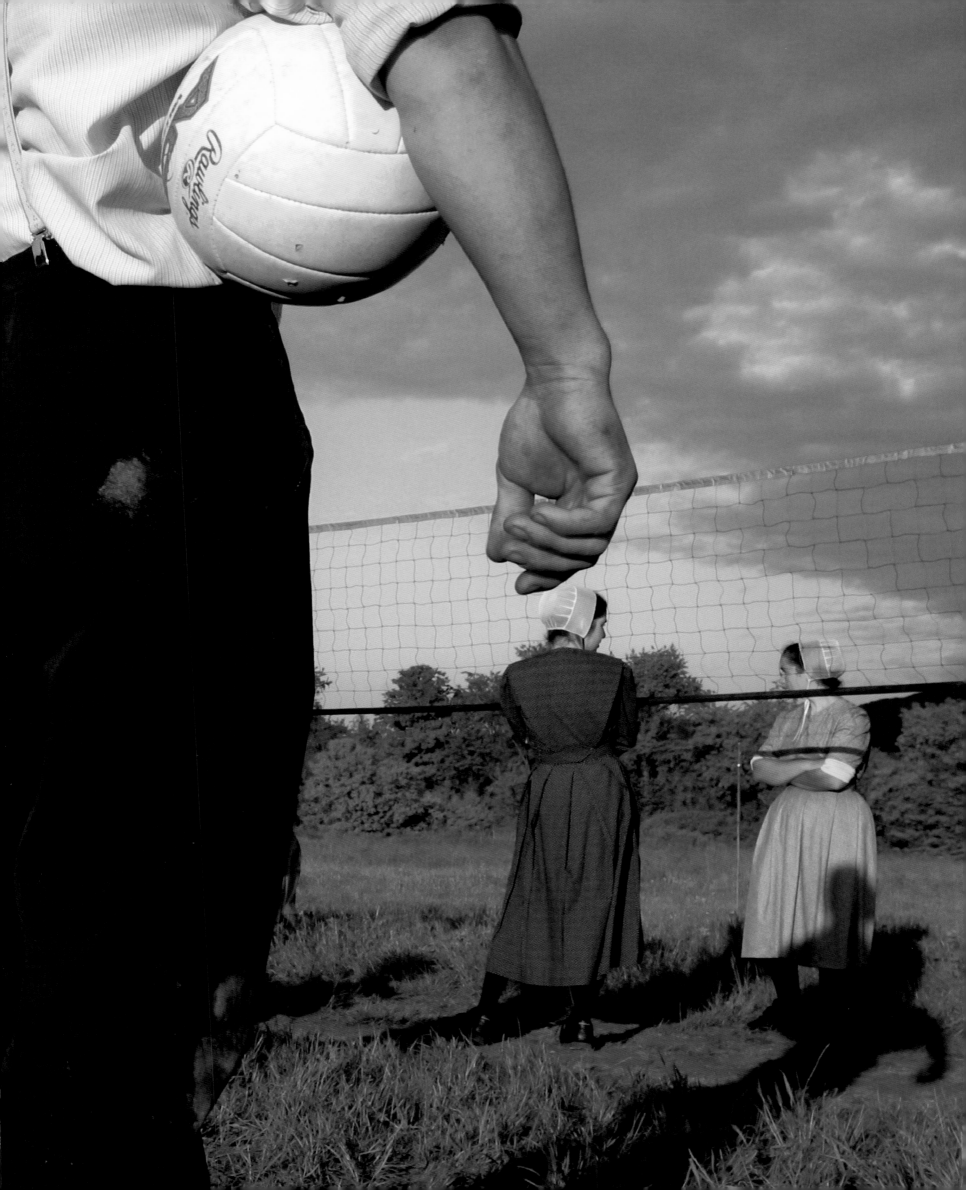

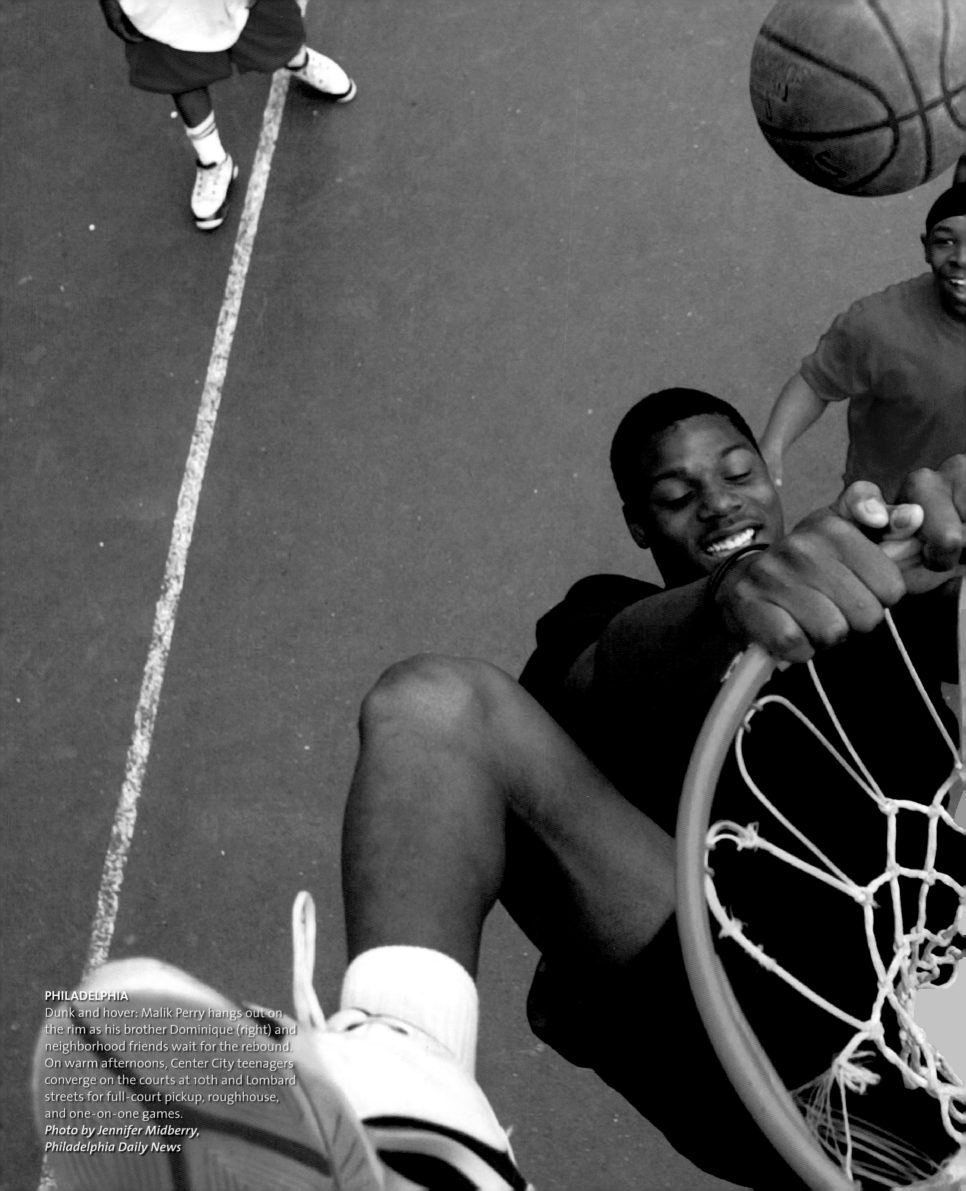

PHILADELPHIA
Dunk and hover: Malik Perry hangs out on
the rim as his brother Dominique (right) and
neighborhood friends wait for the rebound.
On warm afternoons, Center City teenagers
converge on the courts at 10th and Lombard
streets for full-court pickup, roughhouse,
and one-on-one games.
Photo by Jennifer Midberry,
Philadelphia Daily News

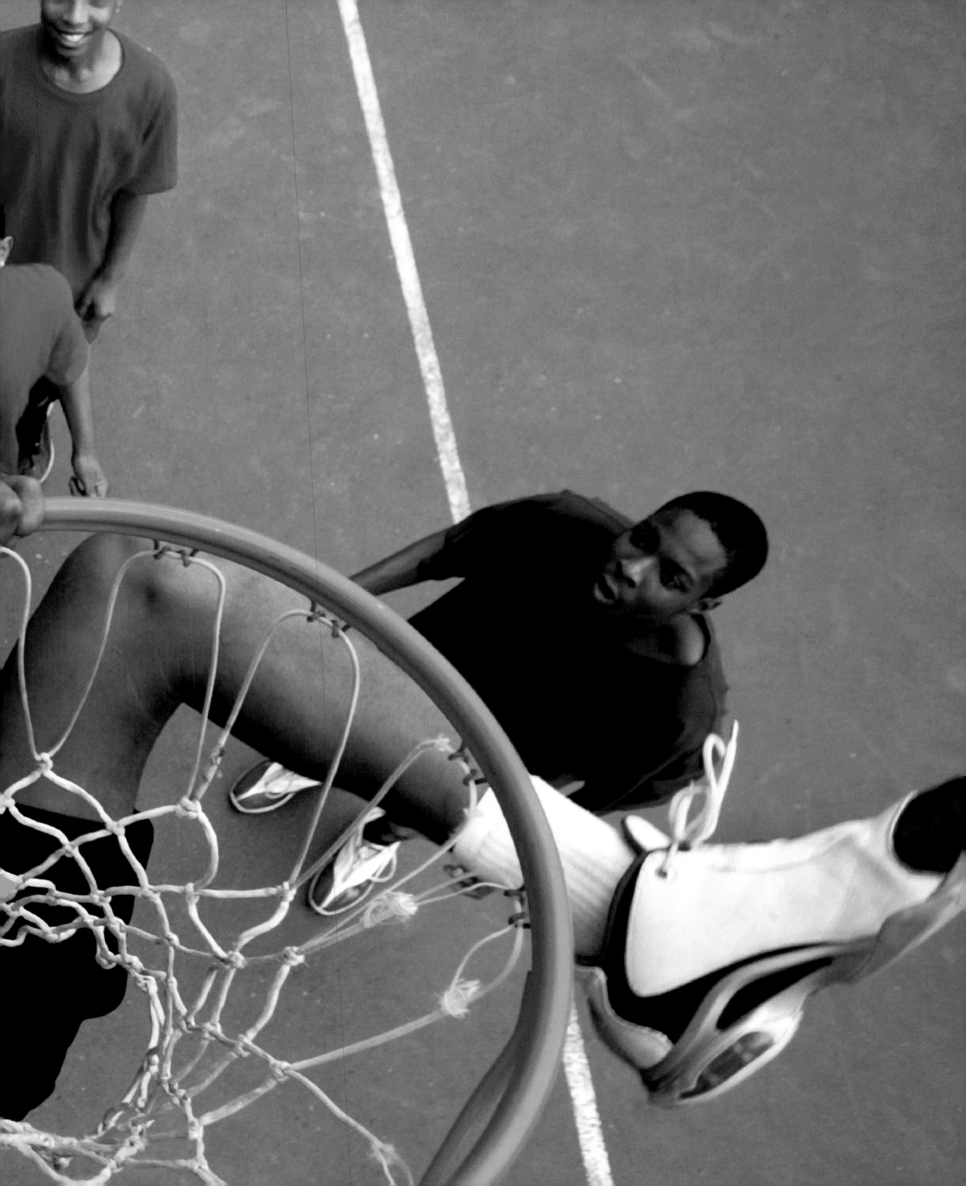

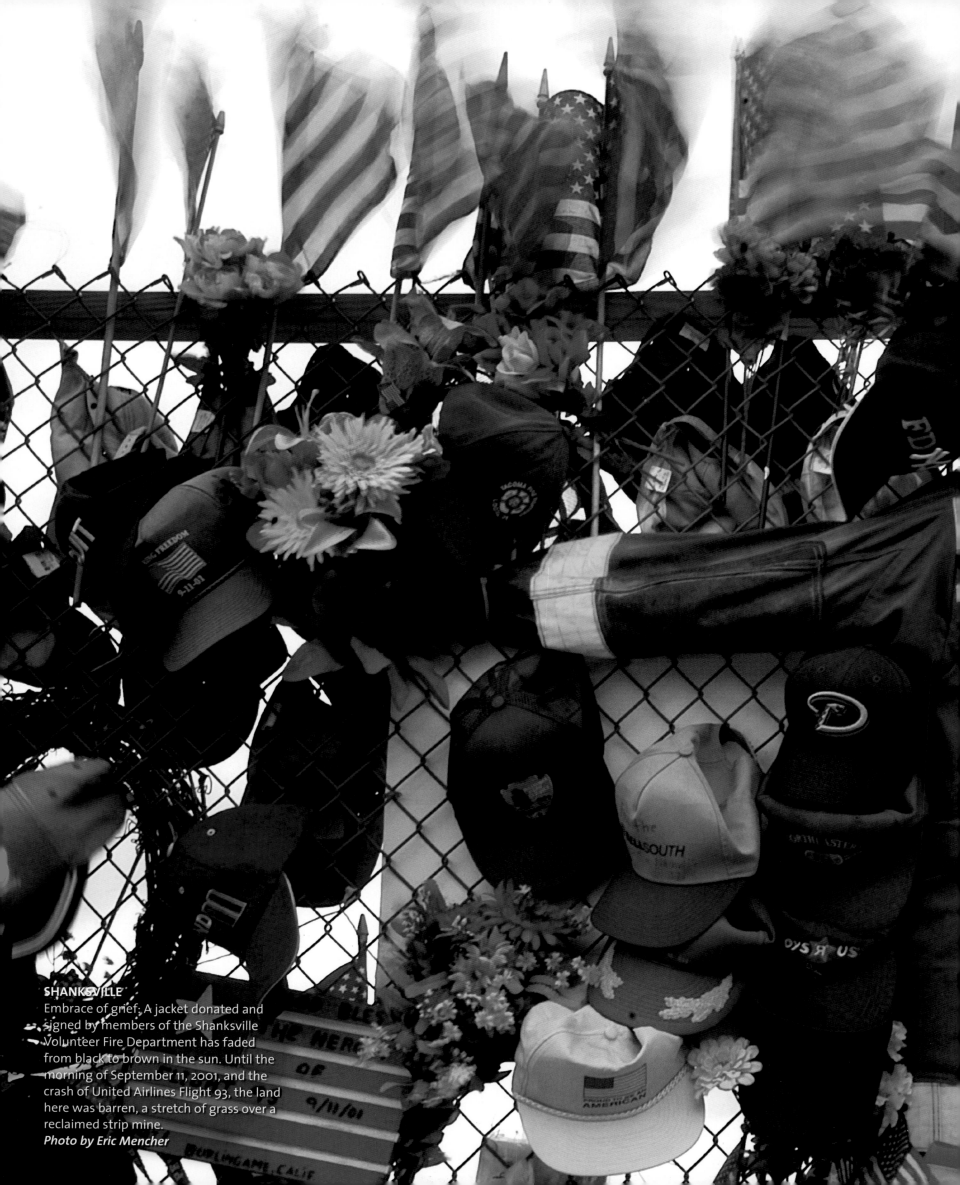

SHANKSVILLE
Embrace of grief: A jacket donated and signed by members of the Shanksville Volunteer Fire Department has faded from black to brown in the sun. Until the morning of September 11, 2001, and the crash of United Airlines Flight 93, the land here was barren, a stretch of grass over a reclaimed strip mine.
Photo by Eric Mencher

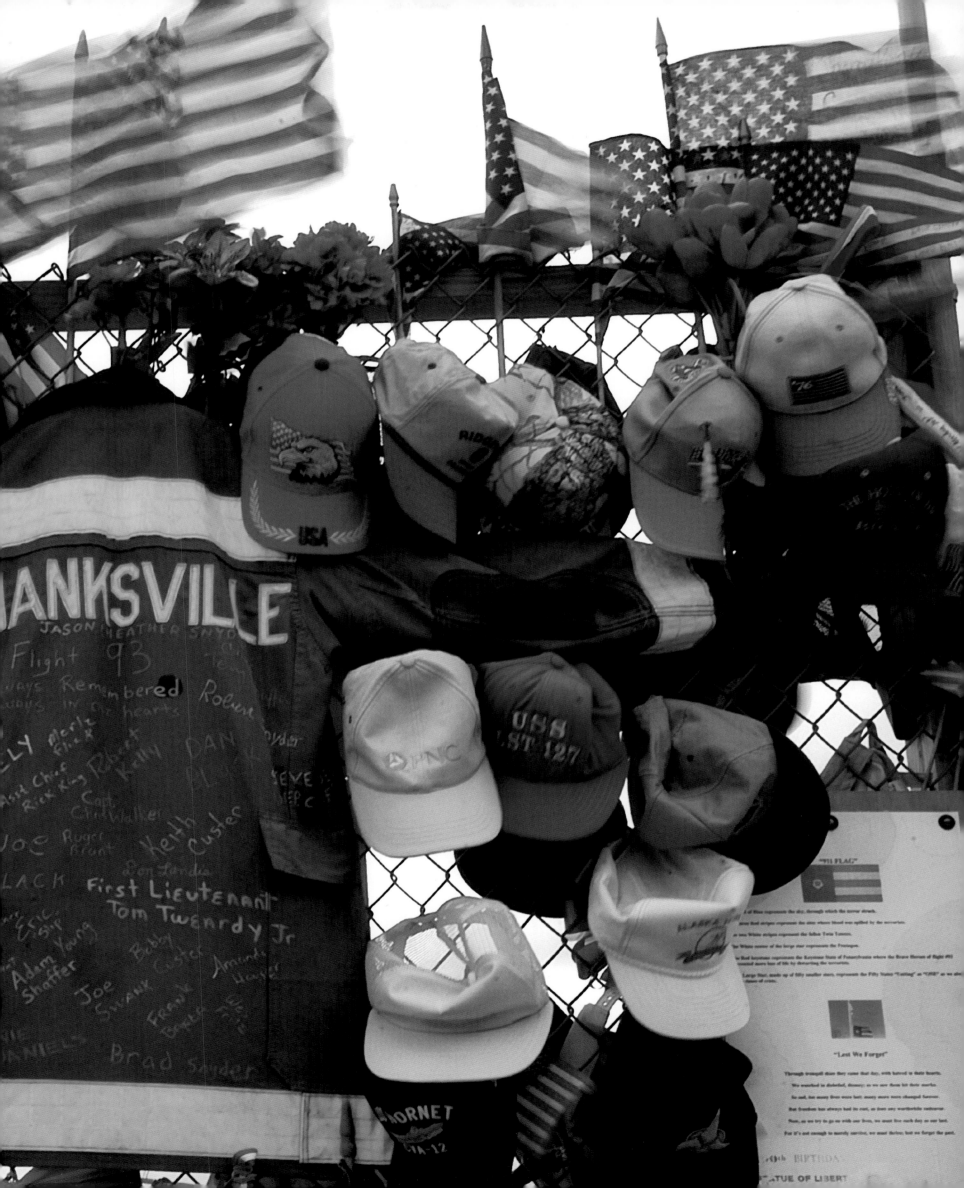

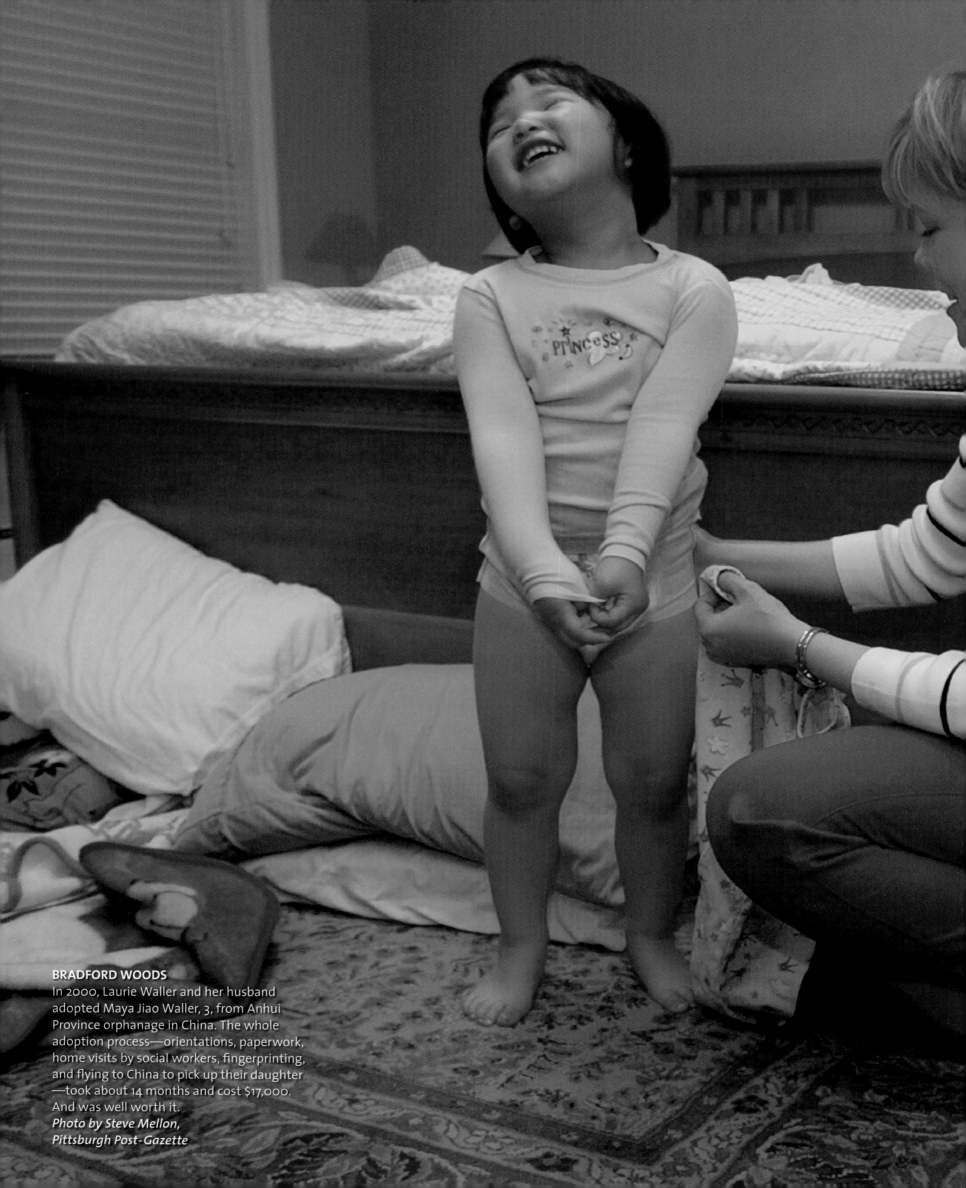

BRADFORD WOODS
In 2000, Laurie Waller and her husband adopted Maya Jiao Waller, 3, from Anhui Province orphanage in China. The whole adoption process—orientations, paperwork, home visits by social workers, fingerprinting, and flying to China to pick up their daughter —took about 14 months and cost $17,000. And was well worth it.
Photo by Steve Mellon,
Pittsburgh Post-Gazette

Hearth & Home

PALMYRA
Facts and figures enthrall Andrew Oscilowski, who memorizes his mother's address book in his downtime. Andrew has Asperger's syndrome, a neurological disorder characterized by impaired social skills and obsessive routines. But his condition also comes with a gift: A photographic memory and a shot at the National Spelling Bee.
Photo by Sean Simmers,
Harrisburg Patriot-News

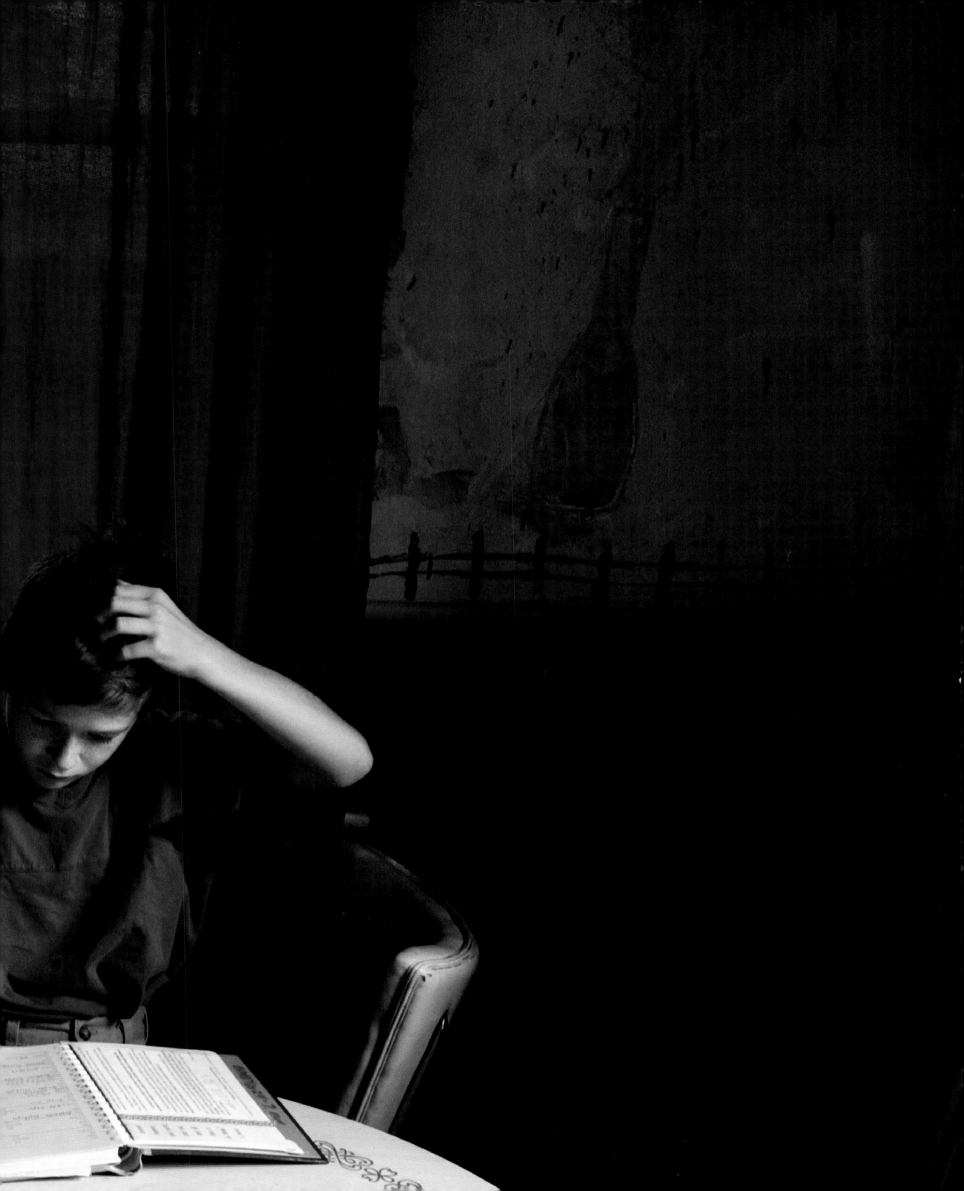

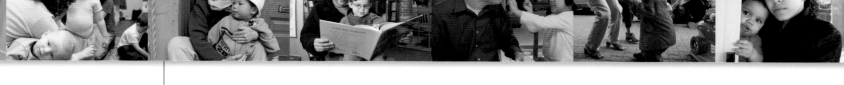

PHILADELPHIA

South Broad Street used to be predominantly
Italian American. Not anymore. The new mix,
which includes African Americans and Asians,
numbers Hau Tran, 80, and her great-grandson
Michael, 1. They're hanging out on their front
stoop after sharing a bowl of soup.
Photo by David Maialetti, Philadelphia Daily News

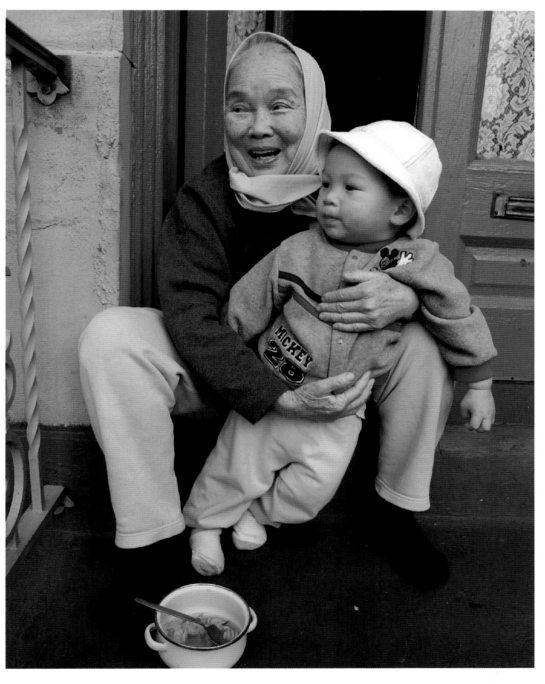

PITTSBURGH
Stay-at-home mom Mikheal Meece (front)
helps her partner Rebecca McTall feed their
7-month-old triplets. Pennsylvania law allowed
Meece to adopt the children legally after McTall,
a physician's assistant, gave birth to them. The
couple has been together four years. "We're a
family," Meece says, "of three kids, two moms,
one income, and no problems."
Photos by Annie O'Neill

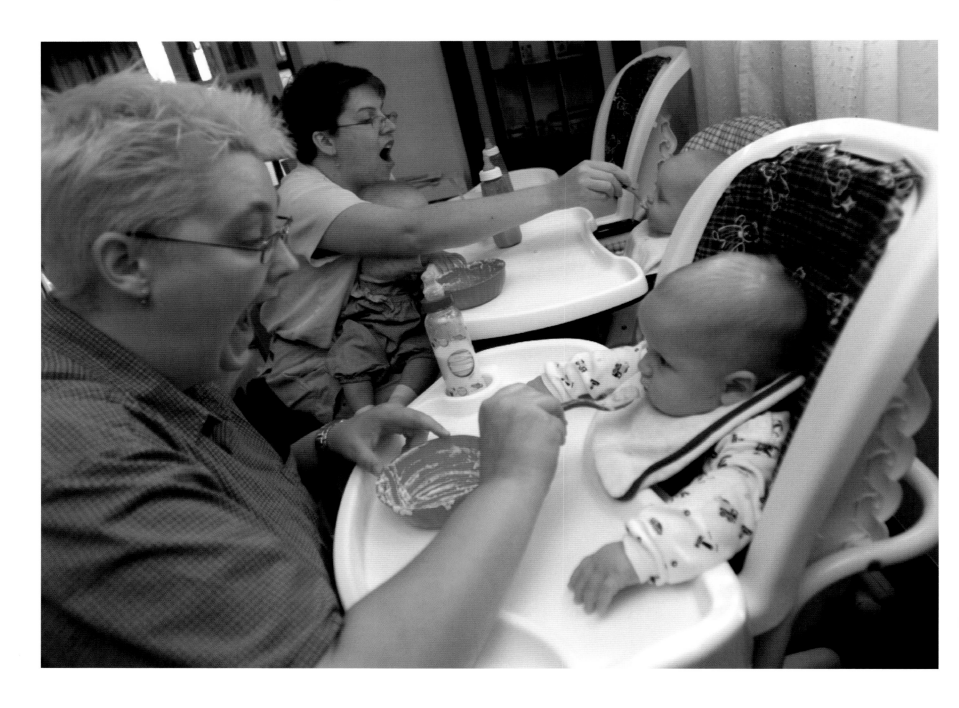

PITTSBURGH

When Meece and McTall's triplets had gastro-intestinal tract infections simultaneously, the pediatrician's regimen forbade formula for several hours after they threw up. Meece kept track so she'd know who could eat again and when. How did they manage it? "One diaper at a time," she says.

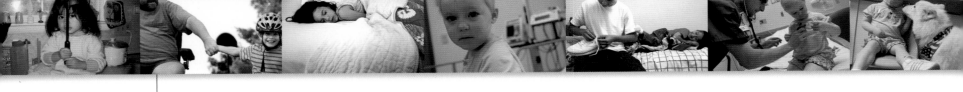

Andy Guest, 38, and son Jamie, 8, play roller
derby in the driveway of their suburban home.
Two years ago, a neurologist diagnosed Guest
with Lou Gehrig's disease, an incurable illness
that causes slow paralysis and death. "I try to
find ways to make my illness and wheelchair
less scary for my kids," says Guest.
Photo by Sean Simmers, Harrisburg Patriot-News

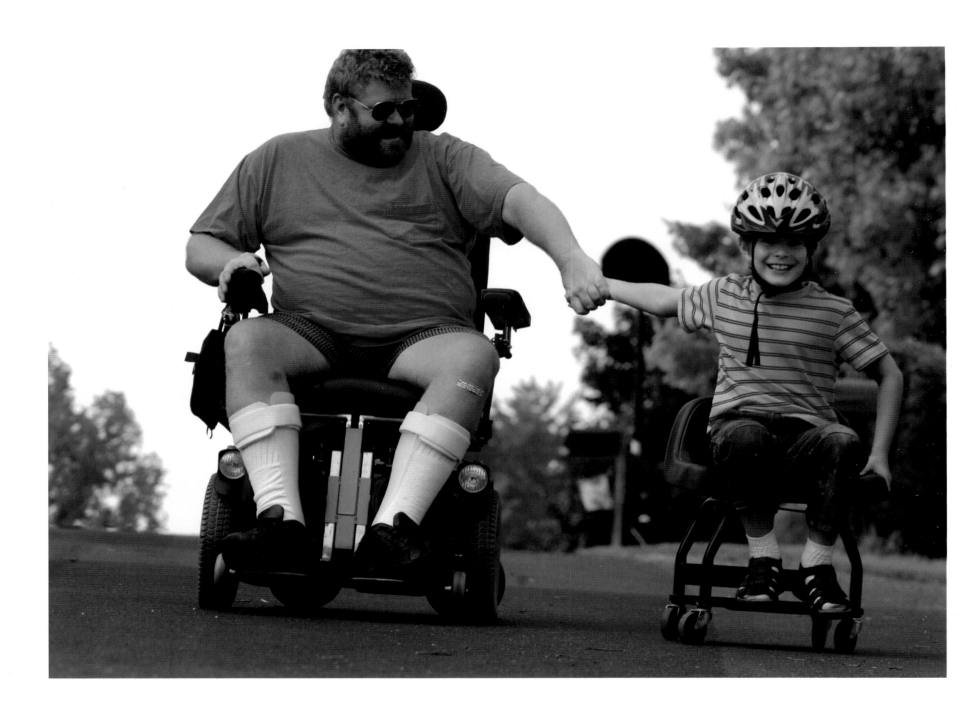

PITTSBURGH

At the Children's Hospital of Pittsburgh, Hannah Hannum cuddles with her mother Holly on the last day of the 3-year-old's month-long stay. Doctors diagnosed Hannah with AML-type leukemia in March. Over a year, she will undergo eight chemotherapy treatments. "If there's a hero in my world," Hannum says, "it's her."
Photo by Jason Cohn, www.jasoncohn.com

PITTSBURGH
At the Western Pennsylvania School
for Blind Children in the Oakland sec-
tion of Pittsburgh, Kevin Mimnaugh, 8,
plays with beads. Learning tools such
as this help children develop the ability to
interpret their environment through touch.
Photo by Scott Goldsmith

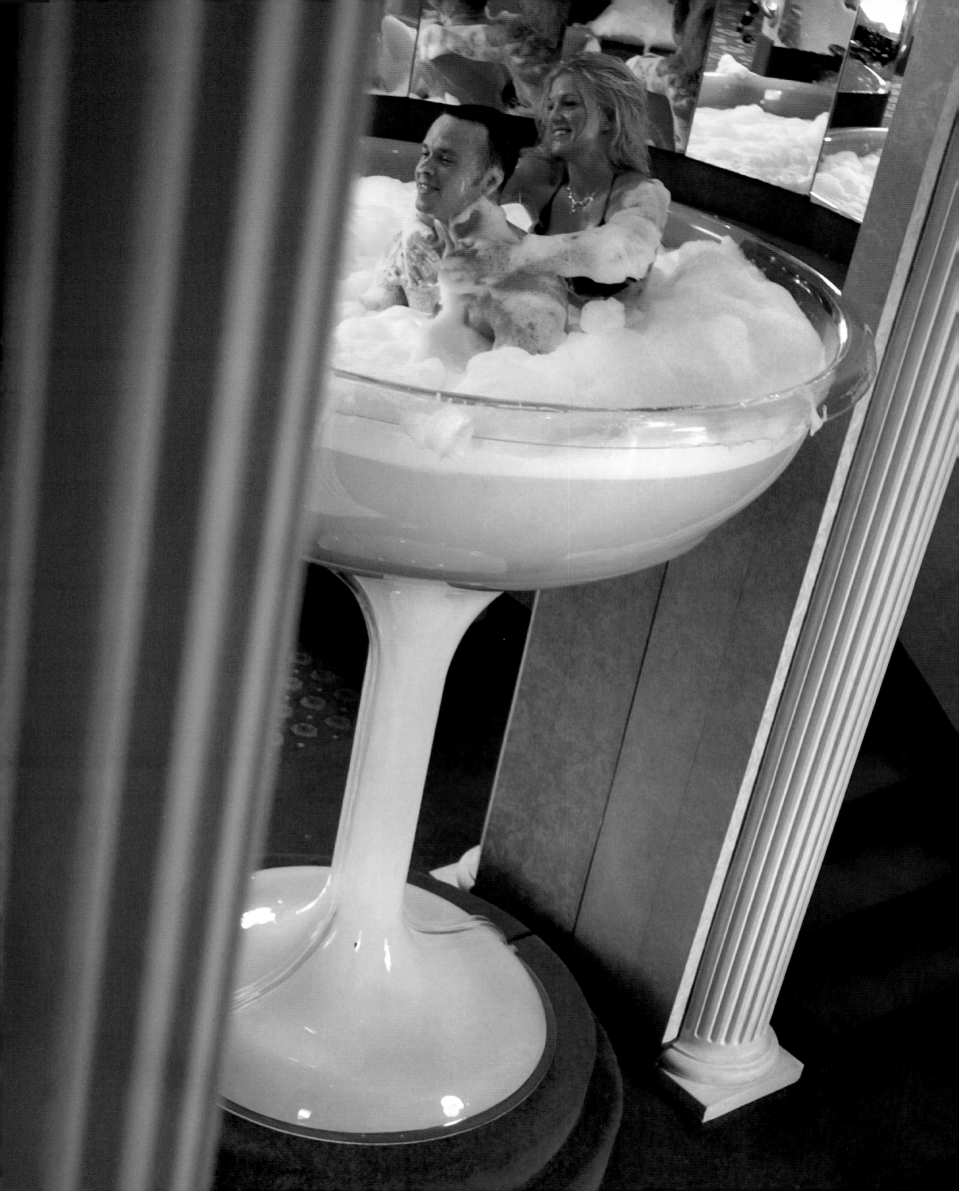

MARSHALLS CREEK

Sudsing up...way up. The Pocono Mountain hotels still provide over-the-top honeymoons. Pittsburgh newlyweds Leah and James Moorhead traveled across the state and up a spiral staircase to pour themselves into their champage-glass bath at the Pocono Palace. And to drink? "Beer," Leah answered. "Neither of us likes champagne."
Photo by Frank Wiese, The Morning Call

ANDALUSIA

Newlyweds Rachel Leonard and Jim Karoli (center), get some coverage from spring showers while waiting for their photographer to set up his lights at the Biddle Estate gardens. Leonard, the fashion director of *Bride's* magazine in New York, wears a champagne Grecian satin wedding gown, a gift from her friend, designer Vera Wang.
Photo by Jane Hanstein Cunniffe, SmilingGoat.com

BATH

Beth and Tien Nguyen already had two children when they married in the month of May; Tien wanted Beth and the kids covered by his health insurance. Tien immigrated from Vietnam in 1989 and settled in Allentown, where he attended high school and met Beth. The bride's sister, Amanda Ordendach, holding the bouquet, approves of the match.
Photo by Yoni Brook

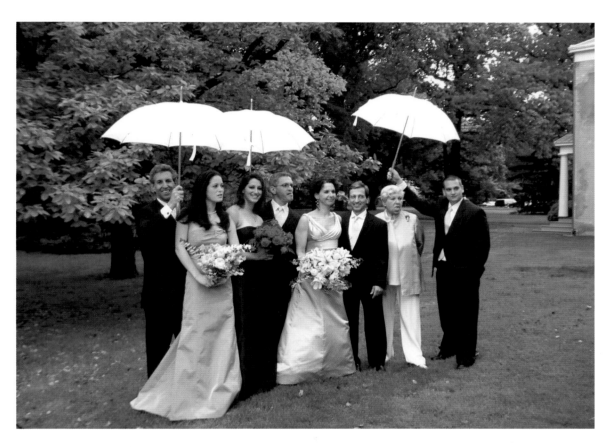

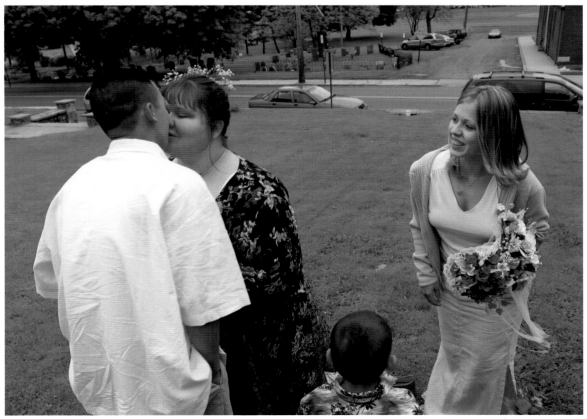

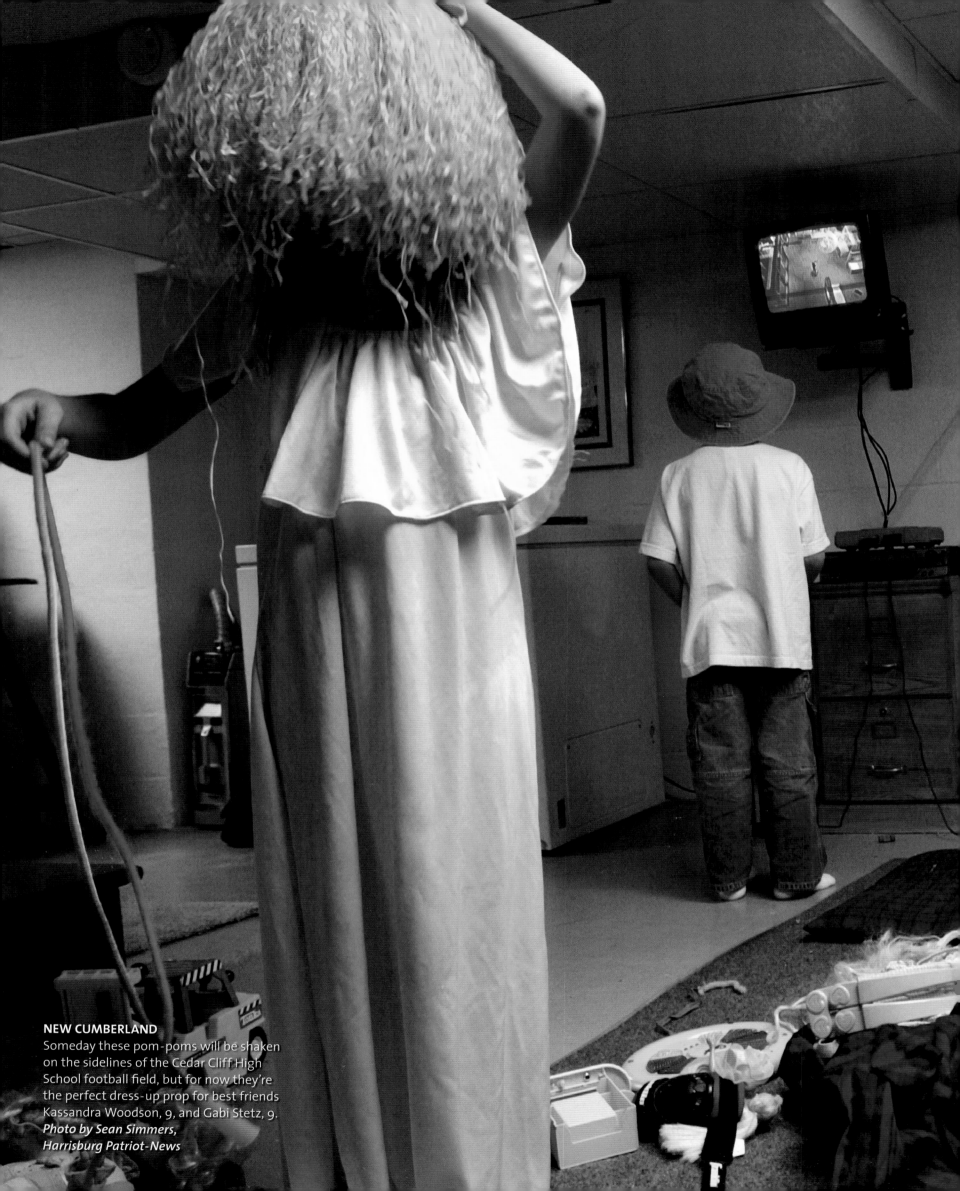

NEW CUMBERLAND
Someday these pom-poms will be shaken on the sidelines of the Cedar Cliff High School football field, but for now they're the perfect dress-up prop for best friends Kassandra Woodson, 9, and Gabi Stetz, 9.
Photo by Sean Simmers,
Harrisburg Patriot-News

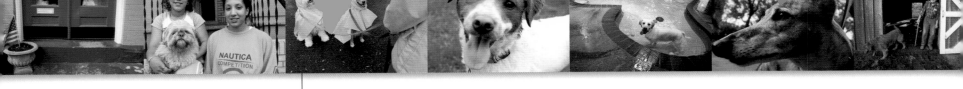

PENN VALLEY

Matsi and Sophie's yellow slickers make walks in the park a much drier affair. Besides rain gear, this fashionable pair also have Halloween costumes and snow boots.
Photo by Sharon Gekoski-Kimmel,
The Philadelphia Inquirer

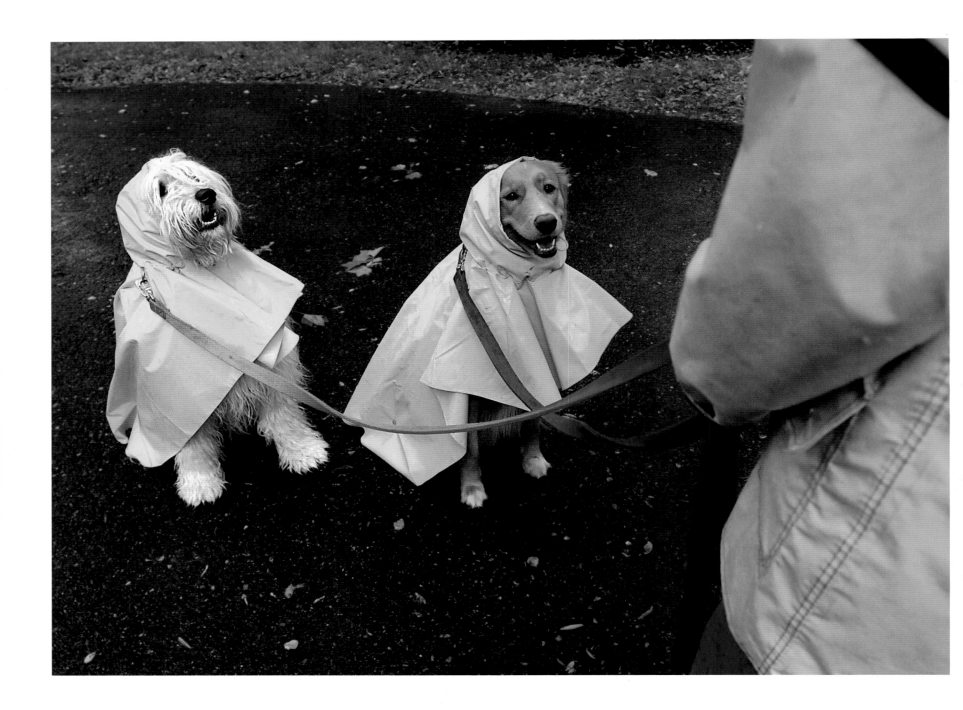

STAHLSTOWN

Princess, a golden retriever, dozes through a soap opera in the Executive Suite of the Cozy Inn Pet Resort & Orchids Spa. The high-end doggy hotel features hot-oil coat treatments, Swedish massage, and a bone-shaped swimming pool. Princess's owners, vacationing for a week, paid $245 for the dog's vacation.
Photo by Jason Cohn, www.jasoncohn.com

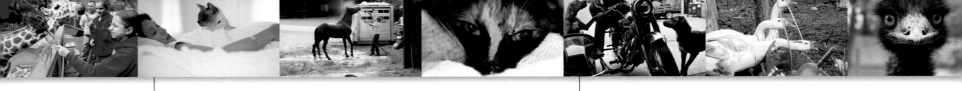

PHILADELPHIA

Cat nap: When Jeanette Aaron was asked to bring something to her birth classes to help her relax, she chose photos of her cats. Merlin, her half-Siamese, half-Tabby, favored his owner's lap before she got pregnant with her first child. Eventually he had to settle for a place beside her.
Photo by Nick Kelsh

PHILADELPHIA

Bonnie, a "Philadelphia pizza terrier," is happiest when she's riding in owner Adam Cramer's sidecar. Bonnie and Clyde (right) are fixtures of their South Philly neighborhood, where they're always looking for a handout. "Once I found Clyde waiting in line across the street at Pat's Cheesesteaks," says Cramer.
Photo by Jennifer Midberry,
Philadelphia Daily News

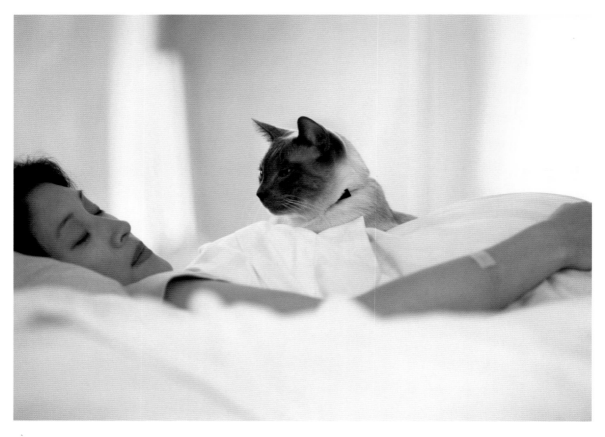

ERIE

James Berdis raises white pigeons for weddings, but his real love is racing the birds. Released together miles from their home coops, racing homing pigeons find their way back to their roosts, and the fastest bird wins. According to Berdis, one of his birds flaps at a sustained 55 mph. Average pigeon velocity is 40 mph.

Photo by Jack Hanrahan, Erie Times-News

CARSONVILLE

Mary is a little lamb. She's also Terry Flanagan's pet. Together with wife Lynn, he raises 150 sheep on their 80-acre commercial farm, but Mary is the only lamb allowed inside the house. Mary was an official witness at the couple's May wedding, where Lynn held a newborn lamb instead of a bouquet as she walked down the aisle.

Photo by Sean Simmers, Harrisburg Patriot-News

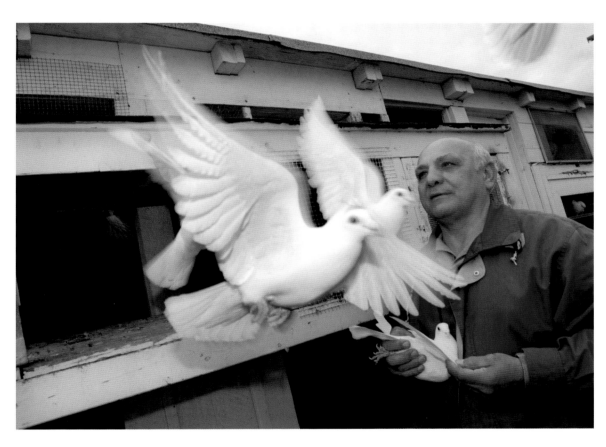

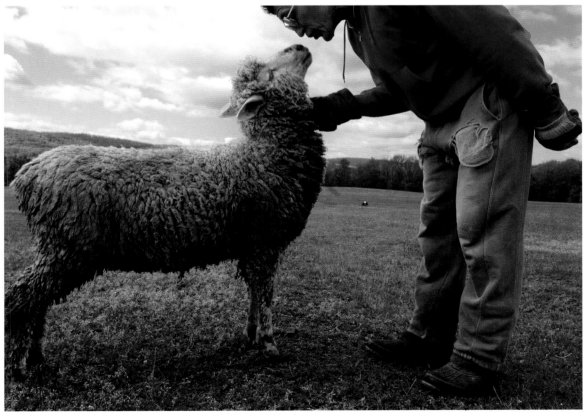

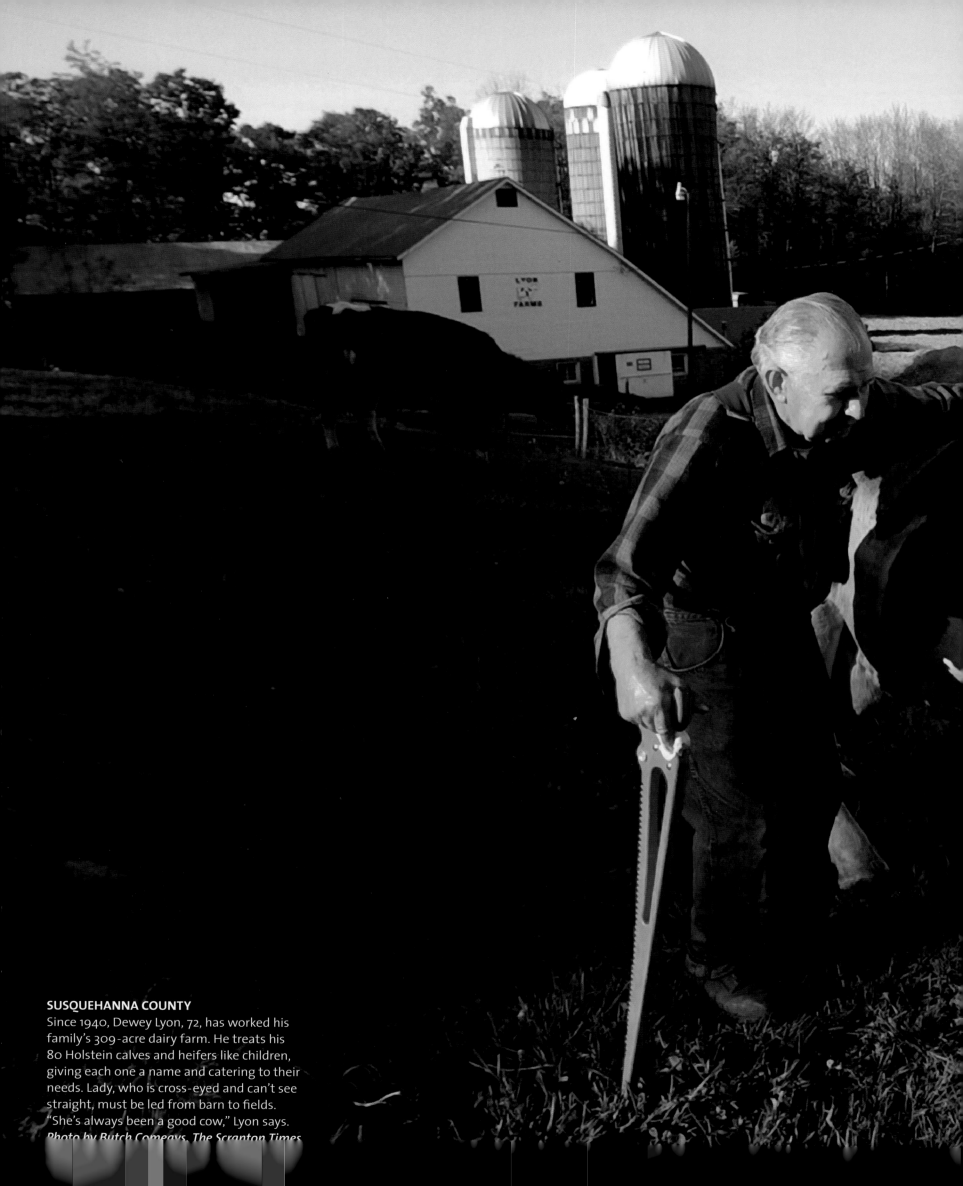

SUSQUEHANNA COUNTY
Since 1940, Dewey Lyon, 72, has worked his
family's 309-acre dairy farm. He treats his
80 Holstein calves and heifers like children,
giving each one a name and catering to their
needs. Lady, who is cross-eyed and can't see
straight, must be led from barn to fields.
"She's always been a good cow," Lyon says.
Photo by Butch Comegys, The Scranton Times

The year 2003 marked a turning point in the history of photography: It was the first year that digital cameras outsold film cameras. To celebrate this unprecedented sea change, the *America 24/7* project invited amateur photographers—along with students and professionals—to shoot and, via the Internet, submit digital images. Think of it as audience participation. Their visions of community are interspersed with the professional frames throughout this book. On the following four pages, however, we present a gallery produced exclusively by amateur photographers.

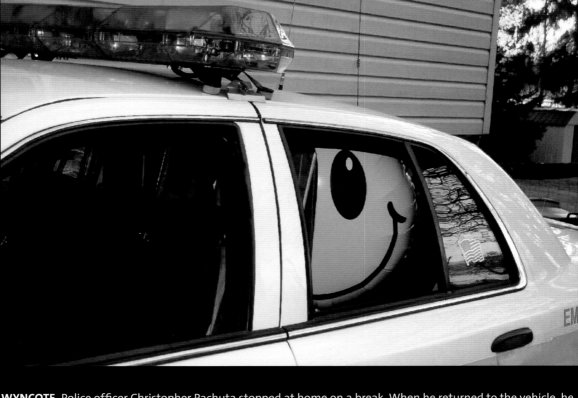

WYNCOTE Police officer Christopher Pachuta stopped at home on a break. When he returned to the vehicle, he found a passenger, of sorts, in the back seat. *Photo by Christopher Pachuta*

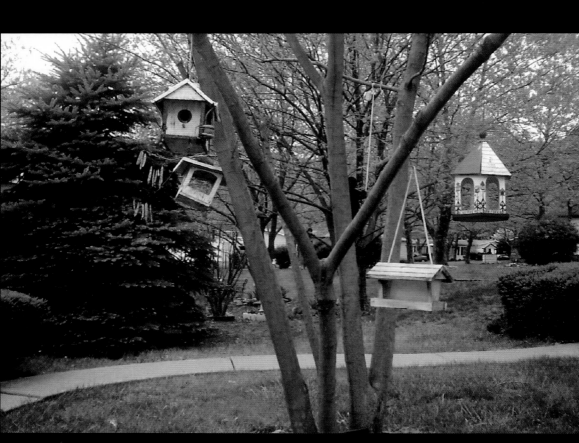

BATH Bird lady: Kay Welsh loves to watch birds, and so do her seven indoor cats. Feeders festoon her front yard and the side of her house. Several others are ready to be hung. "Probably come spring," she says.
Photo by Stephen Welsh

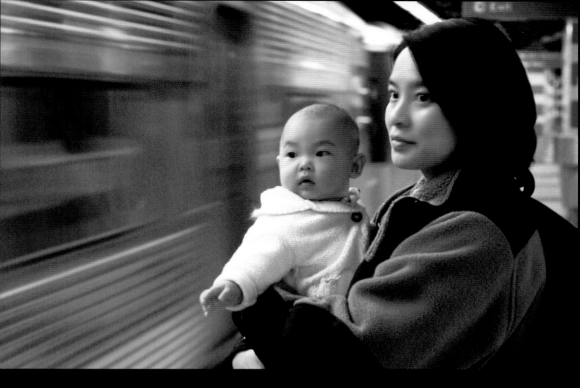

PHILADELPHIA Debra Shick and her daughter Chenjing use the PATCO high-speed line to cross the Delaware to visit friends in New Jersey. *Photo by Yischon Liaw*

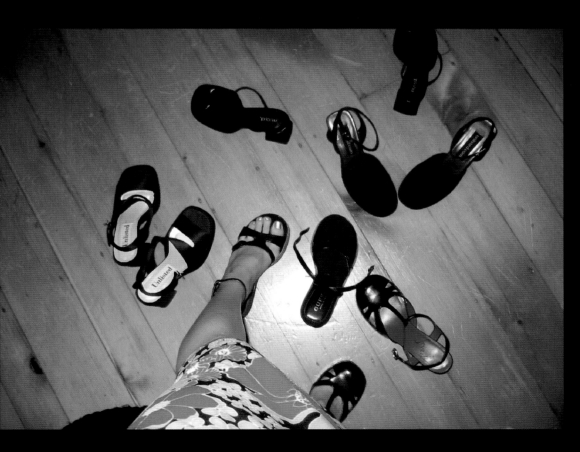

BEDFORD Joan De Lurio, footwear fashionista, tries on nearly every shoe in her closet before stepping out on a Saturday night. *Photo by Joan De Lurio*

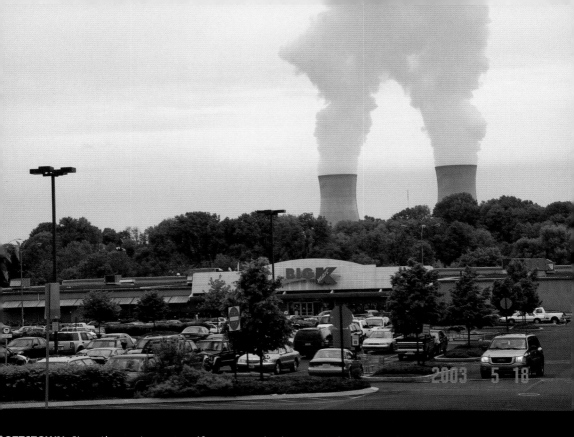

POTTSTOWN Since the equipment malfunction and subsequent shutdown of Three Mile Island in 1979, the U.S. Nuclear Regulatory Commission has issued operating licenses to five nuclear power plants in Pennsylvania, including the Limerick Nuclear Station. *Photo by June McGaha*

LANCASTER David Bender and Stephen Olin rustle up some saucy hens during the 50th annual Lancaster

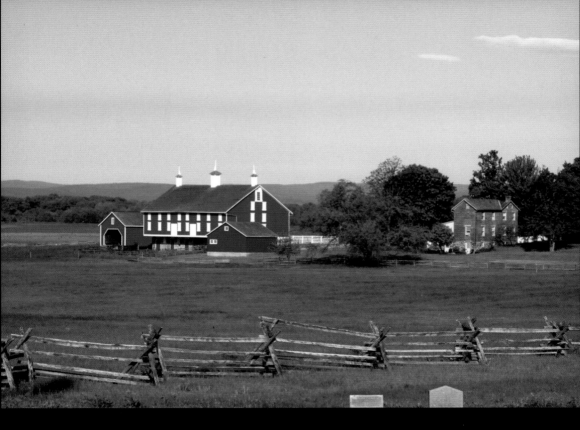

GETTYSBURG July 2, 1863: The Staub family had already fled their farm when General George Pickett reluctantly obeyed orders to attack Union forces across its fields. *Photo by Thomas Jenkins*

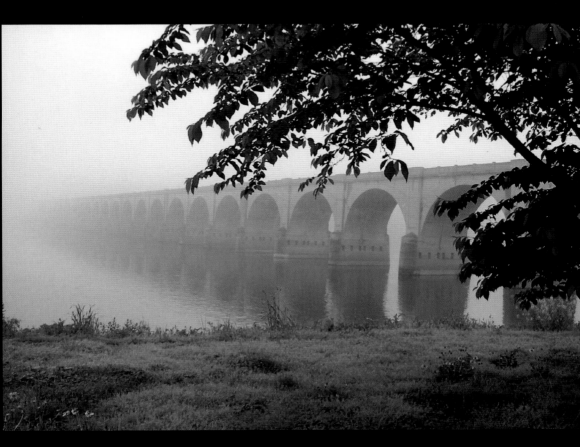

HARRISBURG The Reading Railroad's Susquehanna River bridge, built in the 1920s with steel-reinforced concrete to withstand flooding and ice, replaced a truss bridge. It is used today by the Norfolk Southern line. *Photo by Anthony DelGandio*

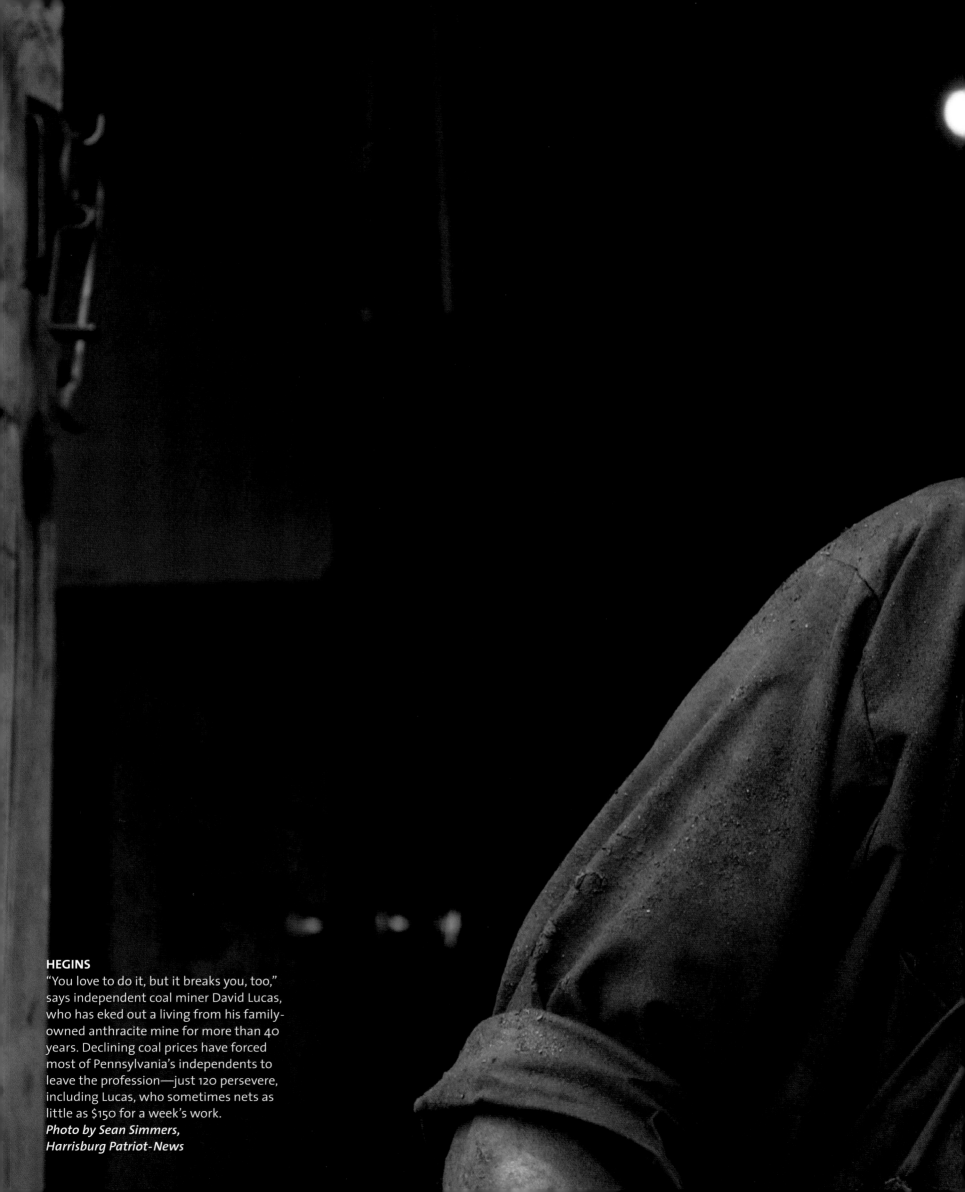

HEGINS
"You love to do it, but it breaks you, too," says independent coal miner David Lucas, who has eked out a living from his family-owned anthracite mine for more than 40 years. Declining coal prices have forced most of Pennsylvania's independents to leave the profession—just 120 persevere, including Lucas, who sometimes nets as little as $150 for a week's work.
Photo by Sean Simmers,
Harrisburg Patriot-News

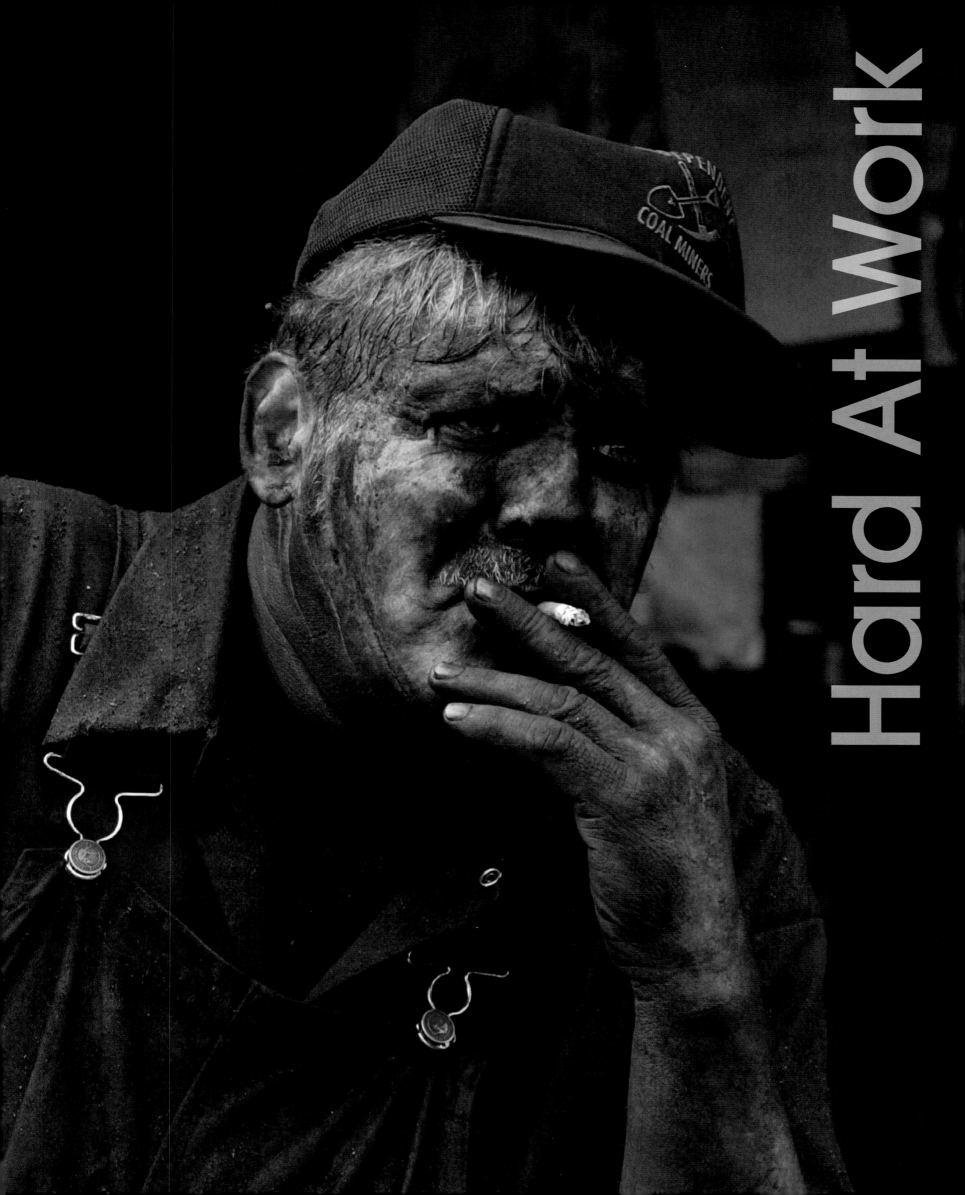

Hard At Work

SCRANTON

"I'm the United Nations barber," says Myer Carter of Myer Carter Hair Salon in downtown Scranton. "I cut Black hair, Russian hair, German hair, Puerto Rican hair."

Photo by Butch Comegys, The Scranton Times

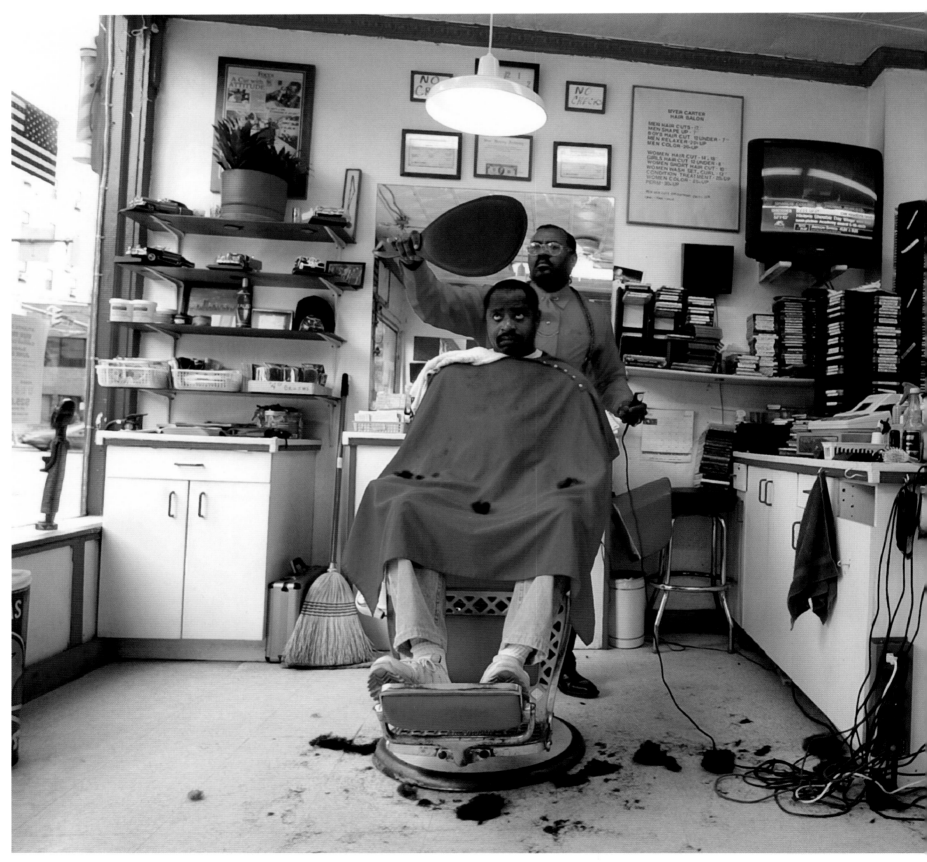

PHILADELPHIA

Six months before her wedding, Donna DiMeo test drives a manicure, pedicure, and updo at Adolf Biecker, an upscale Rittenhouse Square salon. Three hours and $300 later, the bride-to-be saw a sneak preview of the polished look she will wear to the altar at the Ritz-Carlton Hotel.
Photo by Jennifer Midberry,
Philadelphia Daily News

PITTSBURGH

Chava Tombosky, a Lubavitch Hassidic Jew, runs her wig store in the basement of her Squirrel Hill home. Married Orthodox Jewish women must cover their hair in public, and some choose wigs over traditional *tichels*, or head scarves. Tombosky's custom-made wigs of human hair cost between $700 and $3,000.
Photo by Scott Goldsmith

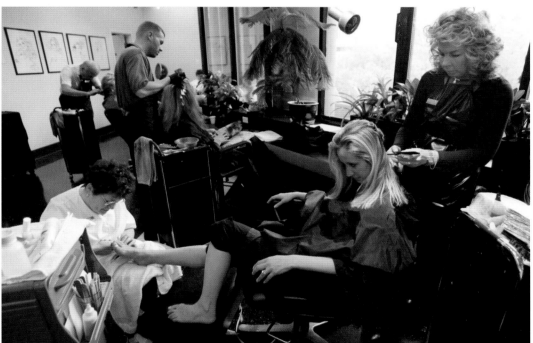

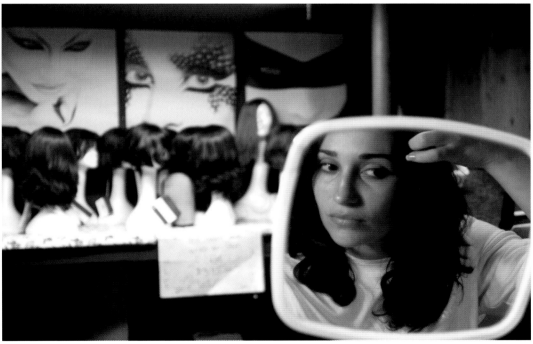

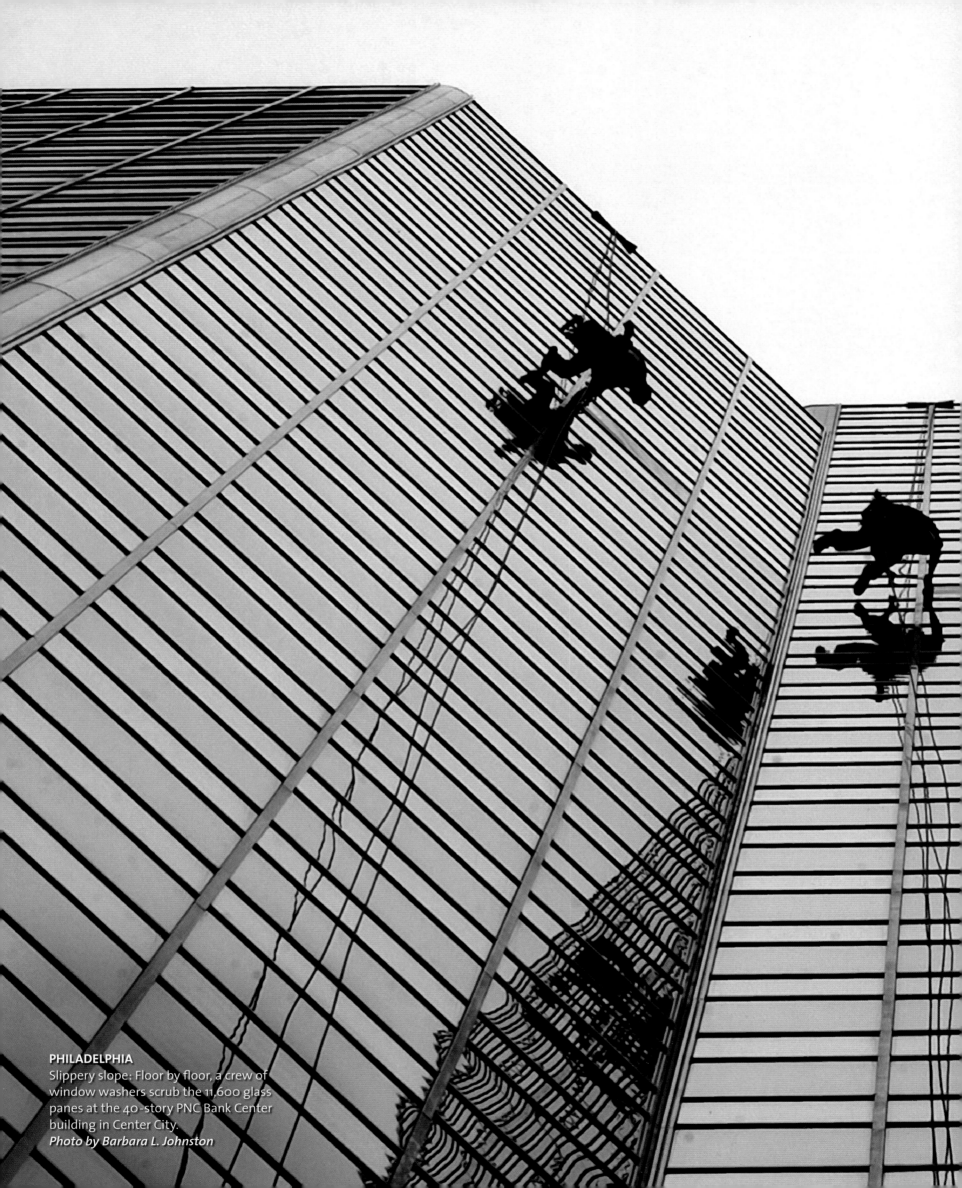

PHILADELPHIA
Slippery slope: Floor by floor, a crew of window washers scrub the 11,600 glass panes at the 40-story PNC Bank Center building in Center City.
Photo by Barbara L. Johnston

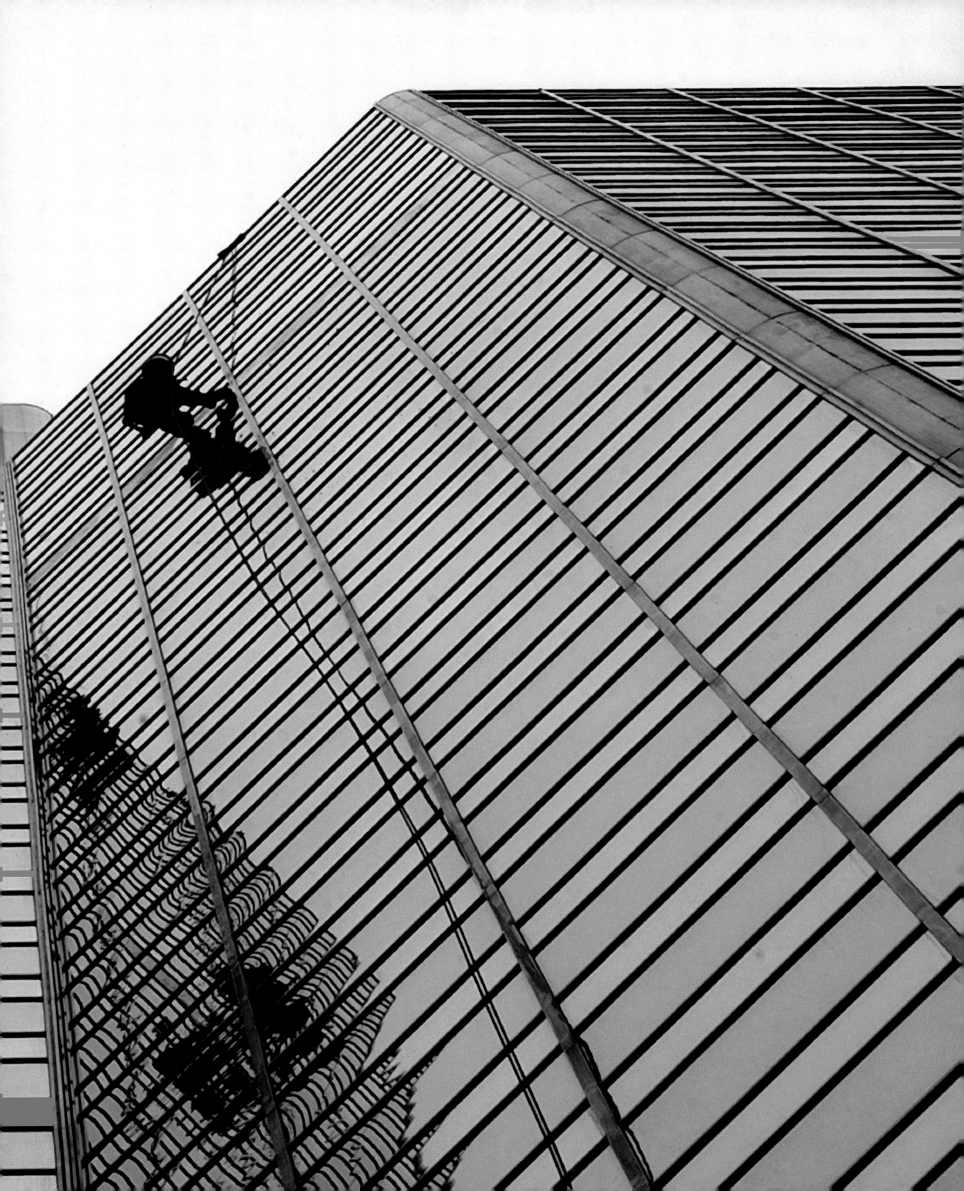

WOMELSDORF

Eighty miles northwest of where Betsy Ross stitched her flag together, Barbara Smith stitches hers at the Valley Forge Flag Company. First she sews together stripes for the flag's "short" (the part with short stripes), and attaches it to the "field" (the part with the stars). The flag will be 20 by 38 feet when completed.

Photo by Michael Bryant, Bryant Photo

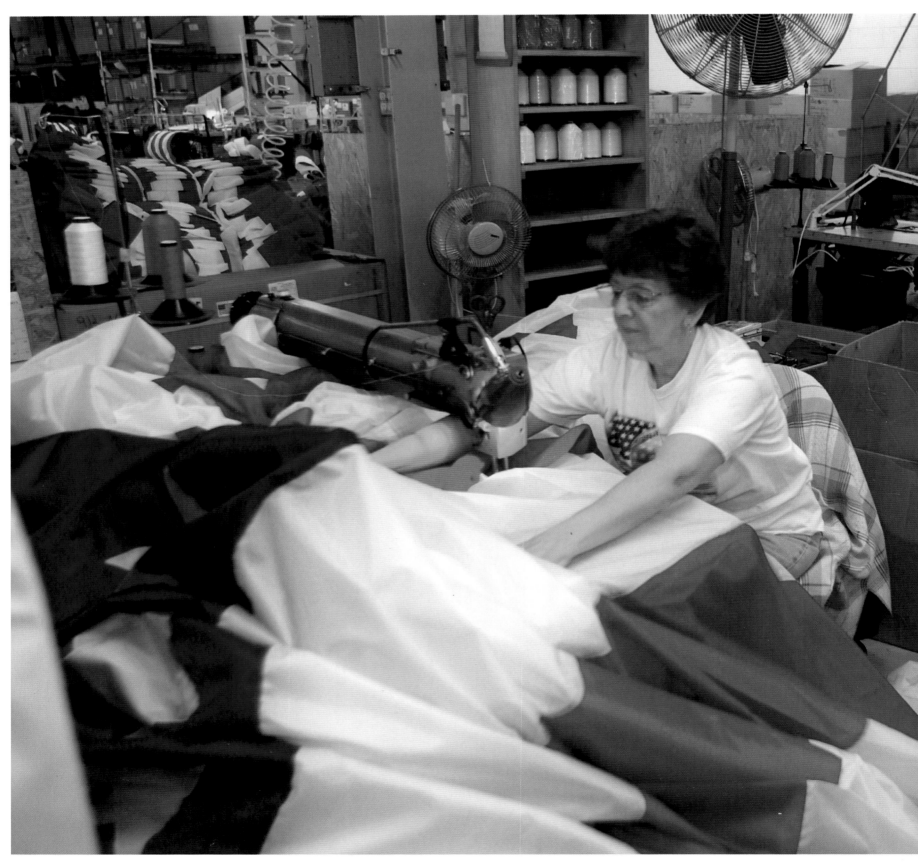

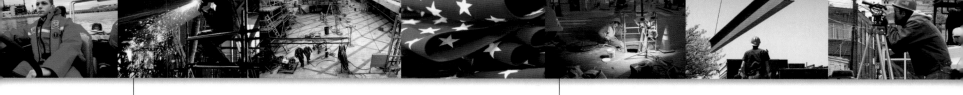

PHILADELPHIA

Sparks fly at the Aker Kvaerner shipyard on
the Delaware River as welder Robert Plowden
fires a seam on the 711-foot *M.V. Malukai*, the first
ship built in Philadelphia in three decades. After
the governor and mayor committed $396 million in
public money to modernize Philadelphia's shipyard,
Aker Kvaerner, an Anglo-Norwegian conglomerate,
moved in and now employs 1,000 workers.
Photo by Michael S. Wirtz, The Philadelphia Inquirer

PHILADELPHIA

The city sleeps as cable lineman Jamie Jenkins
installs circuit breaker wires at the intersection
of 18th and Ludlow Streets. Crime once emptied
Philadelphia's downtown area after dark, but
urban renewal efforts have recently revived the
dormant nightlife. Even so, Jenkins works with
a police escort during his 6 p.m. to 4 a.m. shift.
Photo by E.A. Kennedy 3rd, Image Works

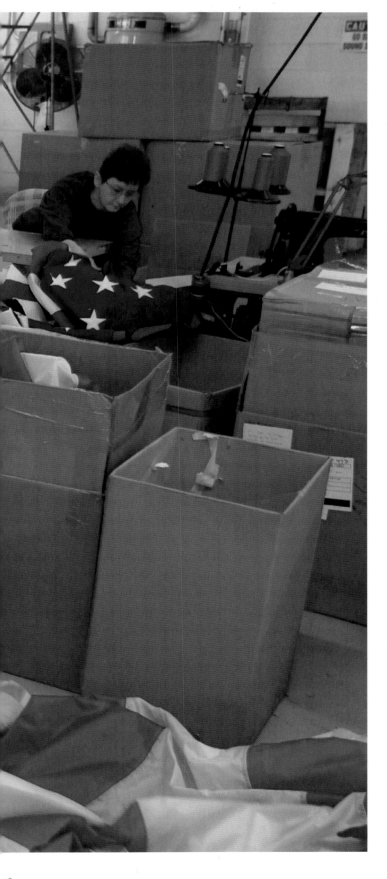

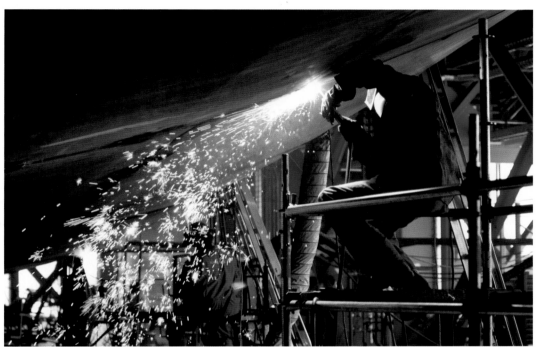

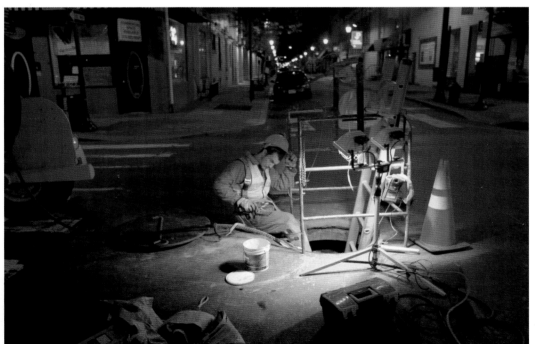

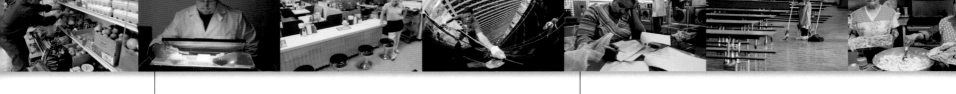

PHILADELPHIA

The genetic underpinnings of neuromuscular development appear in medical student Darren Hess's ultraviolet lightbox at the University of Pennsylvania School of Medicine.

Photo by Michael Lightner

PHILADELPHIA

Temple University graduate student Kaila Story settles into an all-night paper-grading and clothes-washing session with her girlfriend Serena Reed. Story's studies and community work leave her little time for laundry: In between finishing her master's in African-American studies and starting her PhD, she's mentoring high school students under the auspices of the NAACP.

Photo by E.A. Kennedy 3rd, Image Works

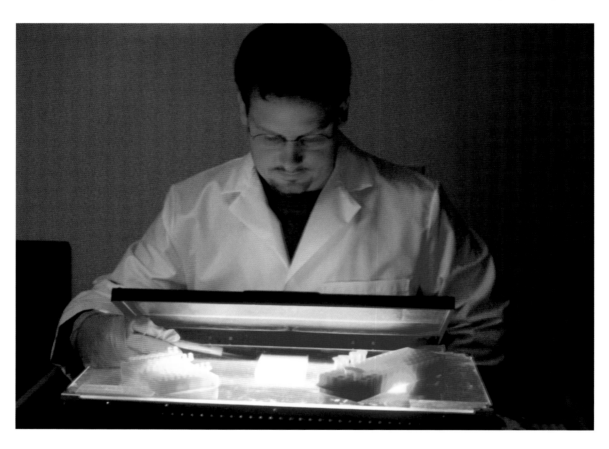

PITTSBURGH

Albert Lexie has been on a crusade to make sure kids get the medical help they need when their families can't afford it. Since 1981, the 61-year-old shoeshine man has given an impressive $89,000 to Children's Hospital, all of it out of the tips he's made shining shoes. Dr. Manuel Meza and other staff at the hospital support Lexie's efforts.
Photo by Robin Rombach

PHILADELPHIA

Firefighter Ed Boney, Jr. steals some shut-eye during his graveyard shift at Philadelphia's busiest firehouse, Engine 50 Ladder 12. Many of the station's calls are accidental blazes caused by squatters living in the thousands of abandoned row houses in North Philadelphia.
Photo by Jennifer Midberry,
Philadelphia Daily News

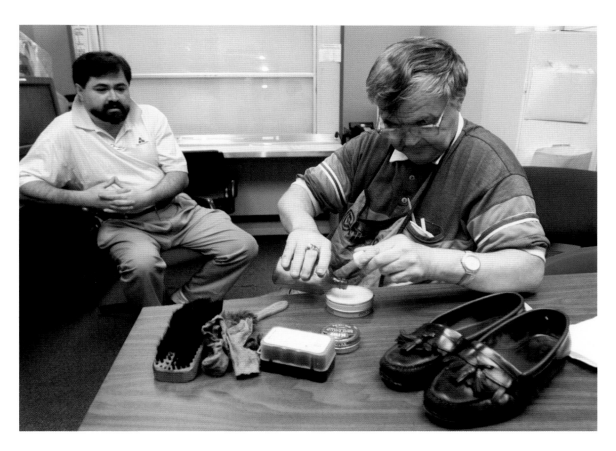

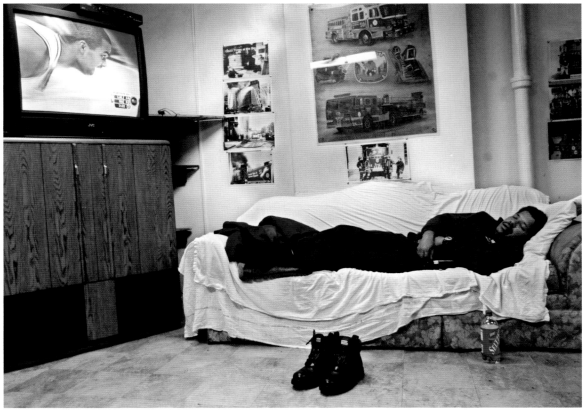

PHILADELPHIA

Two miles west of downtown, a trauma patient arrives on the University of Pennsylvania Hospital's rain-slicked landing pad. The PennSTAR helicopter team retrieves 1,200 critically injured patients annually from throughout the tri-state area of eastern Pennsylvania, southern New Jersey, and Delaware.

Photos by Jennifer Midberry,
Philadelphia Daily News

PHILADELPHIA

An emergency appendectomy operation forced on-call surgeons Kristolffell Dumanand and Ed Woo to put on their scrubs at 2 a.m. The hospital handles more trauma operations—largely to treat gunshot wounds—than any other health-care system in the Greater Philadelphia area. In 2002, the city had the third-highest homicide rate in the country.

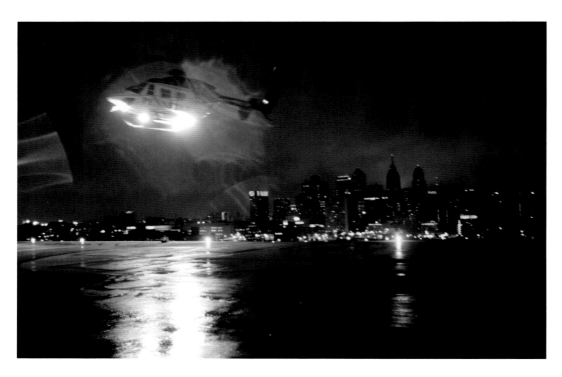

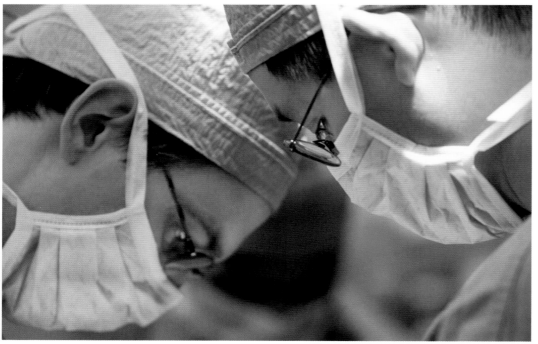

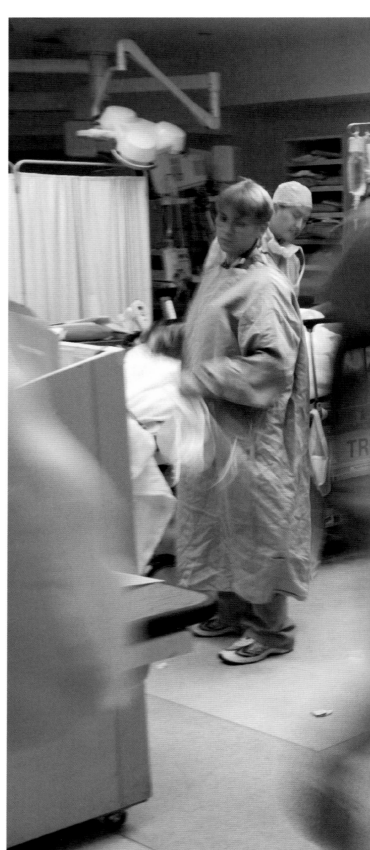

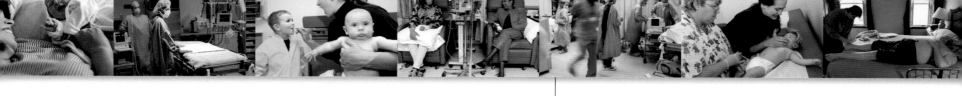

PHILADELPHIA
When the clock strikes 1 a.m., the hospital's trauma unit shifts into high gear. During the next three hours, motor vehicle accident and gunshot wound victims will flood the hospital's ER.

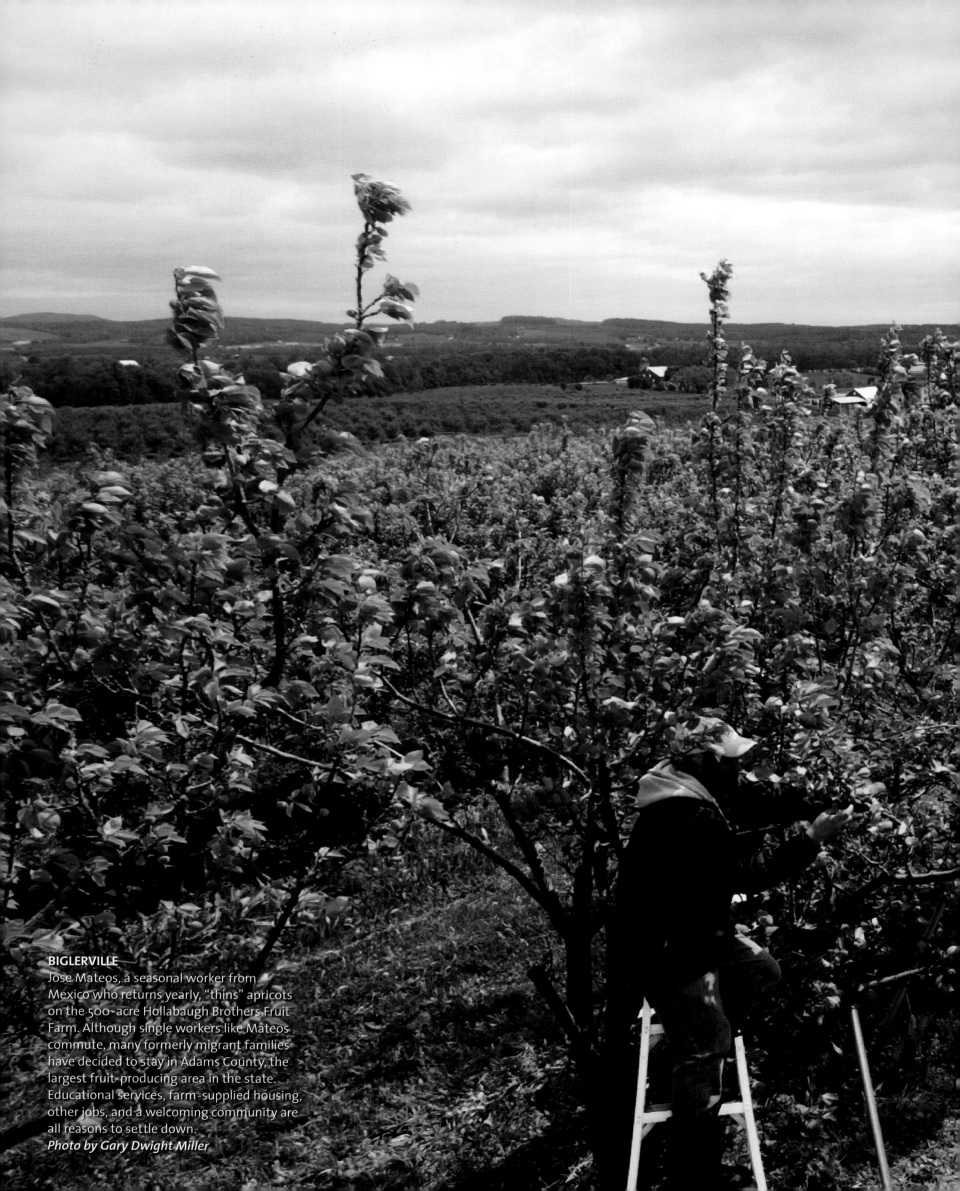

BIGLERVILLE

Jose Mateos, a seasonal worker from Mexico who returns yearly, "thins" apricots on the 500-acre Hollabaugh Brothers Fruit Farm. Although single workers like Mateos commute, many formerly migrant families have decided to stay in Adams County, the largest fruit-producing area in the state. Educational services, farm-supplied housing, other jobs, and a welcoming community are all reasons to settle down.
Photo by Gary Dwight Miller

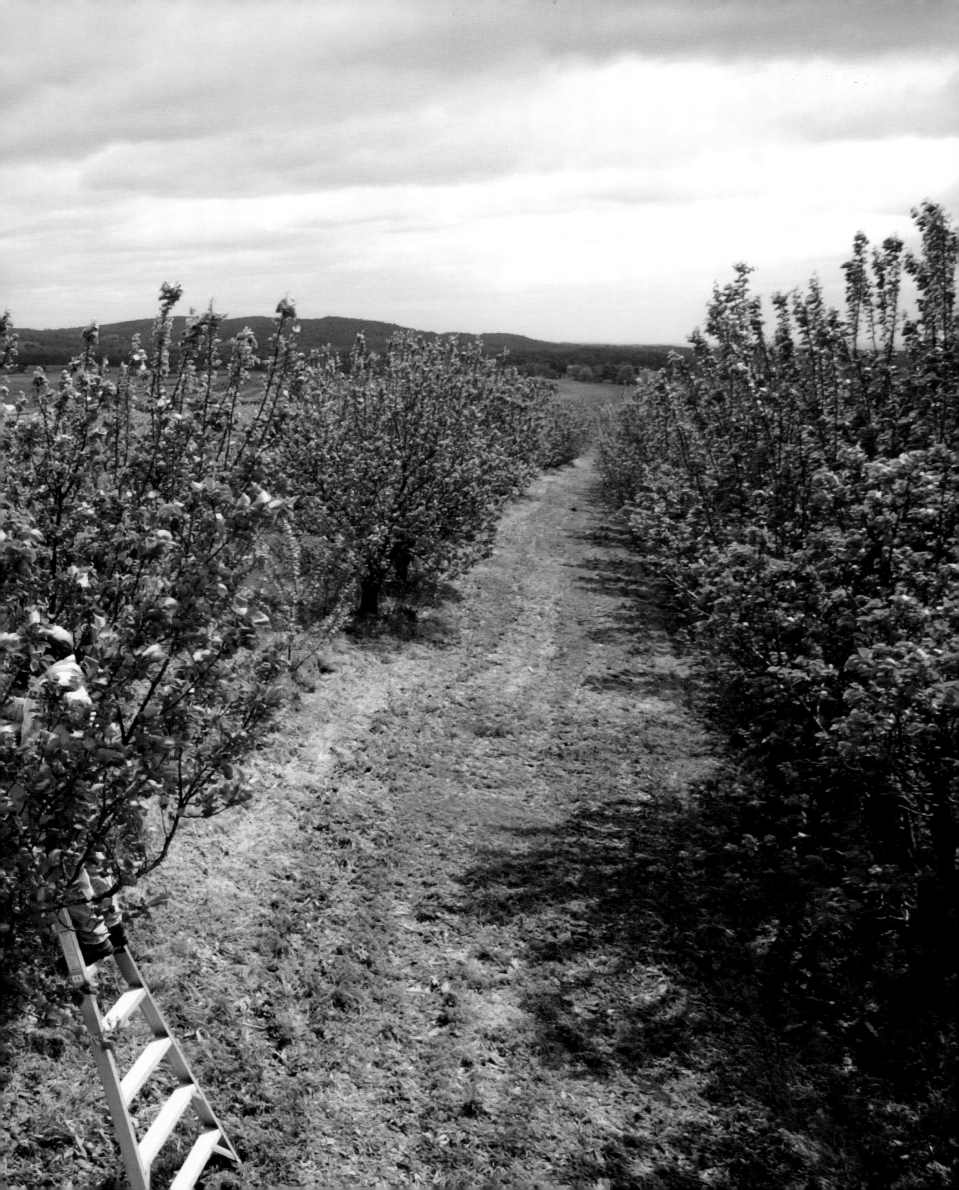

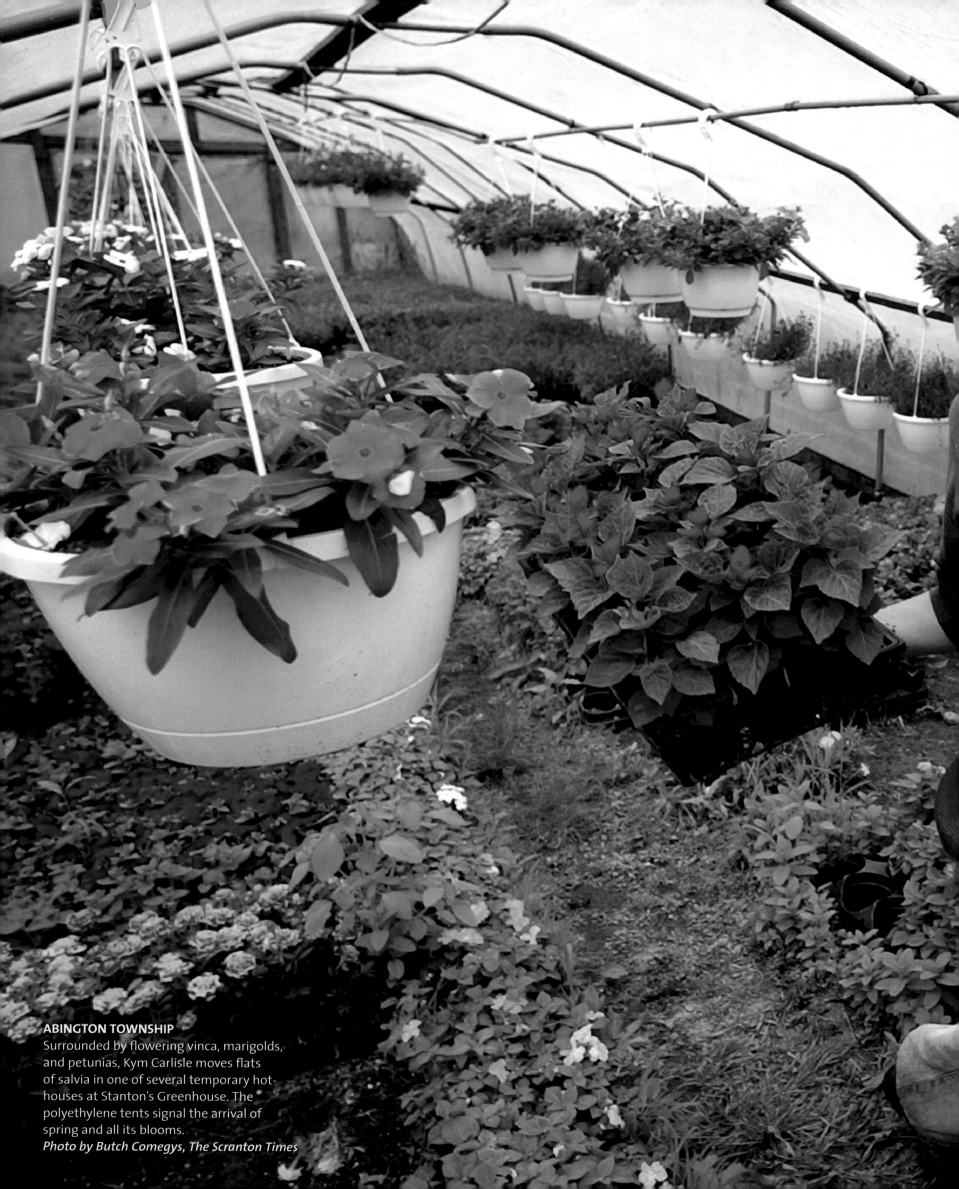

ABINGTON TOWNSHIP
Surrounded by flowering vinca, marigolds, and petunias, Kym Carlisle moves flats of salvia in one of several temporary hot-houses at Stanton's Greenhouse. The polyethylene tents signal the arrival of spring and all its blooms.
Photo by Butch Comegys, The Scranton Times

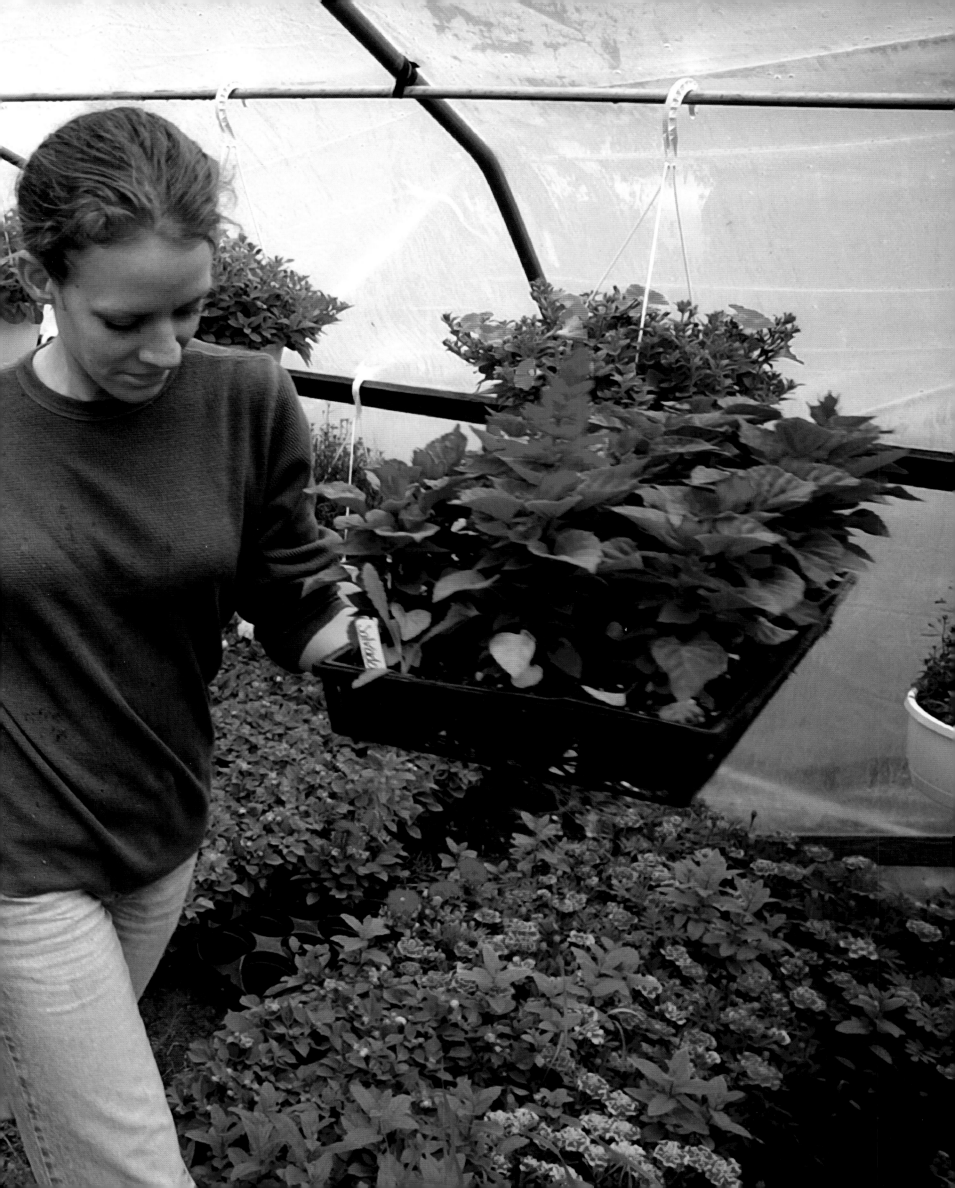

PHILADELPHIA
Students at the Moore College of Art and Design
put their frocks and fripperies on display at the
school's annual spring fashion show. The college,
founded in 1848 as a women's trade school, still
limits enrollment to women.
Photo by David Maialetti, Philadelphia Daily News

SCRANTON

Lisa Annacarto, a Marywood University graduate student getting her degree in social work, models a wedding outfit during the Studio RD Hair and Day Spa fashion show. Volunteering to help out the studio, Annacarto received no pay but admits she didn't mind getting coiffed and made up for free.

Photo by Butch Comegys, The Scranton Times

PHILADELPHIA

After a two-set gig at the Zanzibar Blue night-club, trumpeter Byron Stripling relaxes back-stage. The New Yorker has shared the stage with legends like Dizzy Gillespie, Dave Brubeck, and the Count Basie Orchestra, but Philadelphia's great musicians also inspire him. "The Philly cats have a dip in their sound—like it's leaning towards the blues," he says.

Photos by E.A. Kennedy 3rd, Image Works

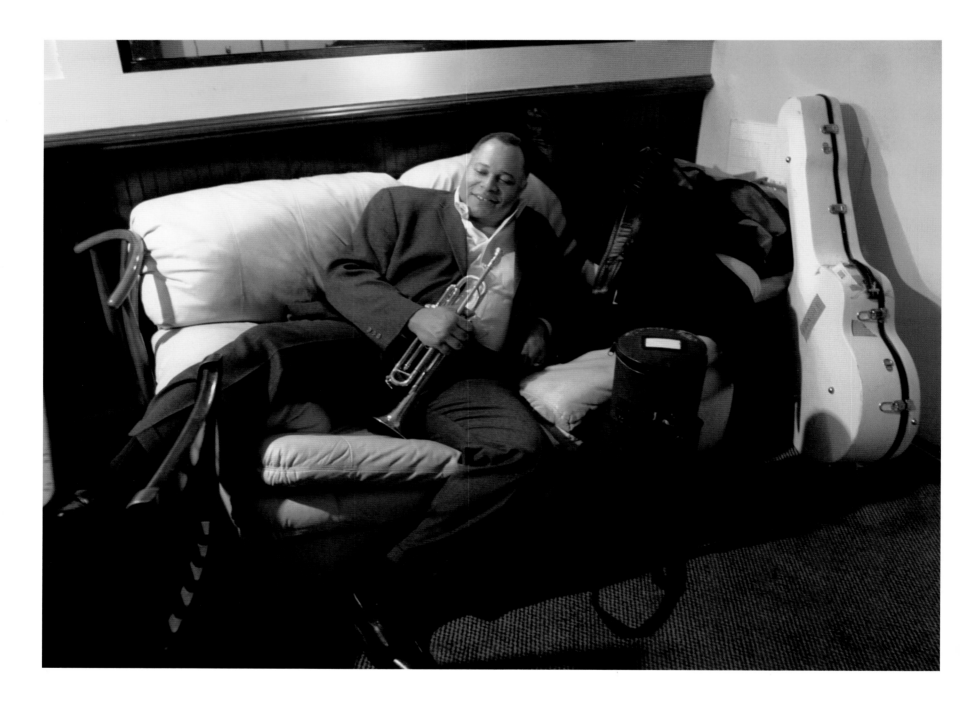

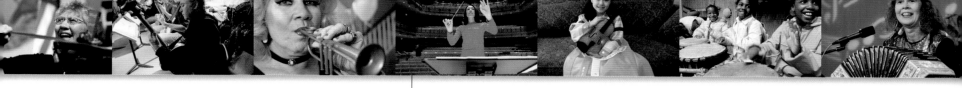

PHILADELPHIA

Assistant conductor Jeri Lynne Johnson leads the 33-piece Chamber Orchestra of Philadelphia through a rehearsal of Schubert's 6th Symphony. Johnson shattered some glass ceilings when she became the orchestra's second-in-command and one of only two black women in America to conduct a major metropolitan classical ensemble.

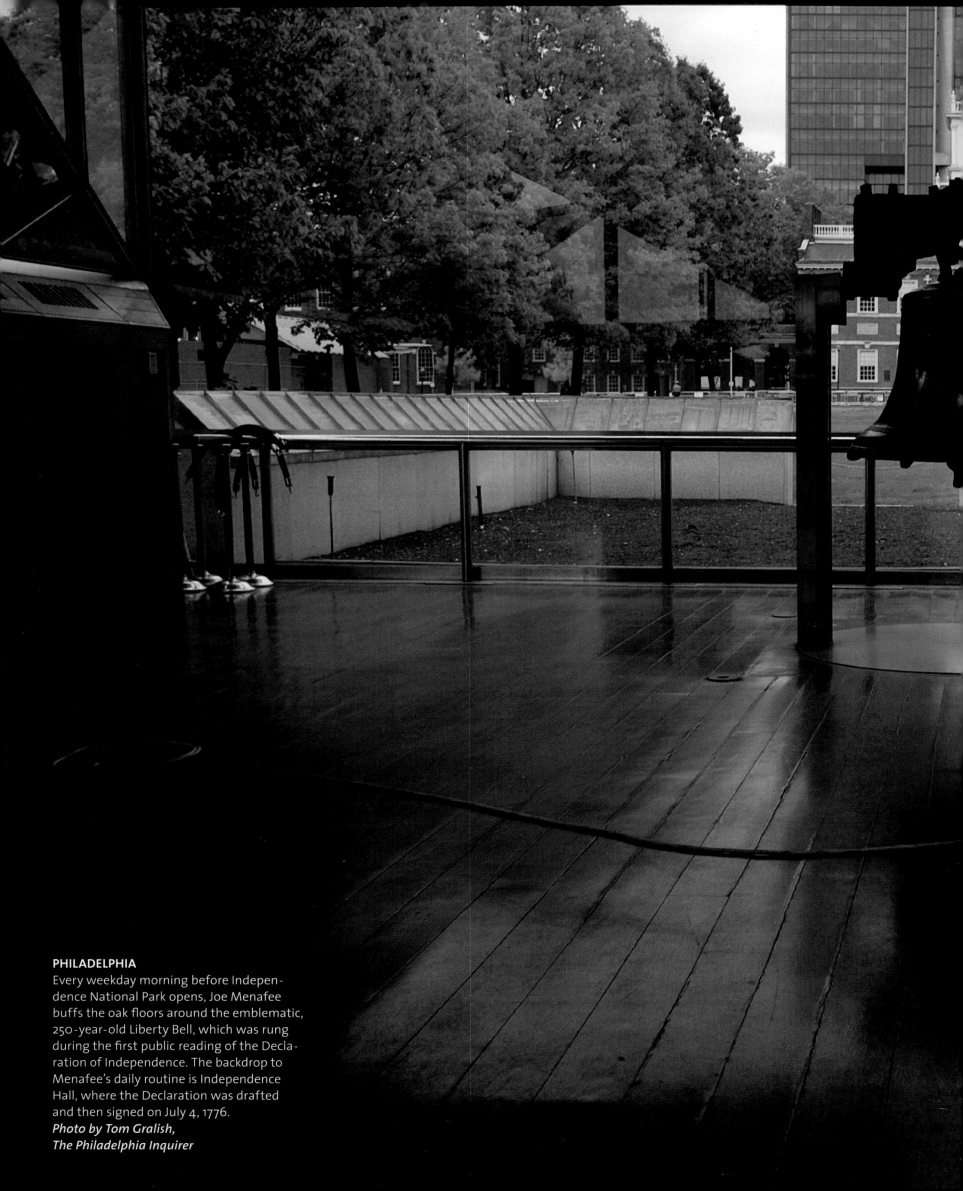

PHILADELPHIA
Every weekday morning before Independence National Park opens, Joe Menafee buffs the oak floors around the emblematic, 250-year-old Liberty Bell, which was rung during the first public reading of the Declaration of Independence. The backdrop to Menafee's daily routine is Independence Hall, where the Declaration was drafted and then signed on July 4, 1776.
Photo by Tom Gralish,
The Philadelphia Inquirer

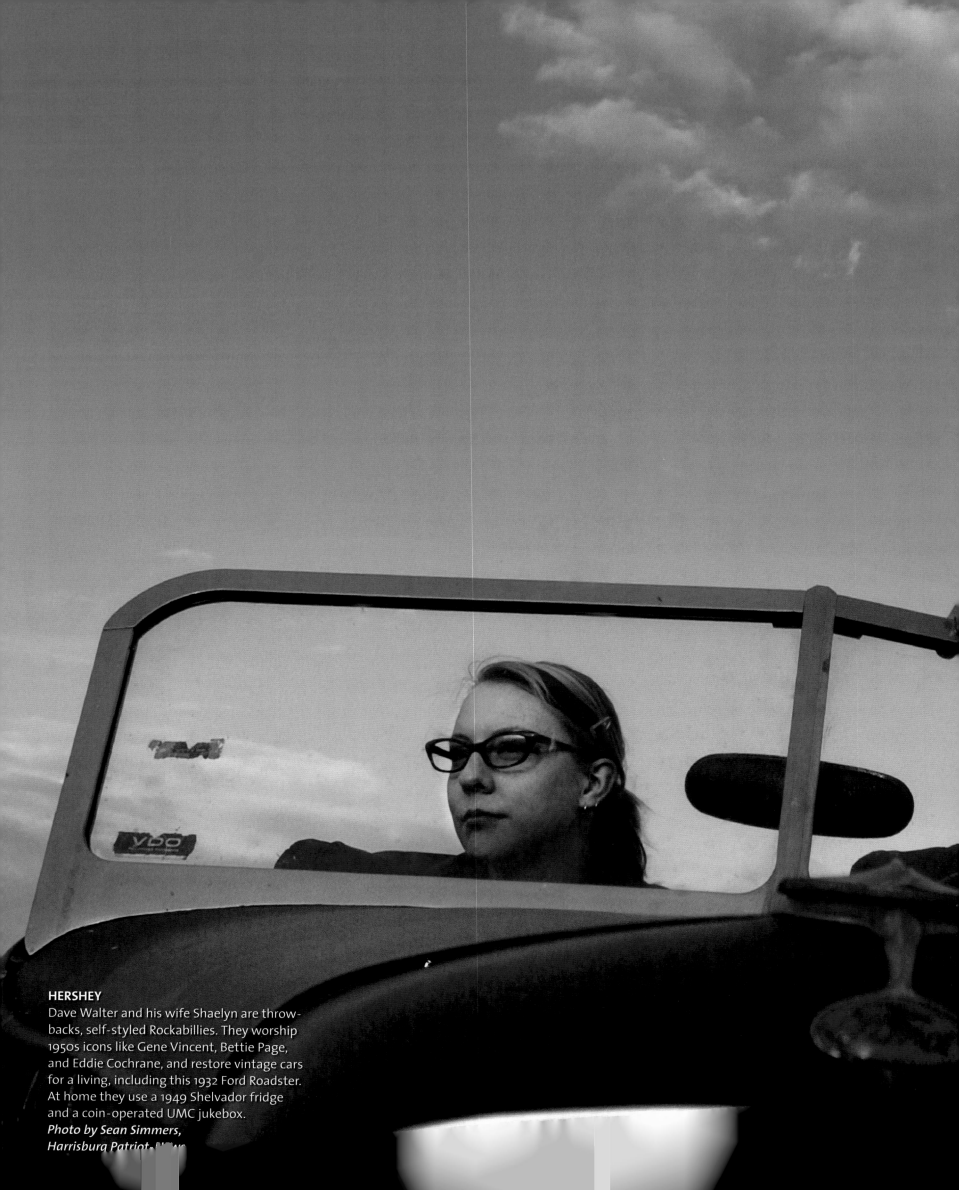

HERSHEY
Dave Walter and his wife Shaelyn are throw-backs, self-styled Rockabillies. They worship 1950s icons like Gene Vincent, Bettie Page, and Eddie Cochrane, and restore vintage cars for a living, including this 1932 Ford Roadster. At home they use a 1949 Shelvador fridge and a coin-operated UMC jukebox.
Photo by Sean Simmers,
Harrisburg Patriot-News

Pennsylvania At Play

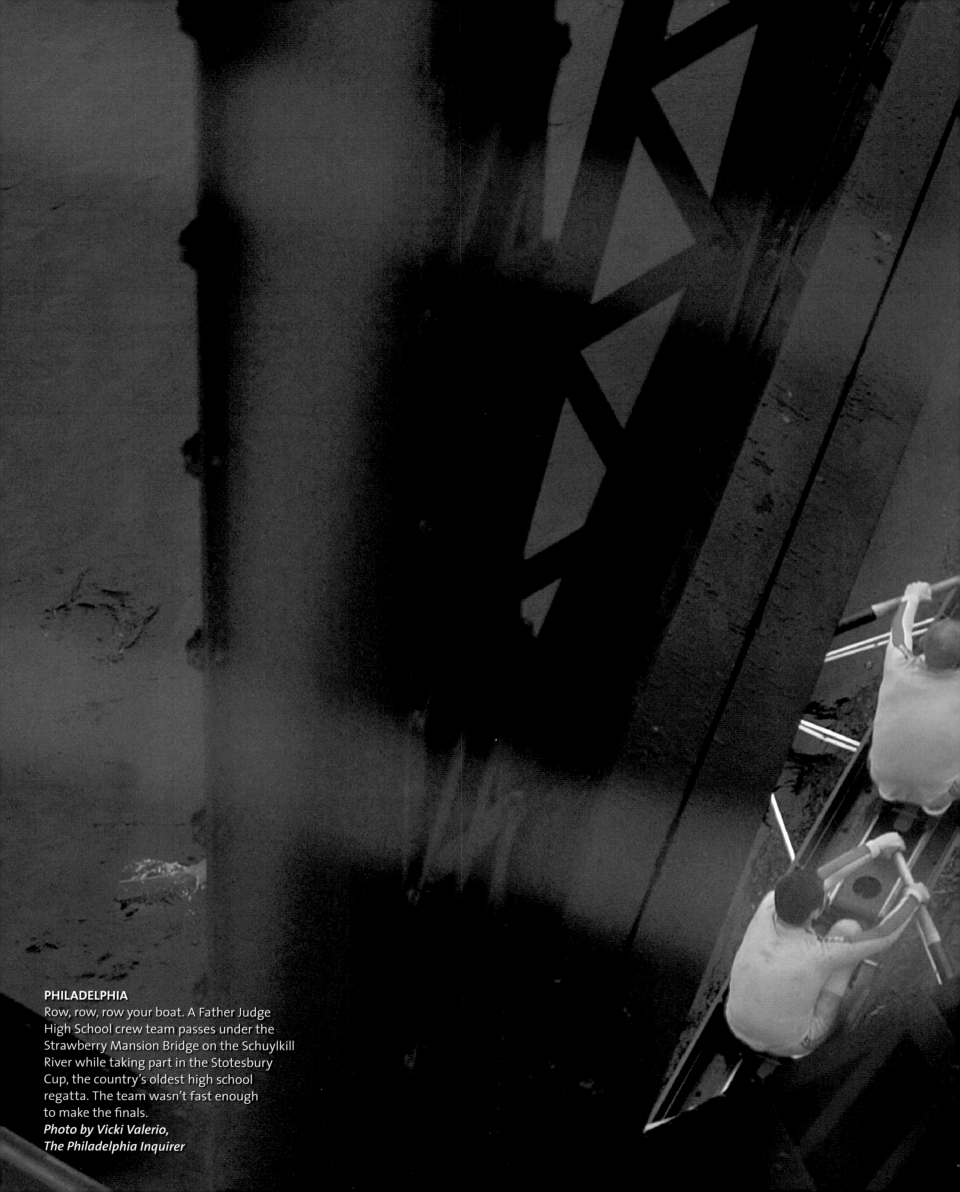

PHILADELPHIA
Row, row, row your boat. A Father Judge
High School crew team passes under the
Strawberry Mansion Bridge on the Schuylkill
River while taking part in the Stotesbury
Cup, the country's oldest high school
regatta. The team wasn't fast enough
to make the finals.
Photo by Vicki Valerio,
The Philadelphia Inquirer

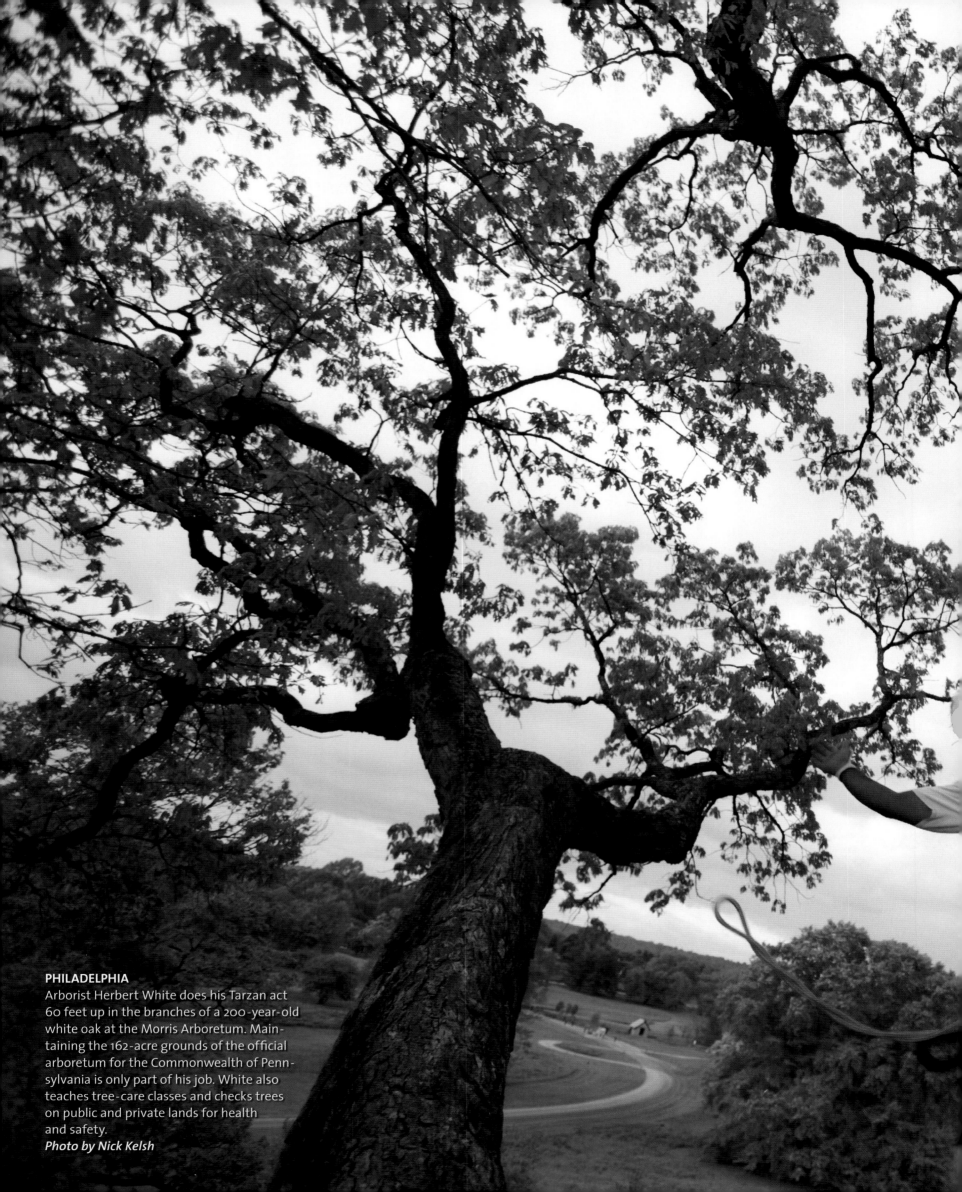

PHILADELPHIA
Arborist Herbert White does his Tarzan act 60 feet up in the branches of a 200-year-old white oak at the Morris Arboretum. Maintaining the 162-acre grounds of the official arboretum for the Commonwealth of Pennsylvania is only part of his job. White also teaches tree-care classes and checks trees on public and private lands for health and safety.
Photo by Nick Kelsh

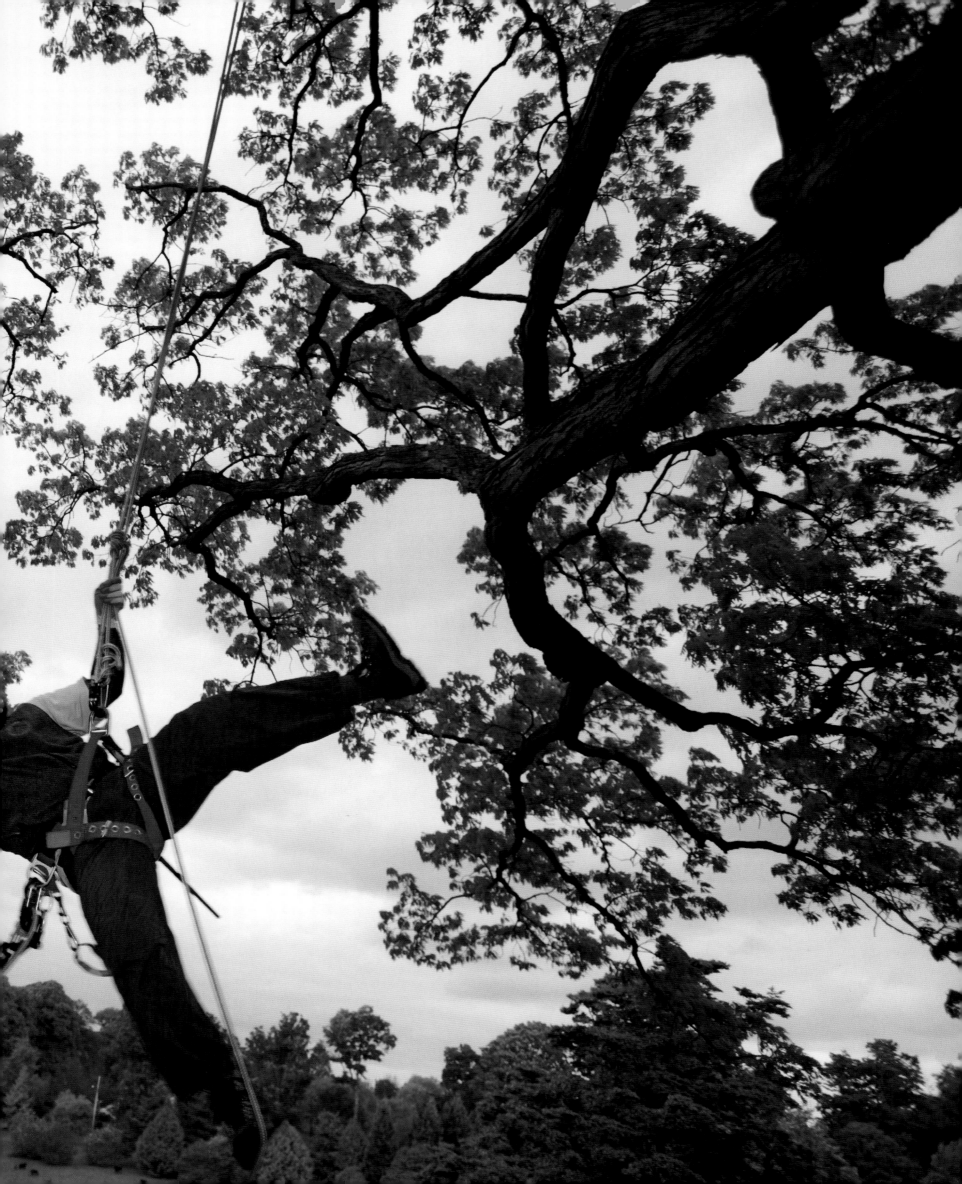

McKEES ROCKS

When Helen Mannarino couldn't find Polish eats in the Pittsburgh area, she saw an opportunity and took it. She opened Pierogies Plus in 1991 in a converted gas station. Now that the Internet has broadened her reach, Mannarino employs 16 women, all of Eastern European descent, who know from good pierogies. Here, Tatyana Shlyakhovskaya opens the shop on a fine May morning.

Photos by Robin Rombach

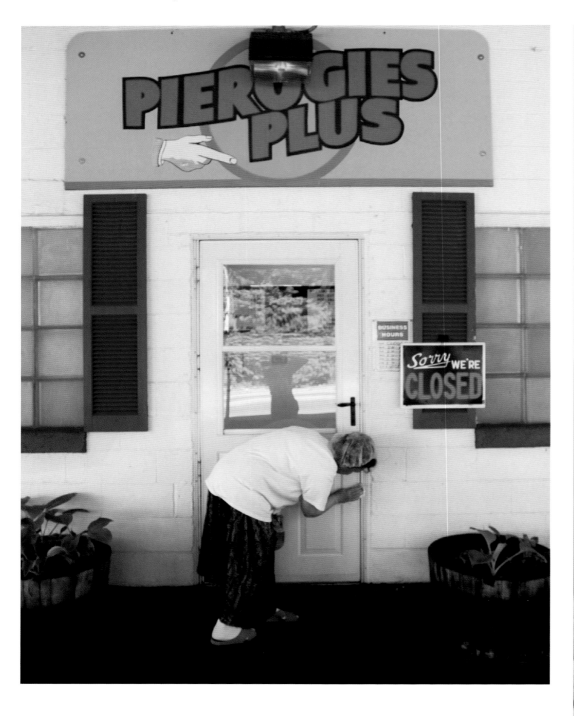

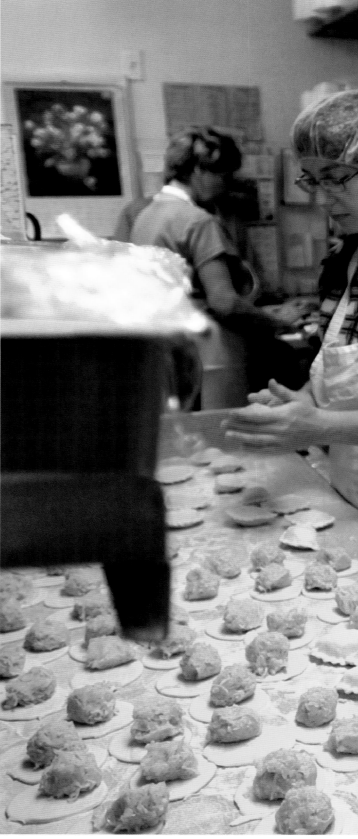

McKEES ROCKS
Zoryana Petrovych, Svitlana Zabetchuk, and Tatyana Shlyakhovskaya, all from Ukraine, fold pasta-like dough to make pierogies. The crescent-shaped dumplings filled with potato, cheese, sauerkraut, and meat are a staple in Eastern Europe.

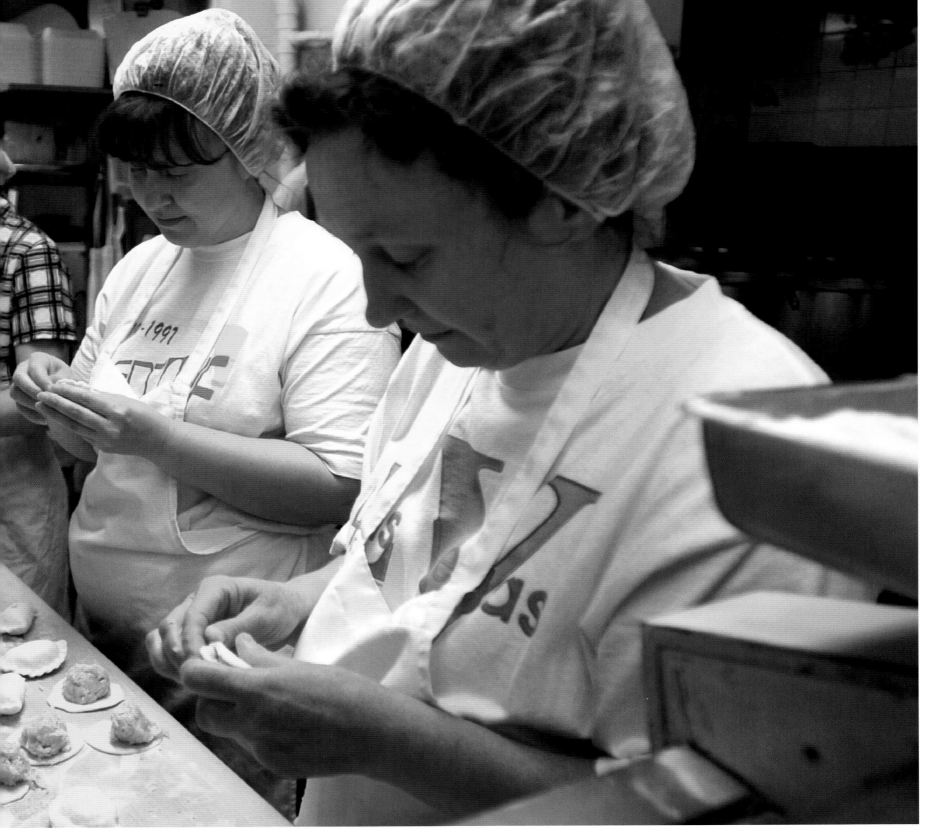

PHILADELPHIA

The most important ingredient in Rick's Philly cheesesteak sandwiches, says owner Rick Olivieri, is the roll. He should know. For 22 years, he's been making and selling cheesesteaks at the old Reading Terminal Market. He makes about 3,000 a week, including one—and only one—that Rick allows himself.

Photo by Vicki Valerio, The Philadelphia Inquirer

BETHLEHEM

Spaghetti and meatballs and rice and beans are only two of the dishes Belen Agosta cooks up and serves at Don Basilio Huertas Senior Center. The native Puerto Rican was raised in New York, returned to Puerto Rico later in life, and then—fleeing the island's heat—moved to Bethlehem, where two of her three daughters live.

Photo by Arturo Fernandez, The Morning Call

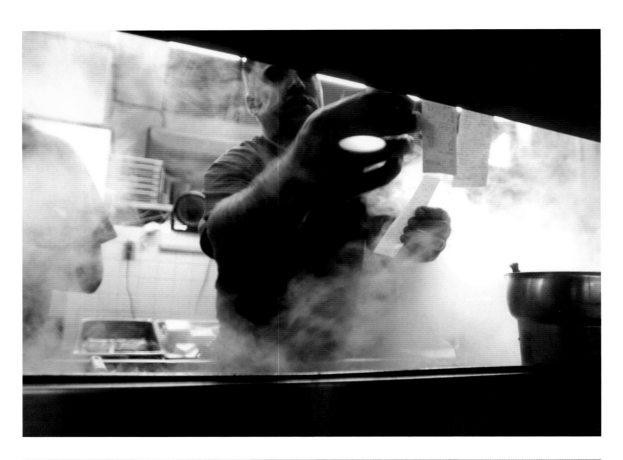

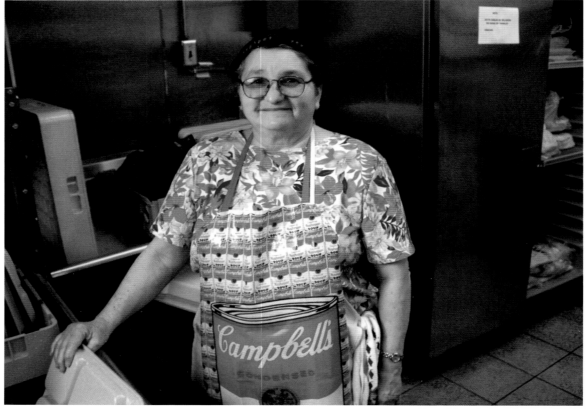

PITTSBURGH

For 30 years, Thelma Smalls has worked at Eddie's diner, a soul food restaurant in the Hill District. She cooks, waitresses, cashiers, orders food, plans the menu, and is generally indispensable seven days a week. If a customer can't pay for a meal, Smalls runs a tab. "It's always good to help out," she says.

Photo by Annie O'Neill

PHILADELPHIA

On a busy Friday night, line cooks Boris Portnoy and Jonathan McDonald prepare meals at Salt, a restaurant off Rittenhouse Square. Owner David Fields opened the upscale, contemporary American-Spanish bistro in November 2002. A former professional photographer, Fields became a foodie after shooting a cookbook for chef Georges Perrier.

Photo by Frances Arnold

JENKINTOWN
Exorbitant greens fees kept No Hong Park (right) from playing golf seriously when he lived in Korea. After immigrating to Philadelphia 17 years ago, he discovered Burholme Park, where an afternoon at the driving range goes for less than $25. Since then, Hong Park has become an instructor and mentor to young Korean-American upstarts including Austin Cho, 8.
Photo by E.A. Kennedy 3rd, Image Works

BROOKLYN
Jennifer Molenko, a 6-year-old second baseman for the Brooklyn Dodgers, squares up for practice.
Photo by Butch Comegys, The Scranton Times

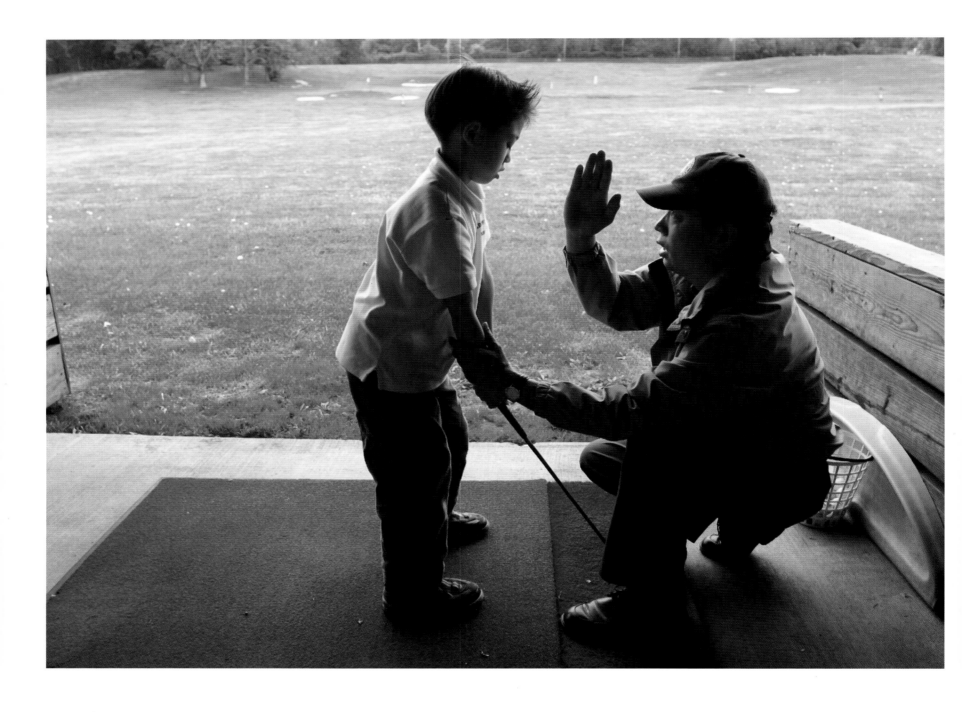

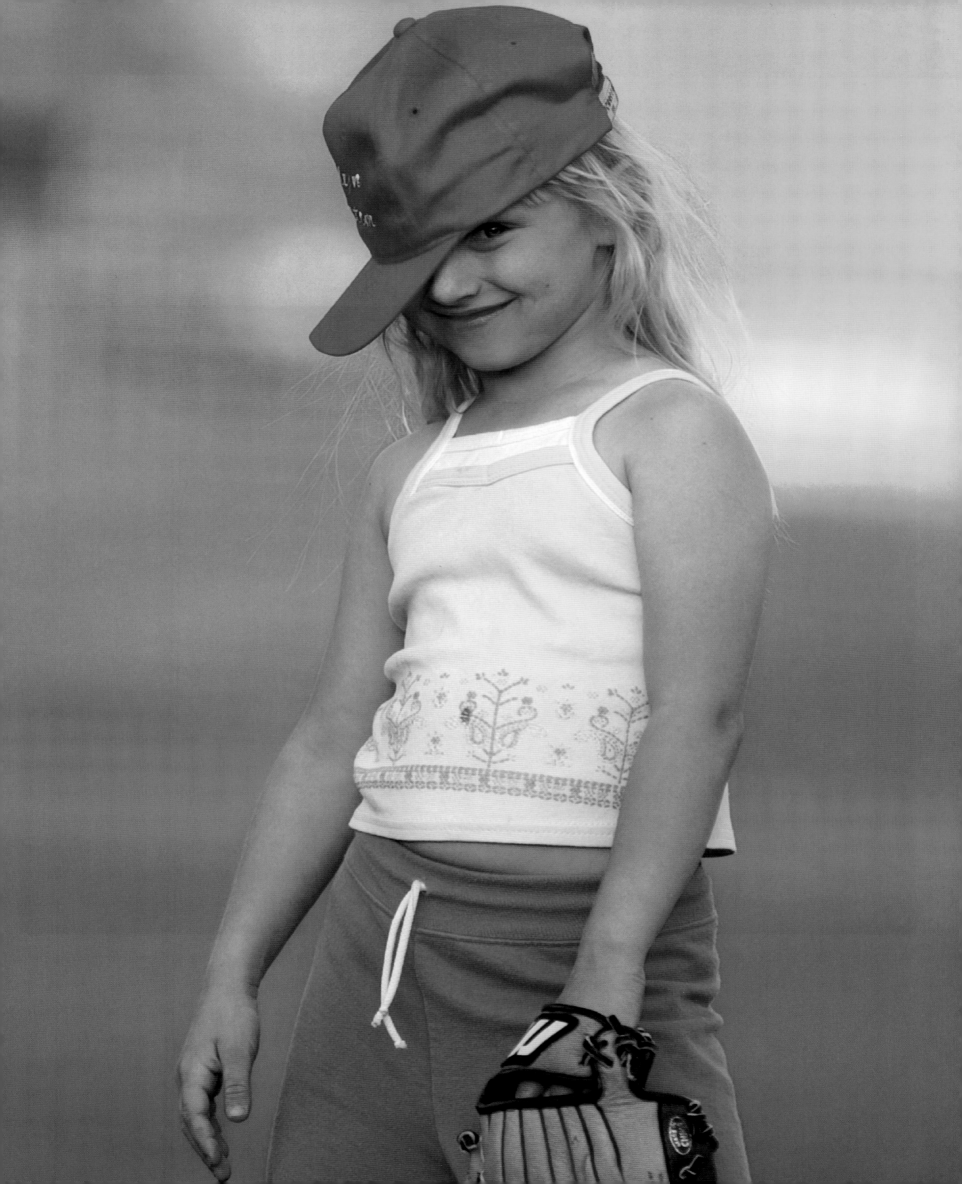

PITTSBURGH

The Pittsburgh Pirates' Parrot Brent Gephart is the only back-flipping mascot in Major League Baseball. A gymnast from age 3, he was training for the 1996 Olympics when his rotator cuff ripped. Now in his fourth season with the Bucs, he jumps rails and runs up seat backs instead of using the aisle at PNC Park.
Photos by Scott Goldsmith

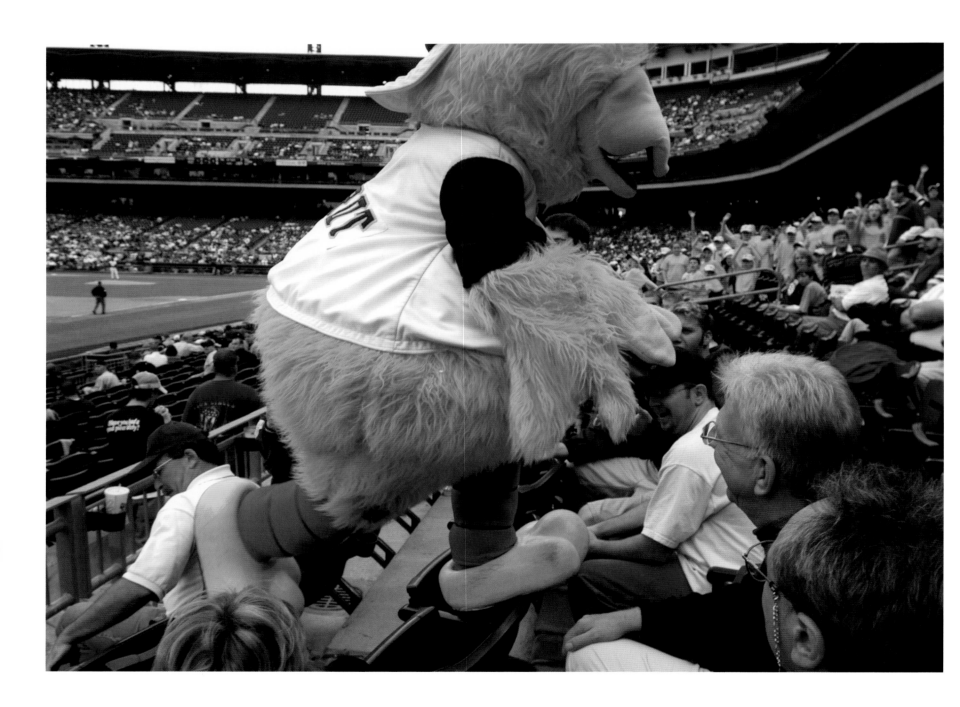

PITTSBURGH

Tradition and baseball go hand in glove at the Pirates' PNC Park, which opened in 2001. Its design pays homage to classic ballyards such as Wrigley, Fenway, and Pittsburgh's own Forbes Field, demolished in 1971. As in other stadiums in America, kids (and their parents) here can still enjoy cotton candy, a sticky tradition started in the early 1900s.

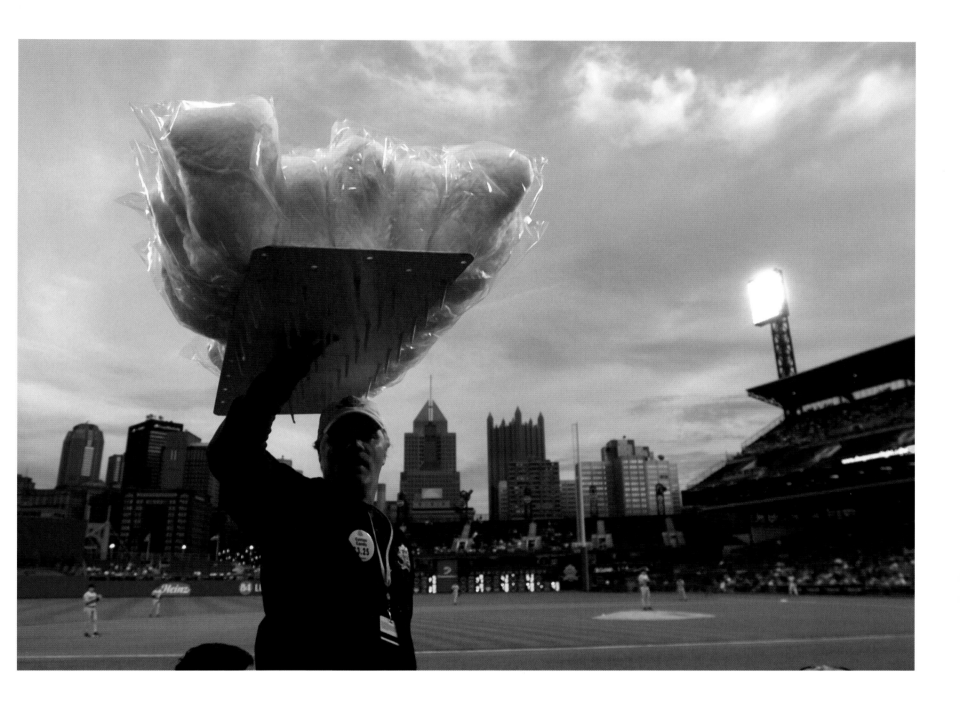

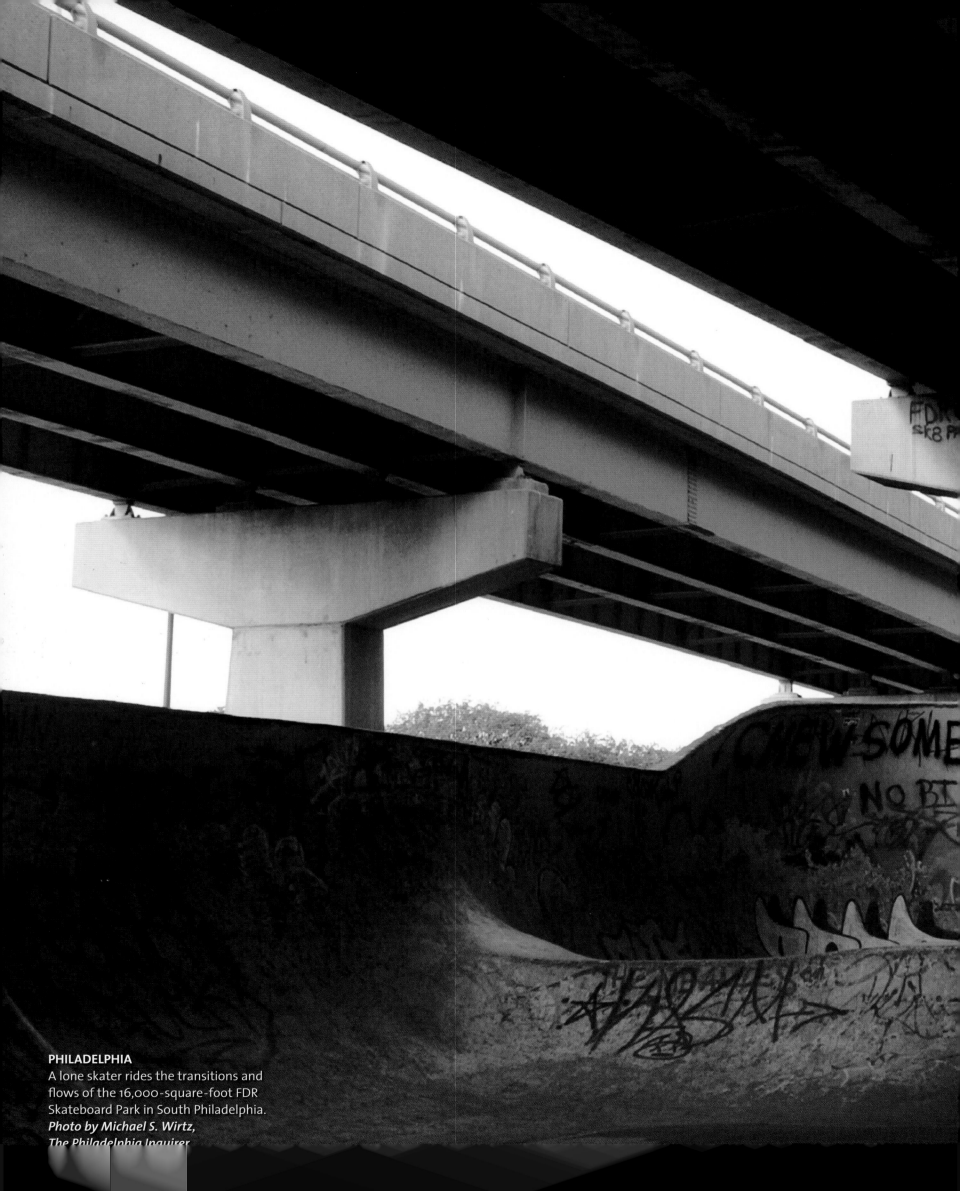

PHILADELPHIA
A lone skater rides the transitions and
flows of the 16,000-square-foot FDR
Skateboard Park in South Philadelphia.
Photo by Michael S. Wirtz,
The Philadelphia Inquirer

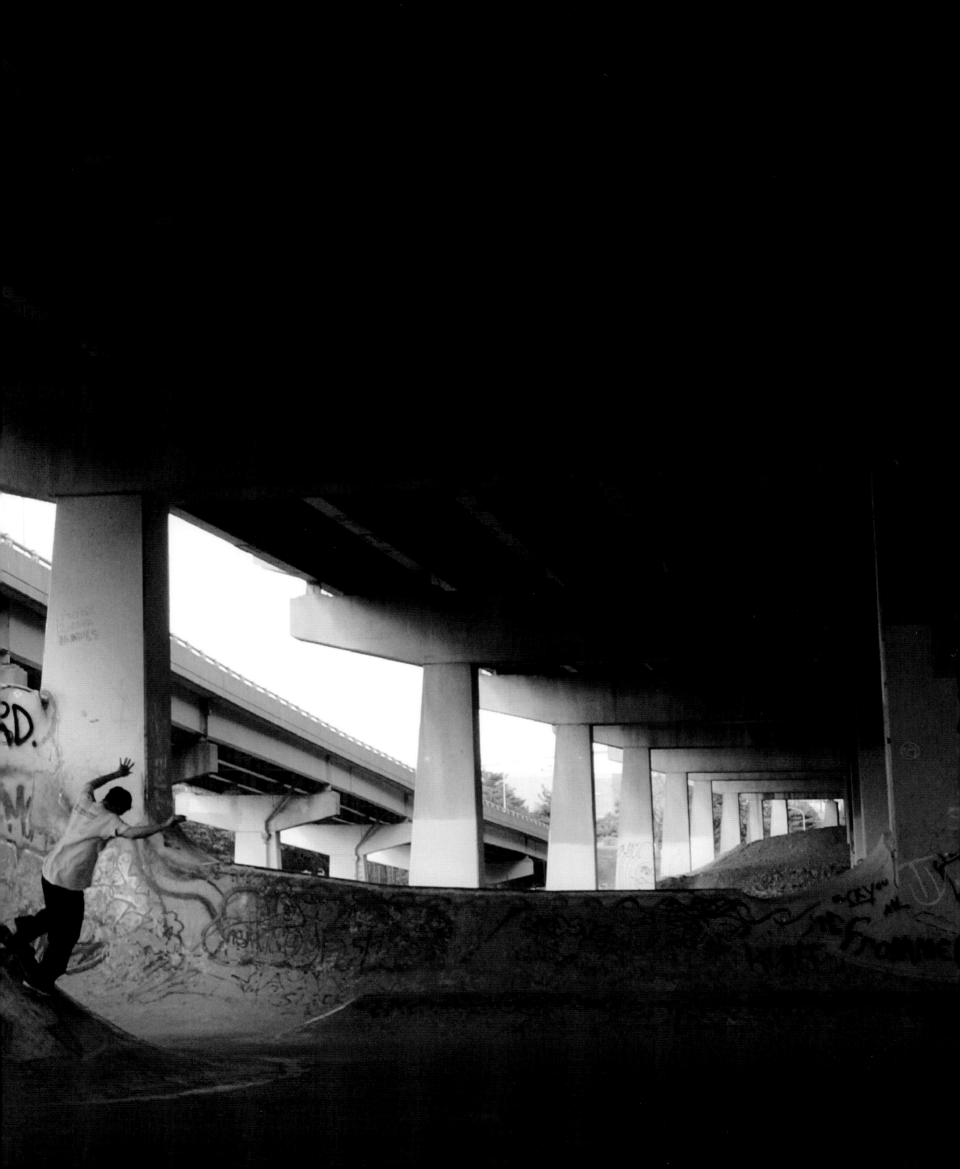

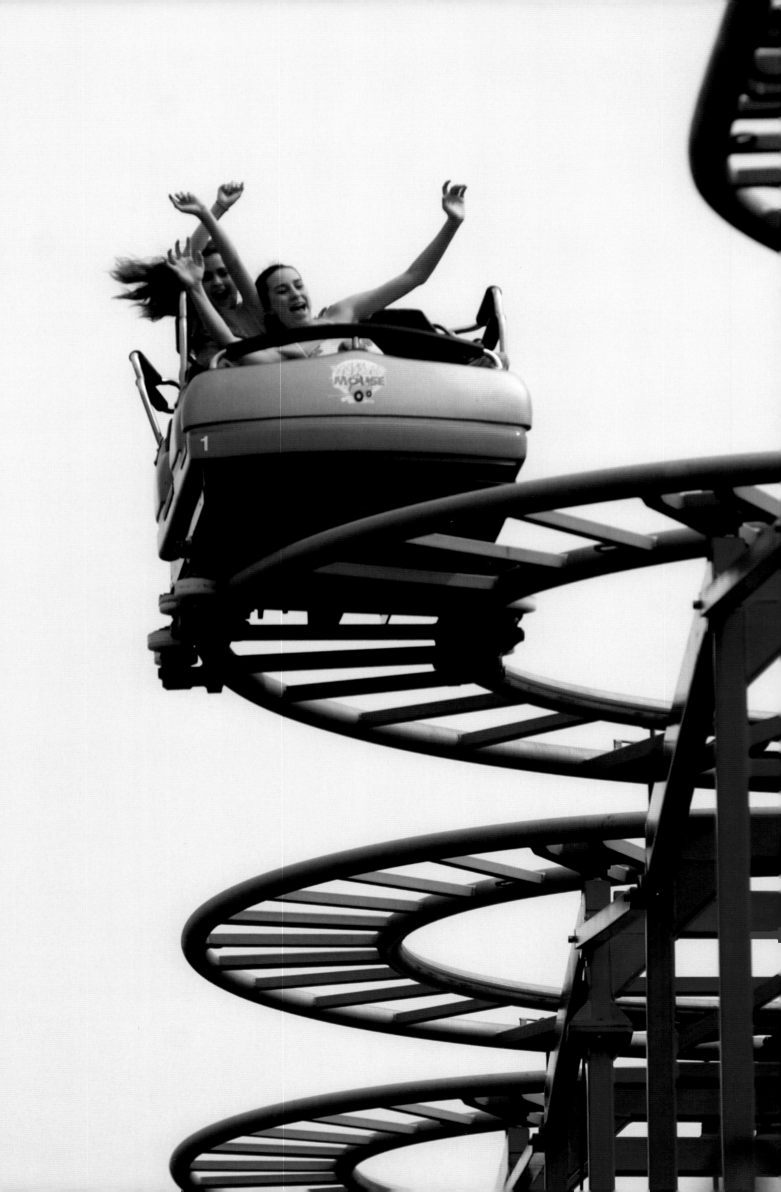

HERSHEY

Thrill seekers Ashley Kilcoin and Ashley Angel embrace the laws of physics on the Wild Mouse at Hershey Park. In 1907, Milton S. Hershey, the inventor of Hershey's milk chocolate, opened the park for the amusement of his factory workers.
Photo by Michael Bryant, Bryant Photo

CARBONDALE

Eat my ash: Mark Taylor, 20, and his ATV raise a storm of coal dust on the culm banks in this former mining town in northeast Pennsylvania.
Photo by Butch Comegys, The Scranton Times

BUTLER

GRASCAR: Between main events at Shadetree Speedway, kids race push mowers but for safety reasons don't start their engines. The track is also the place to be for lawn-tractor racing. Every Sunday from April through September, participants careen around the 1/8th-mile dirt track on their souped-up mowers, reaching speeds of 60 mph.
Photo by Jason Cohn, www.jasoncohn.com

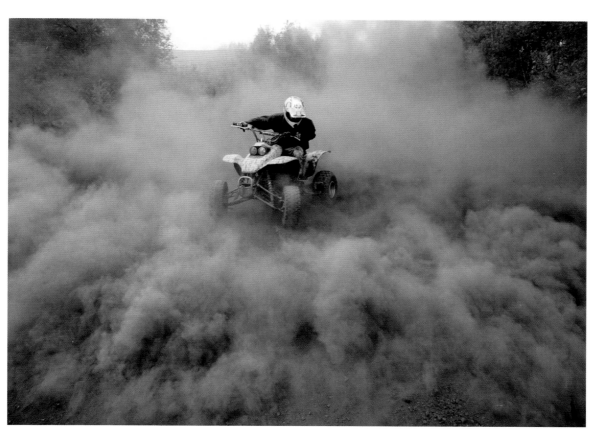

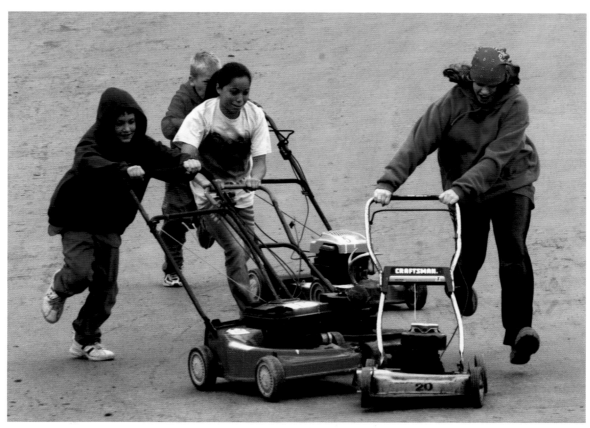

Shadow box: Nick, 16, (far left) and his brother
Vinnie Buff, 12, work out at Larry Holmes's gym
on Canal Street. The boys aspire to be boxers, so
training with the former heavyweight champ's
home team gives their dream the nugget of real
possibility.
Photo by Ed Crisostomo, The Morning Call

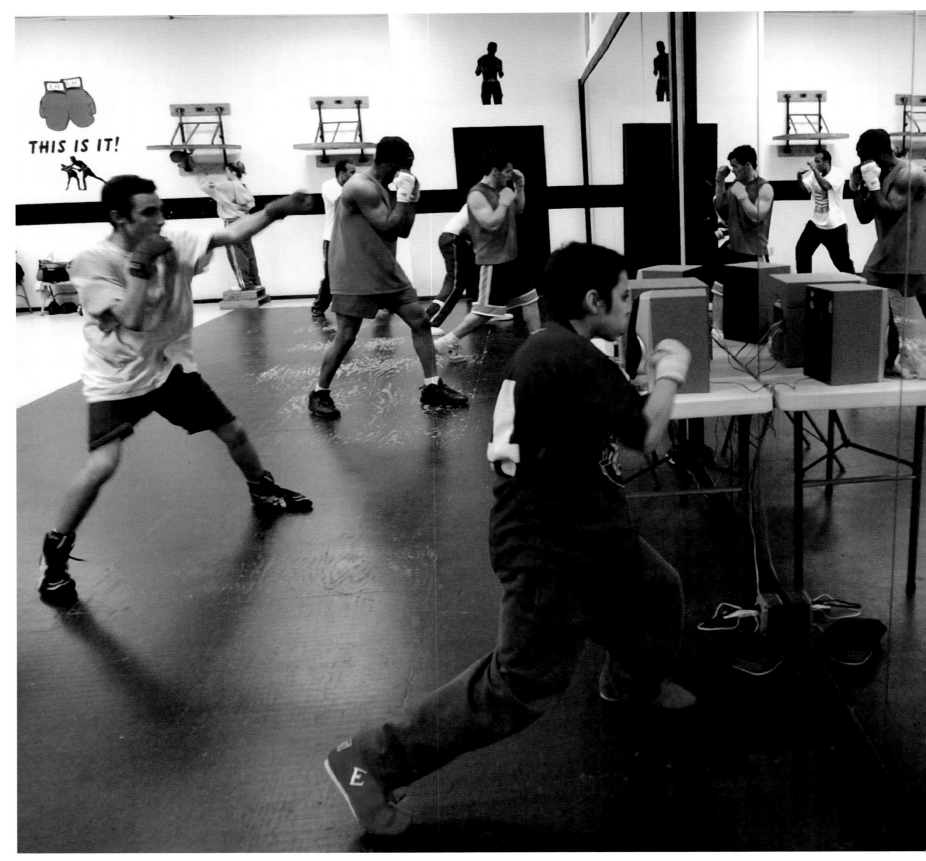

PHILADELPHIA
Suspenders and cigars still reign at the Union League, the second-oldest private club in Philadelphia, established in 1862 by Republican supporters of the Civil War. "I joined primarily for the business contacts," says pool player Ken Wortley, one of the club's 3,000 members.
Photo by E.A. Kennedy 3rd, Image Works

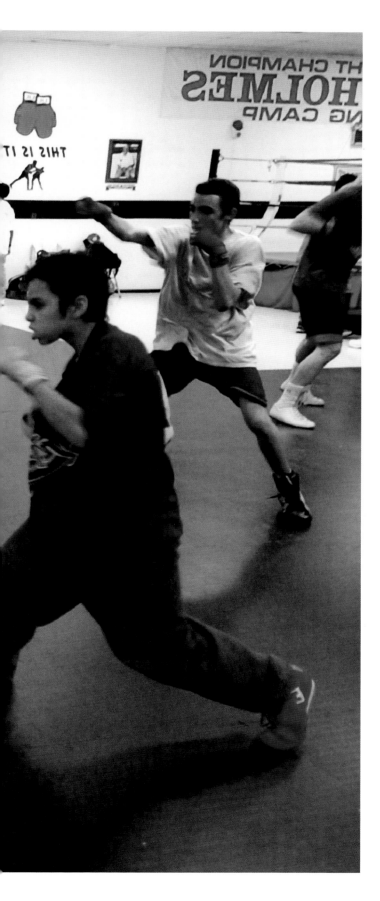

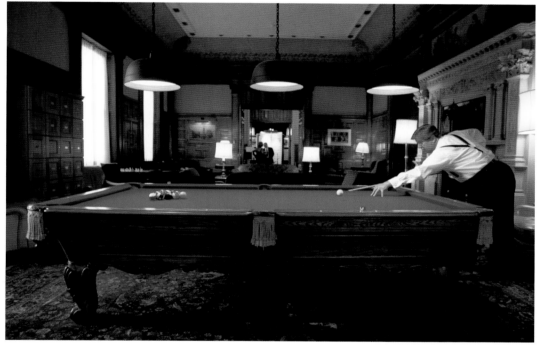

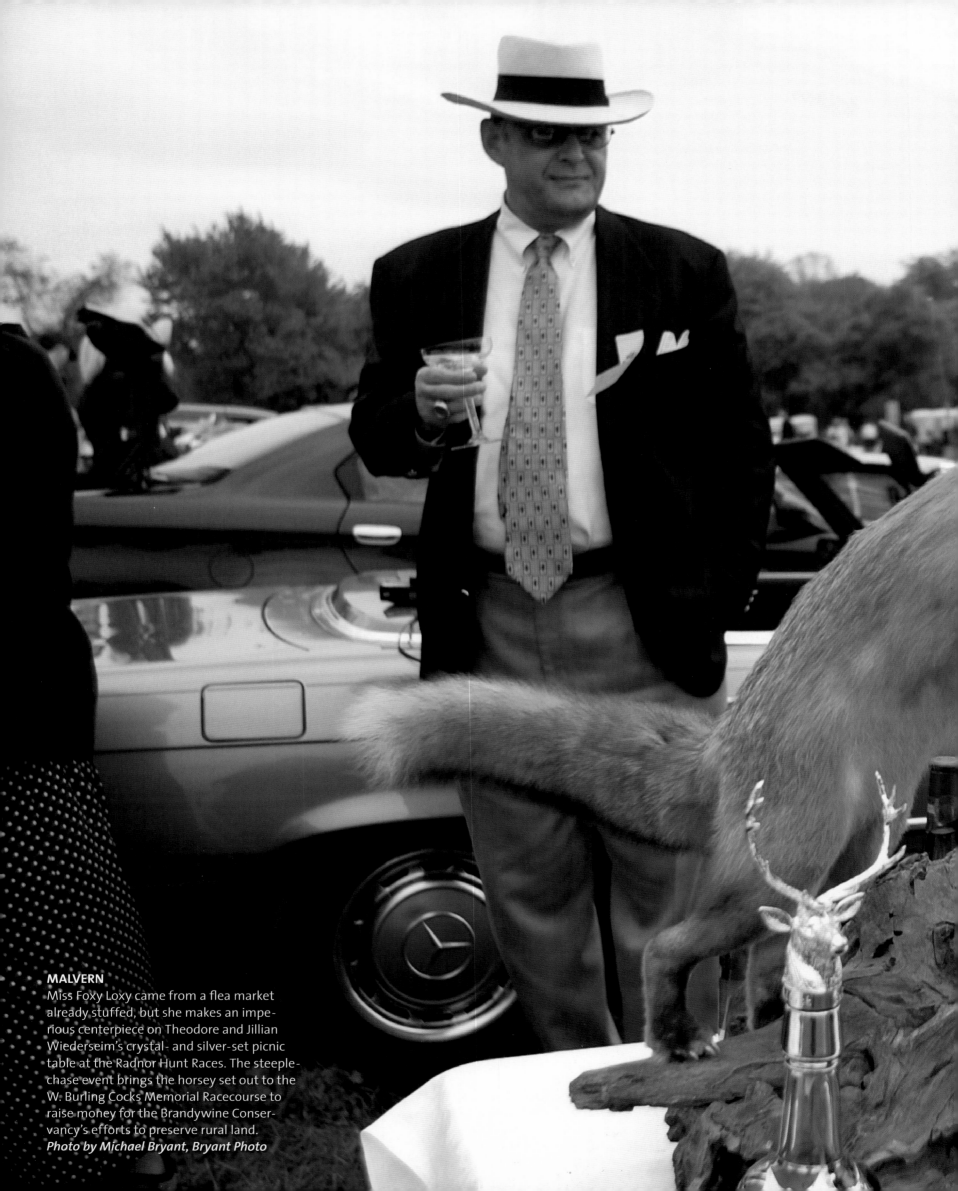

MALVERN

Miss Foxy Loxy came from a flea market already stuffed, but she makes an imperious centerpiece on Theodore and Jillian Wiederseim's crystal- and silver-set picnic table at the Radnor Hunt Races. The steeplechase event brings the horsey set out to the W. Burling Cocks Memorial Racecourse to raise money for the Brandywine Conservancy's efforts to preserve rural land.
Photo by Michael Bryant, Bryant Photo

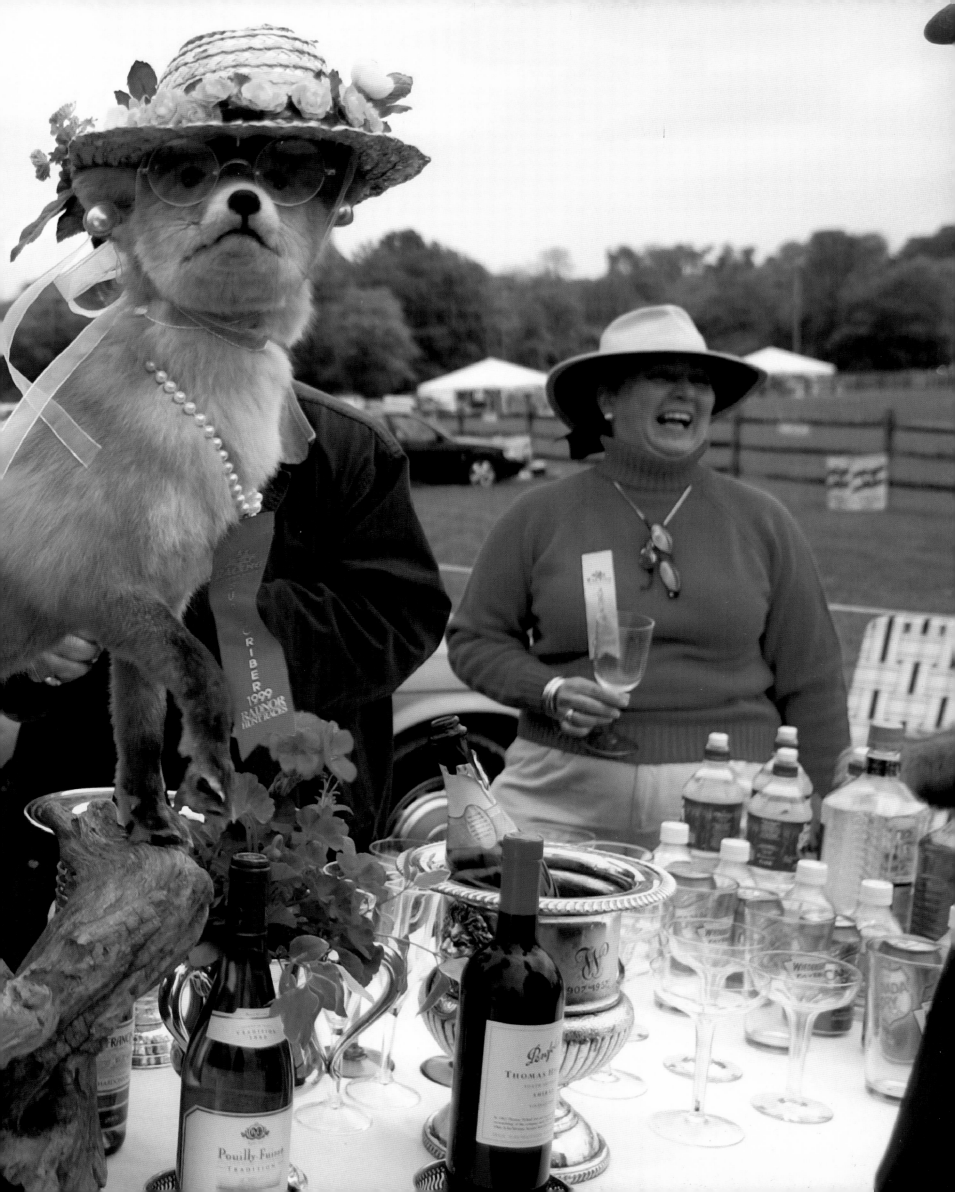

MALVERN

The 73rd Radnor Hunt Races drew 15,000 spectators and sported a total purse of $175,000 in prizes for six races. Jean and Redmond Finney follow their horse, Thunder Gus, running two miles and a half in the Henry Collins Steeplechase. The horse finished in sixth place.
Photos by Michael Bryant, Bryant Photo

MALVERN

Jockey Chip Miller and Darn Tipalarm clear a timber hurdle (just under 4 feet) in the steeplechase. Although the horse was ahead by six lengths in the last lap, he placed fourth at the finish line. The purse: $30,000.

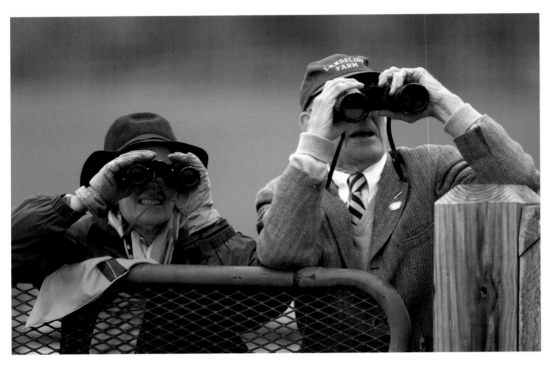

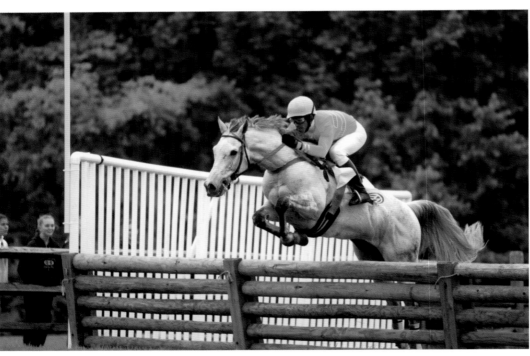

Four-year-old Addison Wallace, chose *Cinderella*, and her sister Hayley, 7, picked *Beauty and the Beast* as inspiration for trimming their spring bonnets. The girls tied for first place in the Child's Chapeau contest at the Radnor Hunt Races.

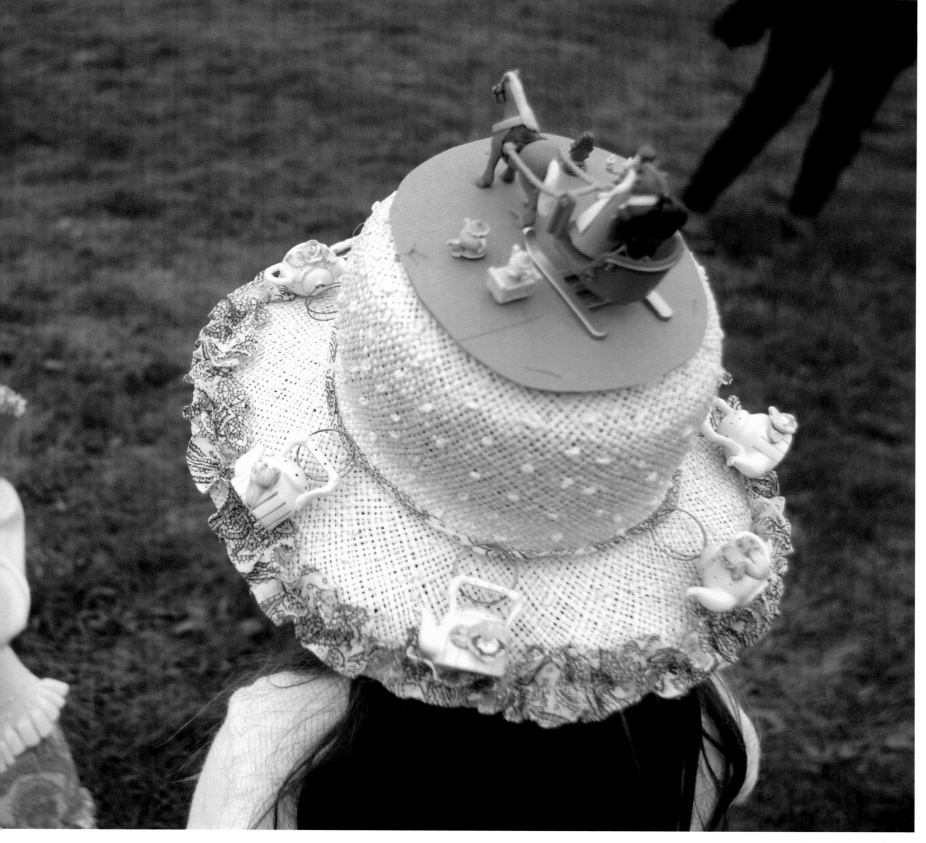

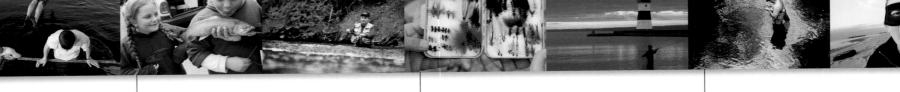

BETHLEHEM

Fish kiss: Caitlin and Ryan McMahon's uncle told them that it's good luck to kiss the fish you catch, so both planted smackers on the two-pound tiger trout Caitlin snagged and Ryan helped land. The sister and brother team were among 500 children who took part in the "Youth Fishing Derby."
**Photo by Arturo Fernandez,
The Morning Call**

LA PLUME

Fisherman and construction worker Bill Domnick presents his alluring menu of hand-tied flies. On the left are "terrestrials," posing as land-based creatures like beetles, ants, and grasshoppers. On the right are "streamers," which resemble small fish that the larger trout feed on.
**Photo by Butch Comegys,
The Scranton Times**

SEVEN VALLEYS

"It's beautiful country," says Travus Brown, at 26 an experienced fisherman but new to fly fishing. He baits his hook in Codorus Creek, which flows into the Susquehanna River. Beauty may be only surface deep; the Codorus Creek Improvement Partnership has launched a program to clear the creek of trash and other forms of pollution.
**Photo by Christopher Glass,
York Daily Record**

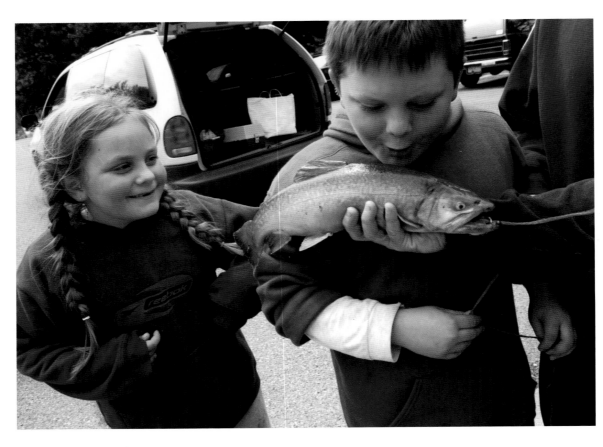

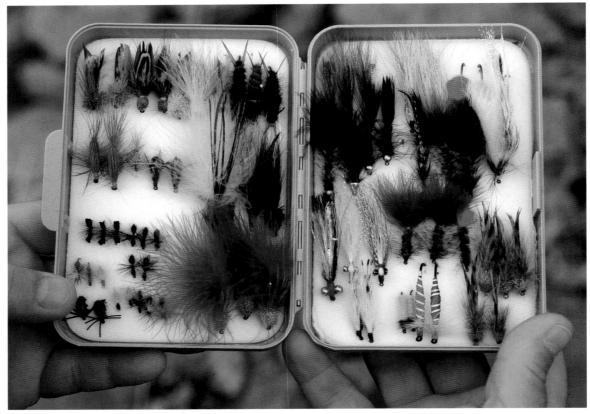

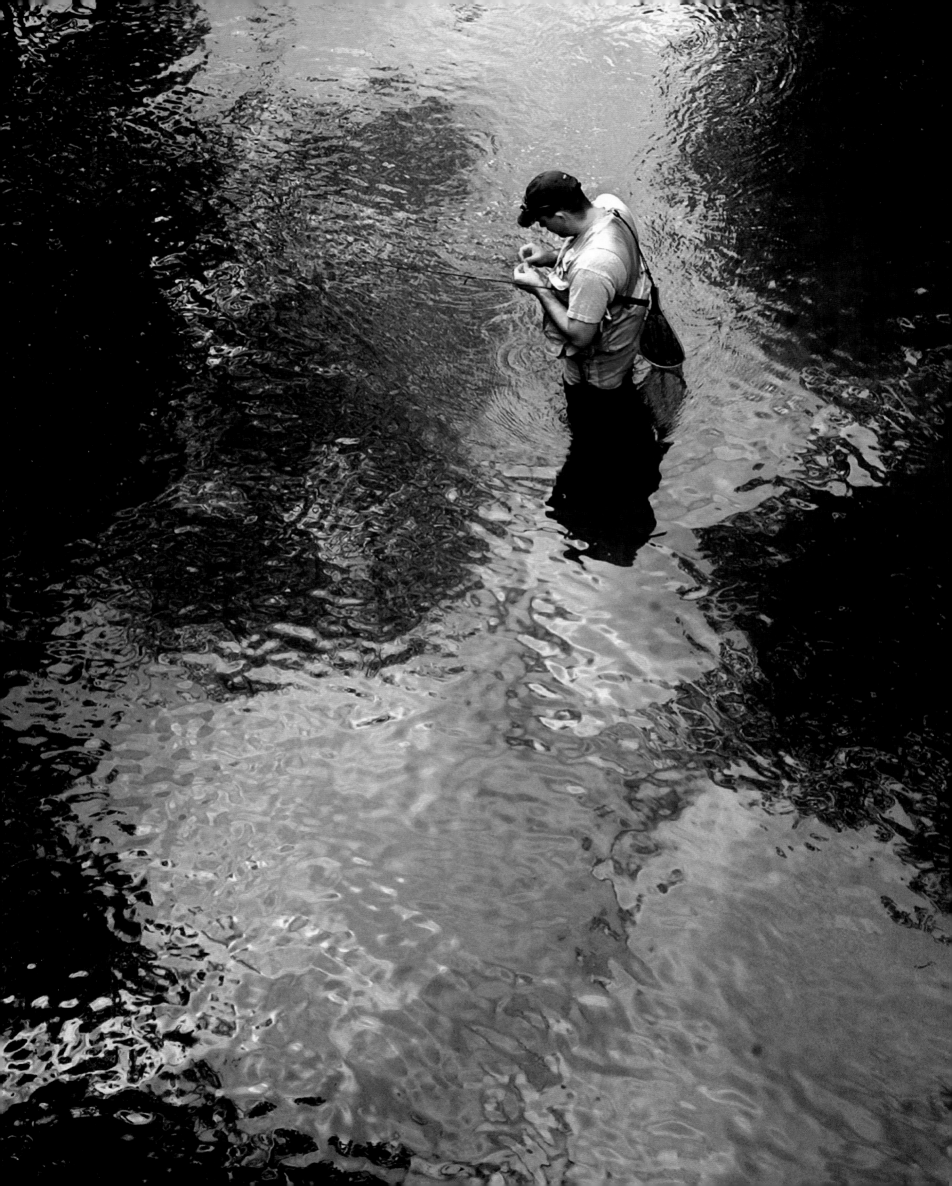

STRASBURG

On the Strasburg Rail Road, passengers wait as the engine backs into a hookup with the First Class parlor car, called the Marian. Laid out in 1832, the railroad is the oldest short line in America. For the 45-minute thrill ride between Strasburg and Paradise, visitors may choose their car: lounge, dining, open-air, or coach.
Photos by Susan L. Angstadt

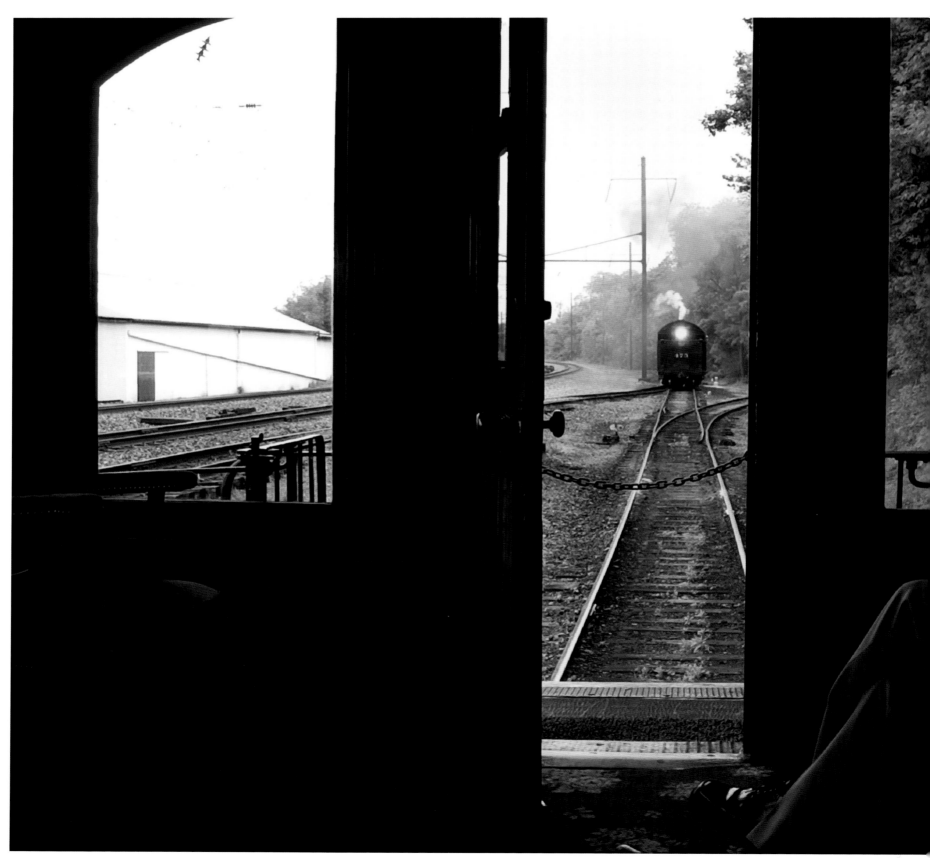

STRASBURG

A Mennonite woman (who actually uses the line for transportation) waits on the Strasburg platform to board the train to Paradise.

STRASBURG

A steam engine, circa 1918, vents at the East Strasburg Depot. In its golden years, 1832 to 1919, the Strasburg Rail Road shuttled passengers and freight, but then cars, trucks, and highways appeared. In 1959 train enthusiast and philanthropist Henry K. Long rescued the line and its stable of six steam locomotives.

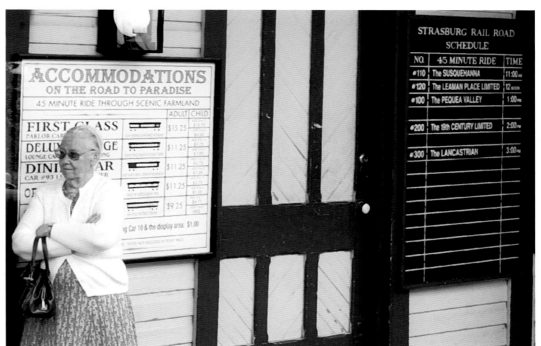

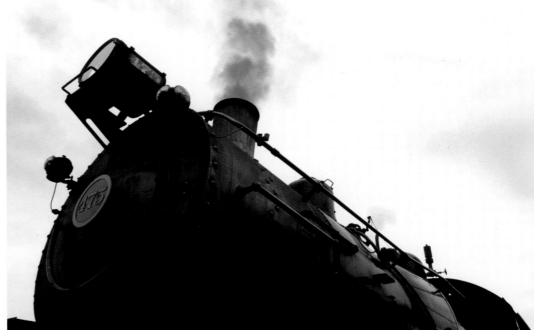

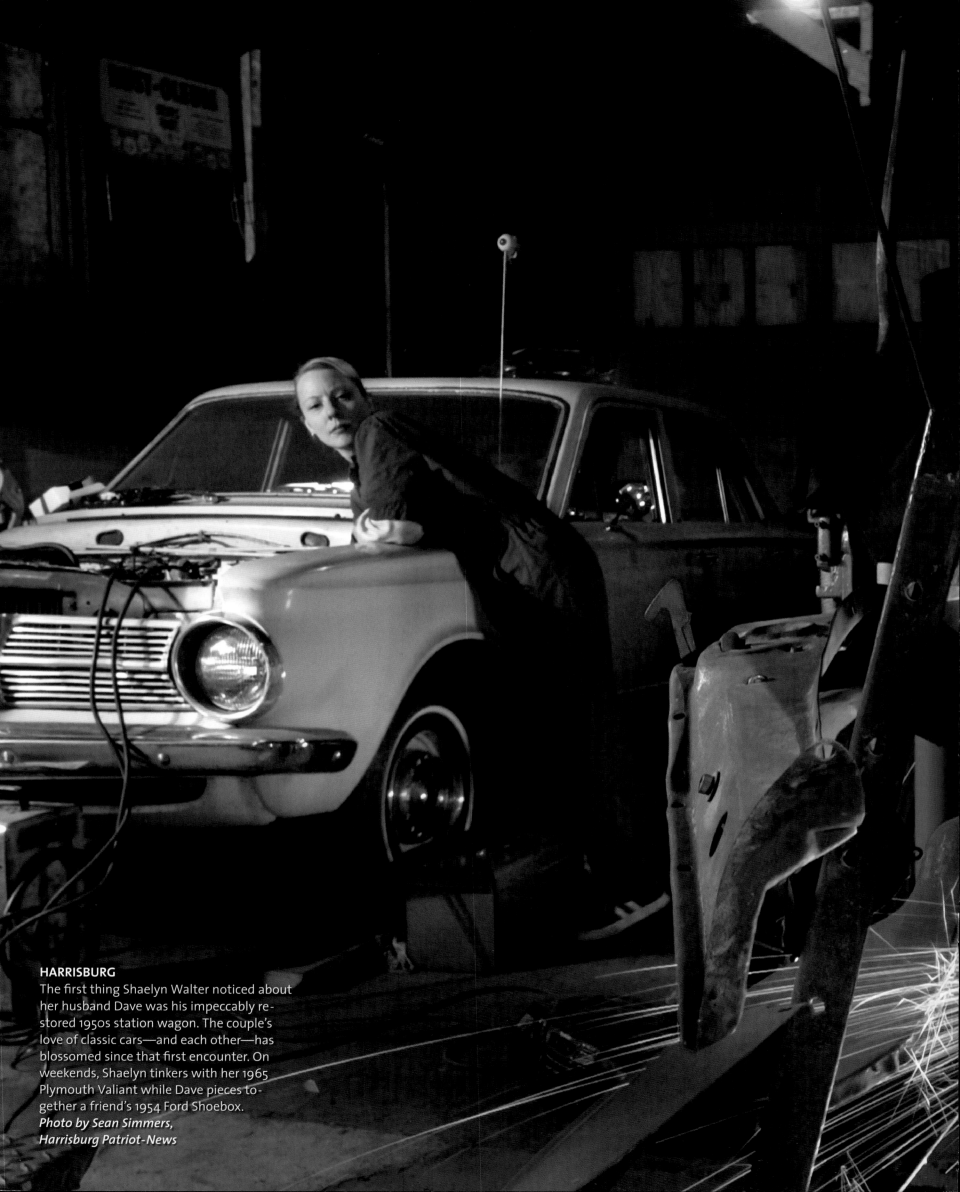

HARRISBURG
The first thing Shaelyn Walter noticed about her husband Dave was his impeccably restored 1950s station wagon. The couple's love of classic cars—and each other—has blossomed since that first encounter. On weekends, Shaelyn tinkers with her 1965 Plymouth Valiant while Dave pieces together a friend's 1954 Ford Shoebox.
Photo by Sean Simmers,
Harrisburg Patriot-News

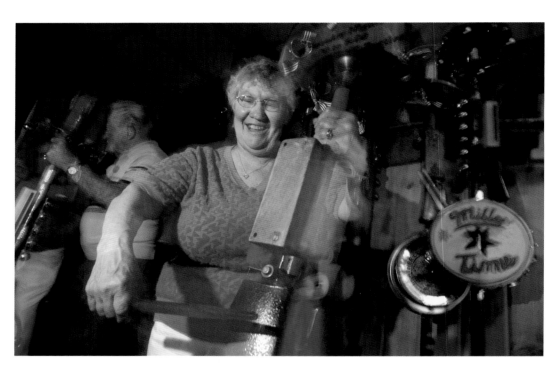

LEATHER CORNER

What sound does a boomba make? "Bang, bang, clank clank!" shouts Molly Keinert, founding member of the Happy Boombadears. She and Edward Scott, left, play their updated Bavarian rhythm sticks to polka tunes from the jukebox at the Leather Corner Post Hotel in Pennsylvania Dutch country. Some boomba players have tried to accompany rap. Don't ask.

Photo by Frank Wiese, The Morning Call

GIRARD

Doug Erickson, 19, and Roman Glass, 20, of the seven-member ska band By George and the Weasles practice in Erickson's parents' garage. One of the band's most notable songs is "She Looks Like Billy Idol With Boobs."

Photo by Jack Hanrahan, Erie Times-News

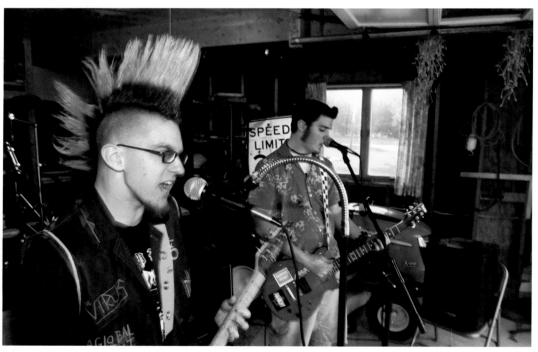

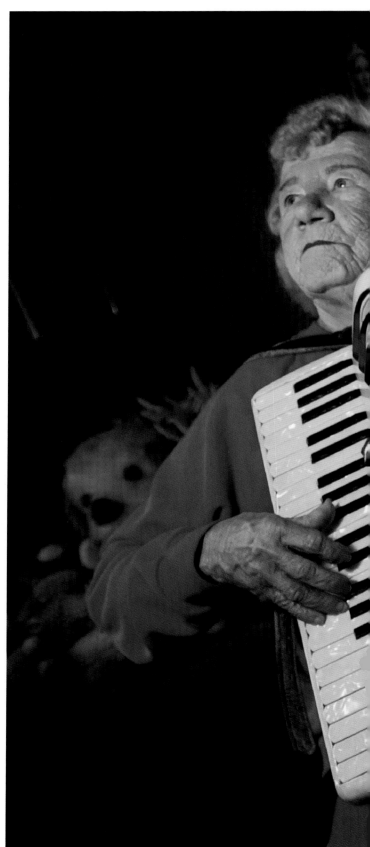

MILLCREEK

Luella Barber, 81, plays her accordion at senior centers with a trio, and sometimes with a 25-piece orchestra. Plus, she fields tunes on six other instruments: piano, organ, bass viol, drums, cymbals, and first-soprano bugle. Her orchestra backs a tap dancer on roller skates and other acts. "It's like an old-time variety show," says the modern-day vaudevillian. "The seniors love it."
Photo by Jack Hanrahan, Erie Times-News

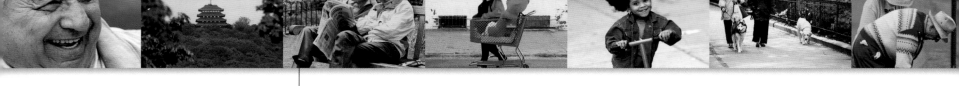

PHILADELPHIA
In Rittenhouse Square, John Manola, 86, reads to his friend William Talero, 65, who is blind. Manola and Talero met in New Jersey in the 1960s but lost touch. Nearly 40 years later, they ran into each other at a concert in Philadelphia. The two go walking every day in Fairmount Park and savor sitting on the banks of the Schuylkill River.
Photo by John S. Needles, Jr.

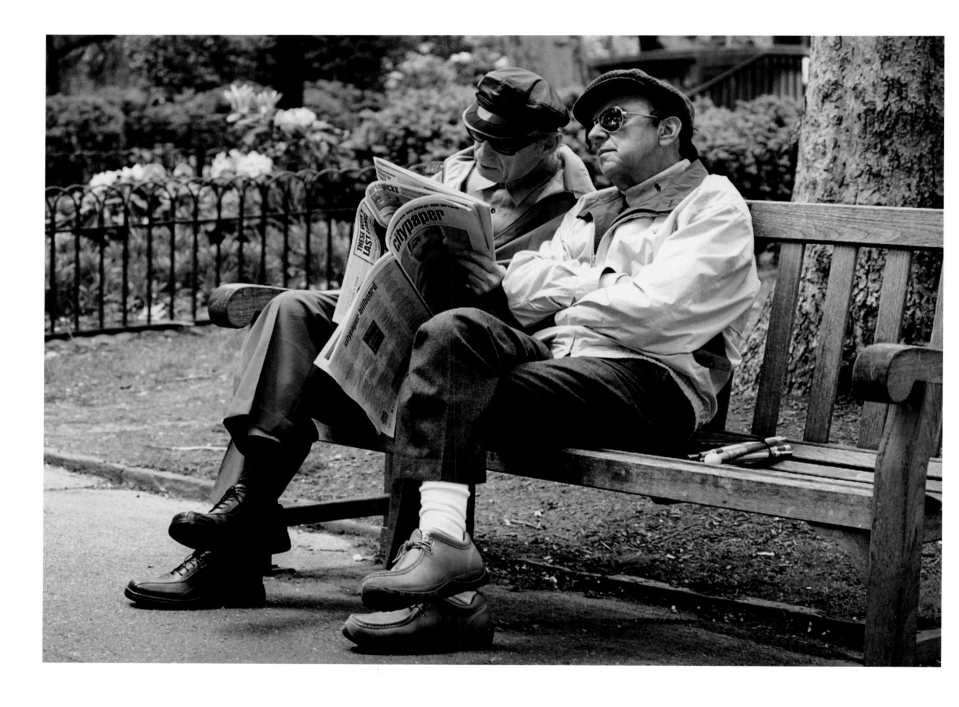

BETHLEHEM
Hands that used to process coal into coke at the Bethlehem Steel plant play "capicu," a style of dominos, at the Don Basilio Huertas Senior Center. Many of the center's regulars came from Puerto Rico to work on farms and began working for Bethlehem in the 1950s.
Photo by Arturo Fernandez, The Morning Call

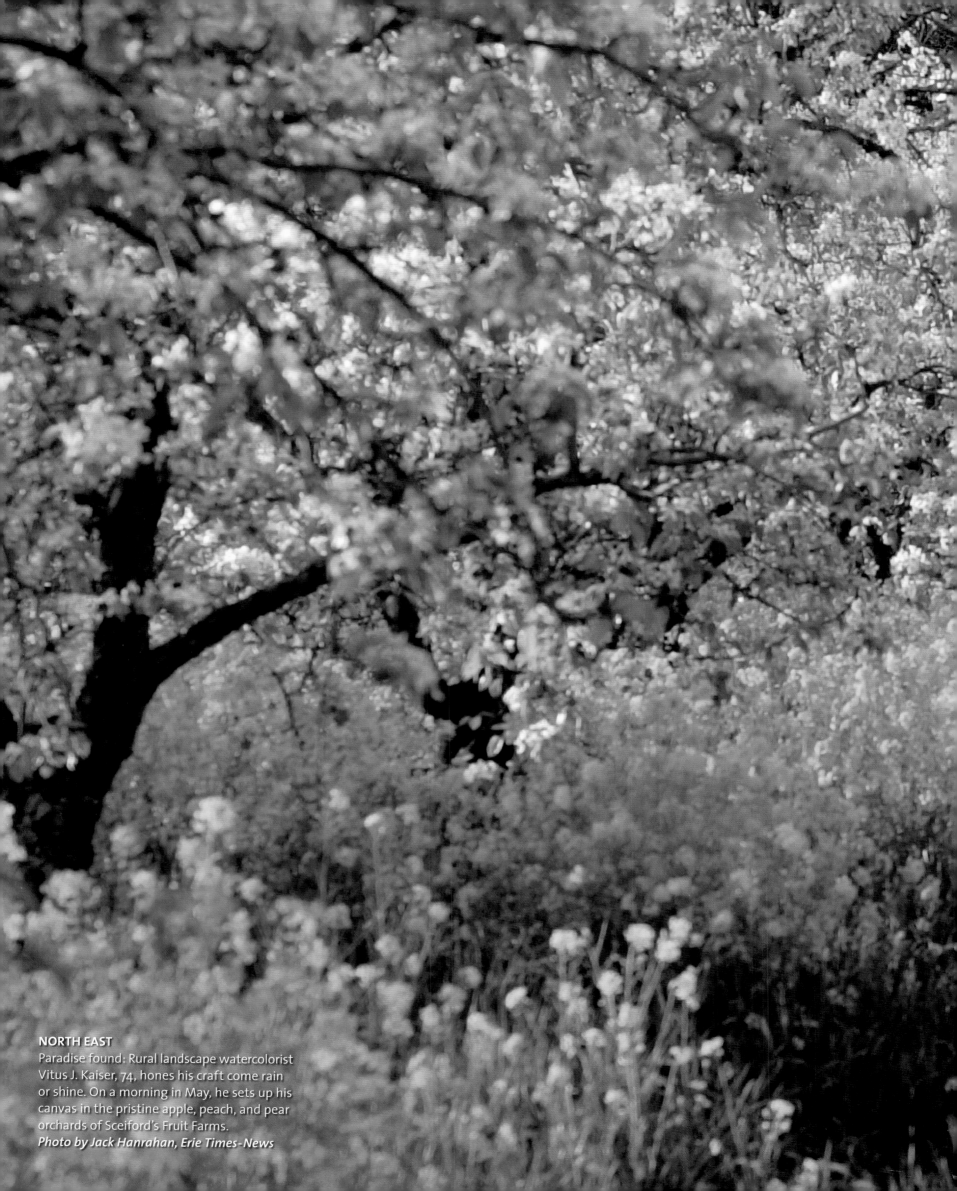

NORTH EAST
Paradise found: Rural landscape watercolorist
Vitus J. Kaiser, 74, hones his craft come rain
or shine. On a morning in May, he sets up his
canvas in the pristine apple, peach, and pear
orchards of Sceiford's Fruit Farms.
Photo by Jack Hanrahan, Erie Times-News

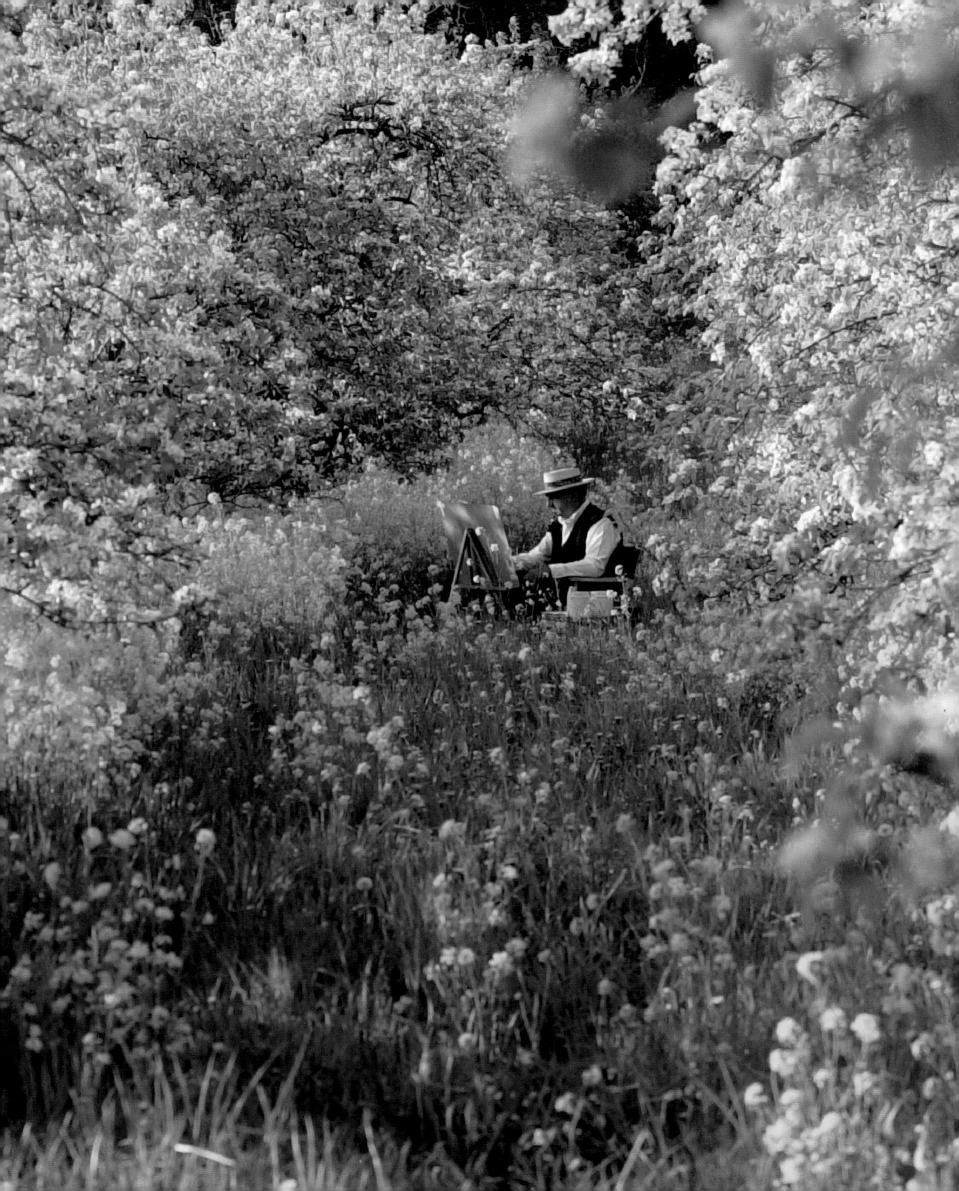

BETHEL PARK
Jean Gedeon assists Allie Litterini, 7, with
the fifth position at the Pittsburgh Youth Ballet
Company. Gedeon is the artistic director and
founder of the company, which she opened in
1983. Through the years, Gedeon students have
won more than $300,000 in scholarships to
ballet schools and companies around the world.
Photo by Scott Goldsmith

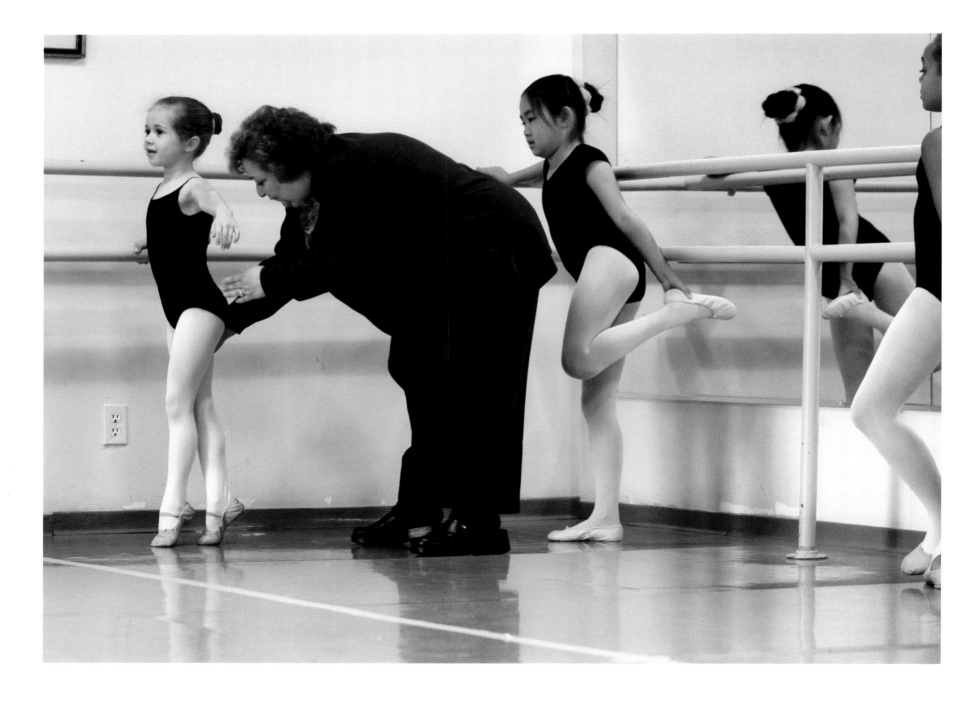

ABINGTON TOWNSHIP
Members of the advanced intermediate class at the Metropolitan Ballet Academy try to hide their nervous energy as they prepare for a dress rehearsal of the school's annual showcase. That night, an audience of 500 watched the dancers perform "Blue," a meditation on the color.
Photo by E.A. Kennedy 3rd, Image Works

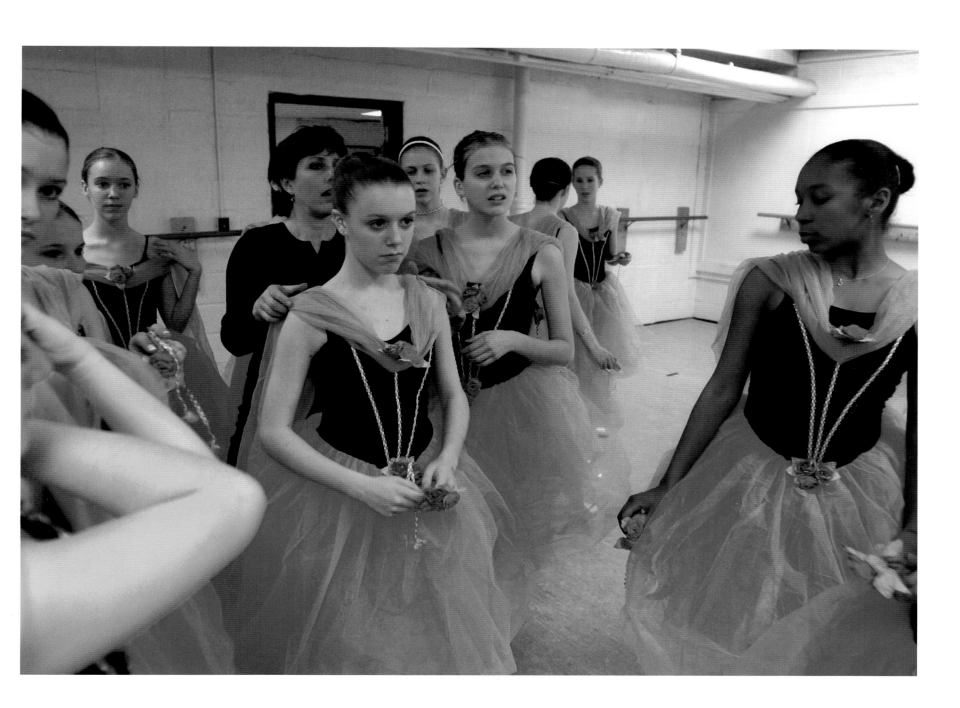

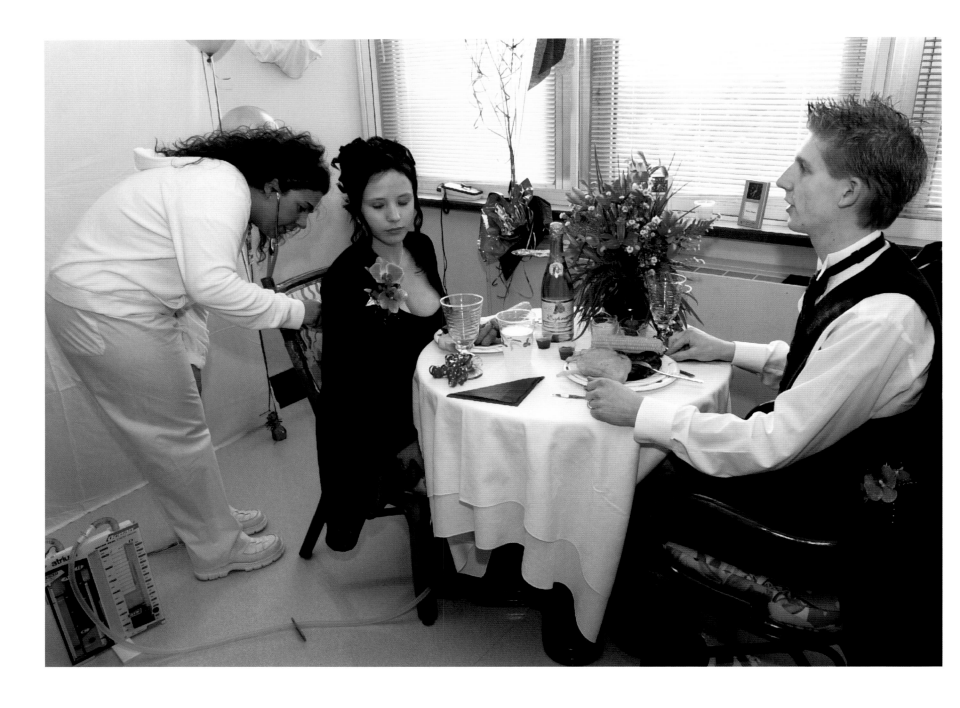

ERIE

Nicole Boyce has a simple goal: To graduate from high school in June 2004. Battling cystic fibrosis since birth, Nicole, 17, attends school, works at McDonalds, and lives at home. When a temporary setback put her in the hospital, Nicole's boyfriend Zach Williams (who wants to marry her) brought the prom to his sweetheart.
Photo by Jack Hanrahan, Erie Times-News

FAIRLESS HILL

Ten years ago a Pennsbury High School student hitched a helicopter ride to the prom. Arriving in style has been a tradition for Pennsbury kids ever since. Among the more memorable modes of arrival during prom night in Fairless Hill (pop. 9,026): a cement mixer, a forklift, and a dragster race car. Heather Raudenbush and friends prove that bigger isn't always better.
Photo by E.A. Kennedy 3rd, Image Works

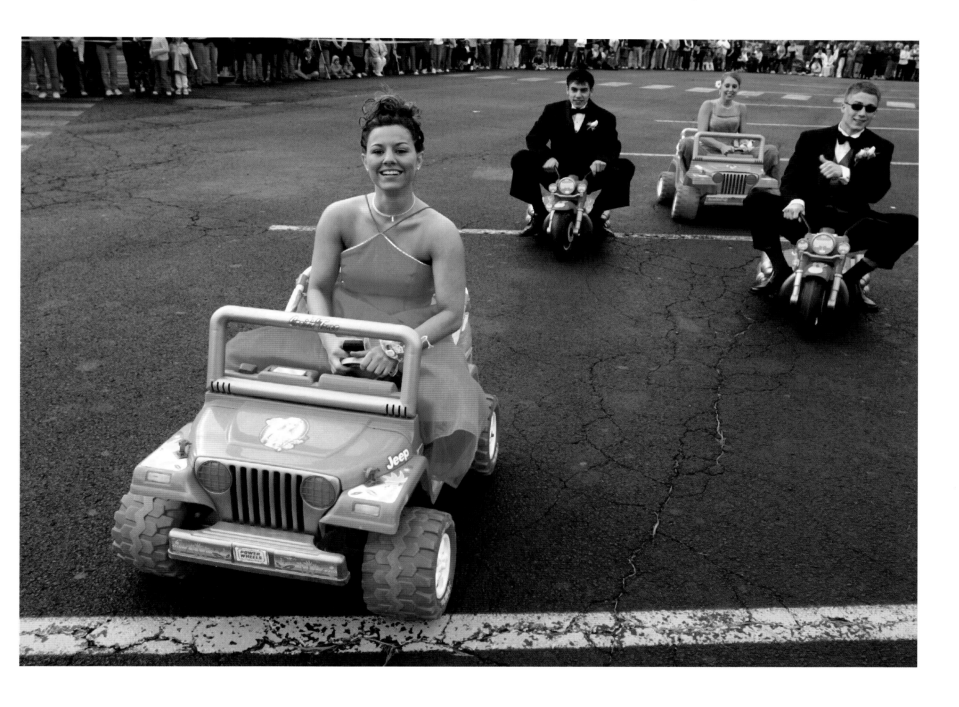

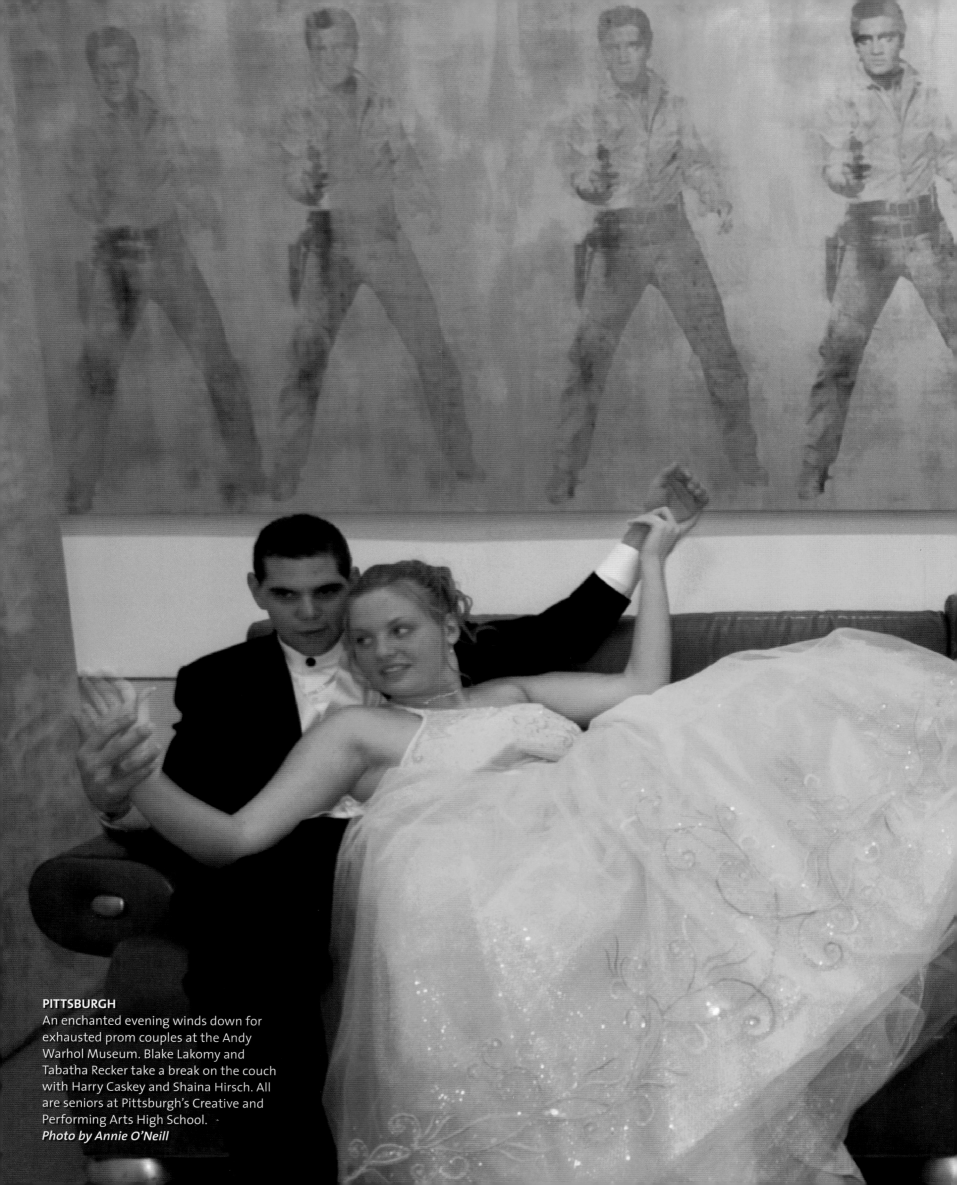

PITTSBURGH
An enchanted evening winds down for exhausted prom couples at the Andy Warhol Museum. Blake Lakomy and Tabatha Recker take a break on the couch with Harry Caskey and Shaina Hirsch. All are seniors at Pittsburgh's Creative and Performing Arts High School. ·
Photo by Annie O'Neill

FOUNTAIN HILL
Jake Bishop slams Moondog Wenzel to the mat during a World Xtreme Wrestling heavyweight title match at the Castle Hill Ballroom. Founded in 1996 in the Allentown area by Afa the Wild Samoan (a trainer for Hulk Hogan), WXW produces matches to give pro-wrestling trainees experience in the ring before they try for the televised circuit.
Photos by Yoni Brook

WILKES-BARRE
Fans cheer for 16-year-old Denise Hudson, doing her rendition of Anita Baker's "Sweet Love" during the Apollo Theatre Amateur Night on Tour at the F.M. Kirby Center. Long before *American Idol* hit the screen, the Apollo Theatre in Harlem jump-started the careers of stars like Ella Fitzgerald, James Brown, and Michael Jackson.

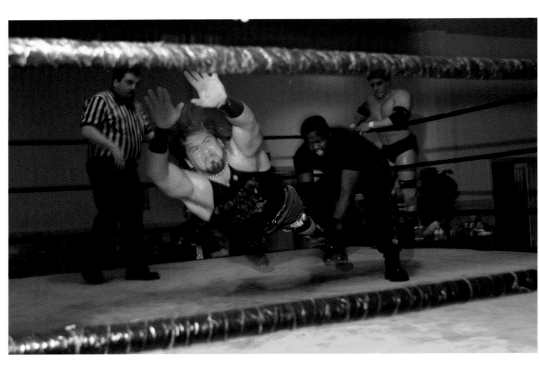

FOUNTAIN HILL
Tossed from the ring during a title match, Moondog Wenzel nearly lands on his fans, who jeer his opponent. WXW trains pro-wrestling wannabes, including several women.

WILKES-BARRE

"Fat Tony" Manorek, 19, psyches himself up for an impromptu boxing match at a late-night party. Manorek and friends call themselves the Northeast Skate Crew. They play rough and sometimes get hurt, but they're "tough kids," and it's part of the fun, says Sara Minsavage, who threw the party.

Photos by Yoni Brook

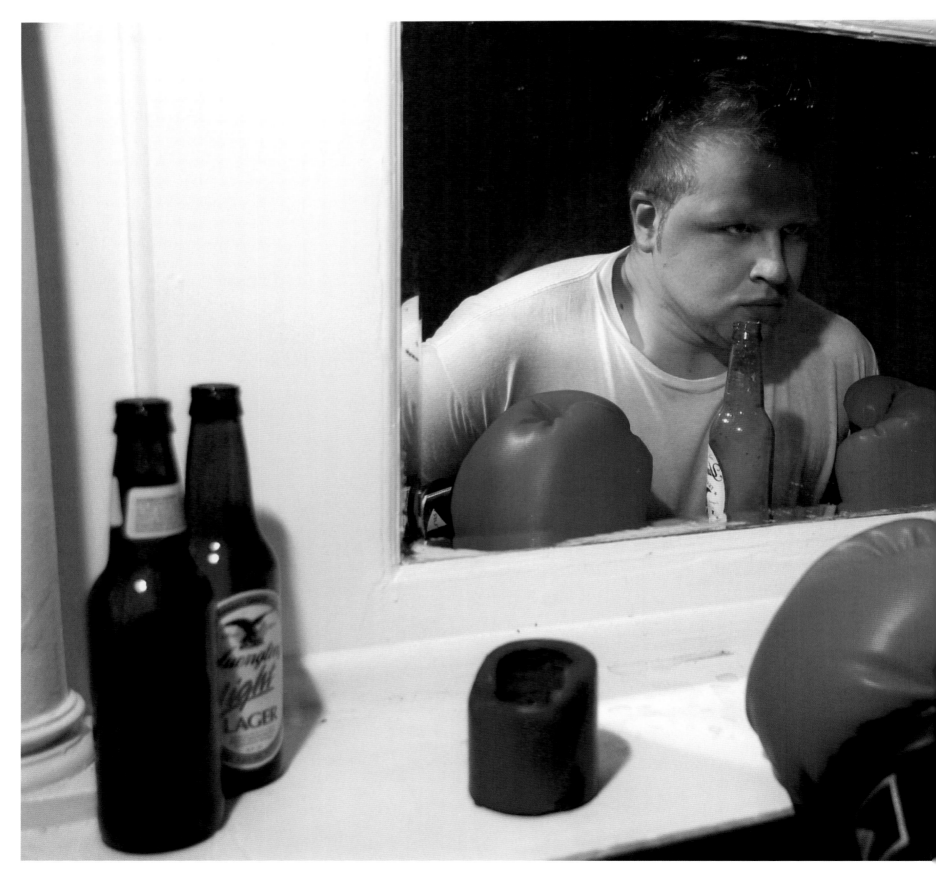

WILKES-BARRE
Gloves make it look serious, but the fight between pals Nick Crittenden, 20, and Tony Manorek is all in fun.

WILKES-BARRE
Gloves make it look serious, but the fight between pals Nick Crittenden, 20, and Tony Manorek is all in fun.

WILKES-BARRE
And the winner is...Tony Manorek!

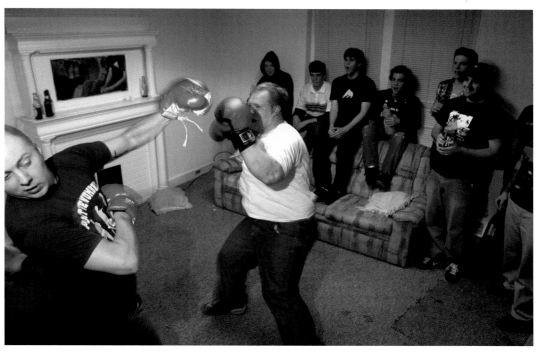

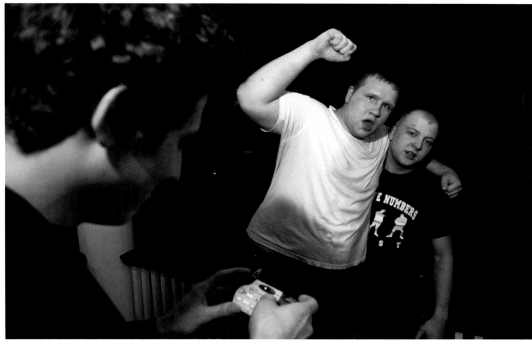

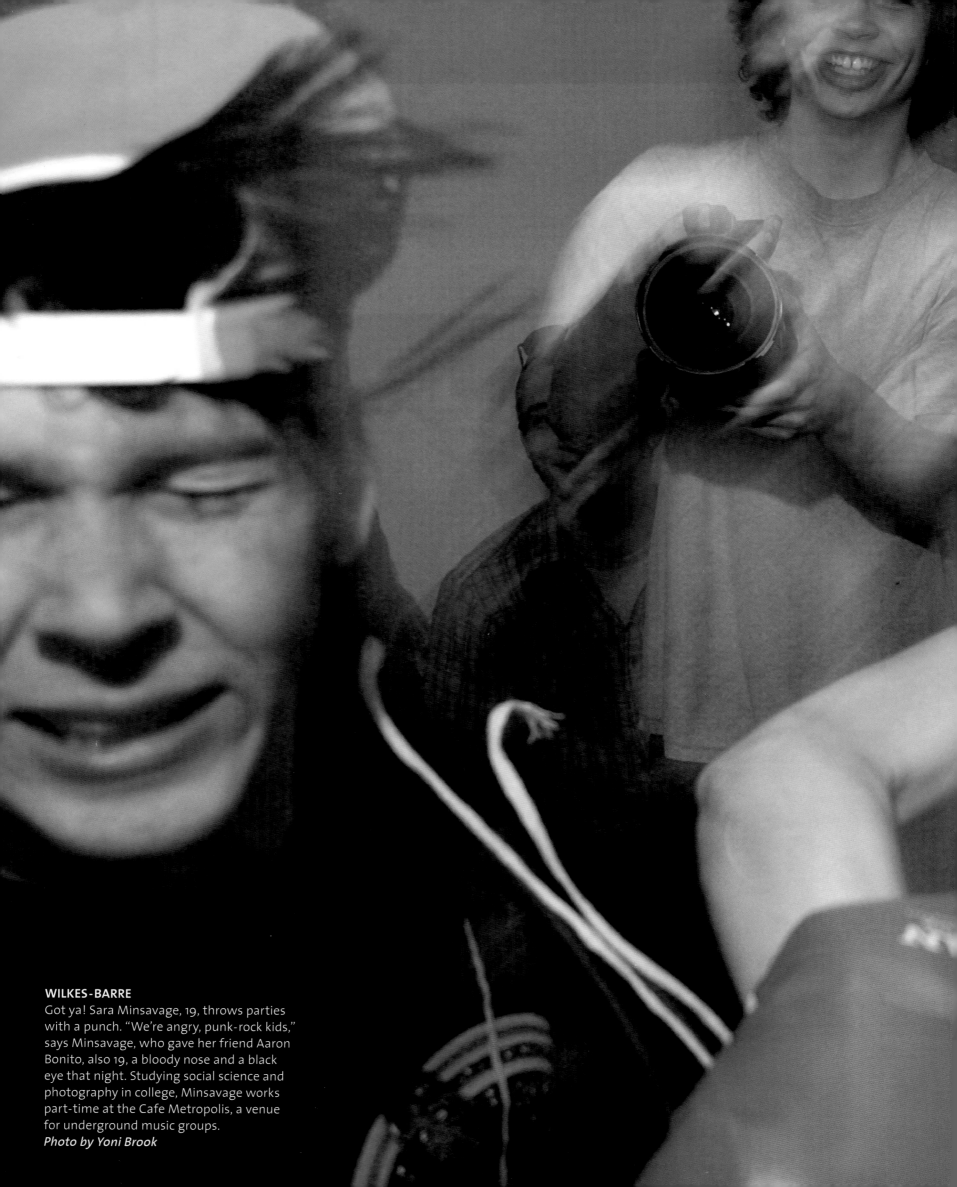

WILKES-BARRE
Got ya! Sara Minsavage, 19, throws parties with a punch. "We're angry, punk-rock kids," says Minsavage, who gave her friend Aaron Bonito, also 19, a bloody nose and a black eye that night. Studying social science and photography in college, Minsavage works part-time at the Cafe Metropolis, a venue for underground music groups.
Photo by Yoni Brook

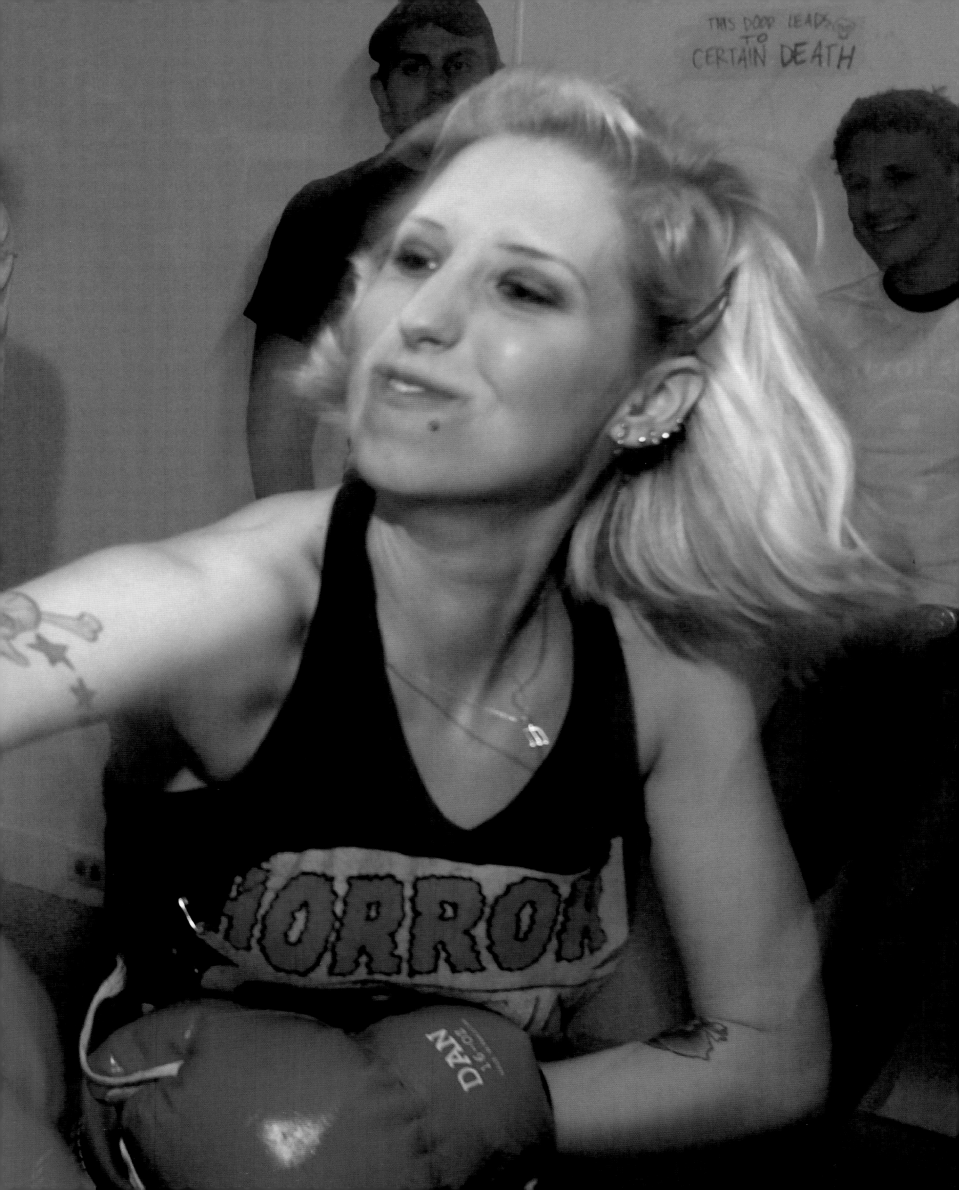

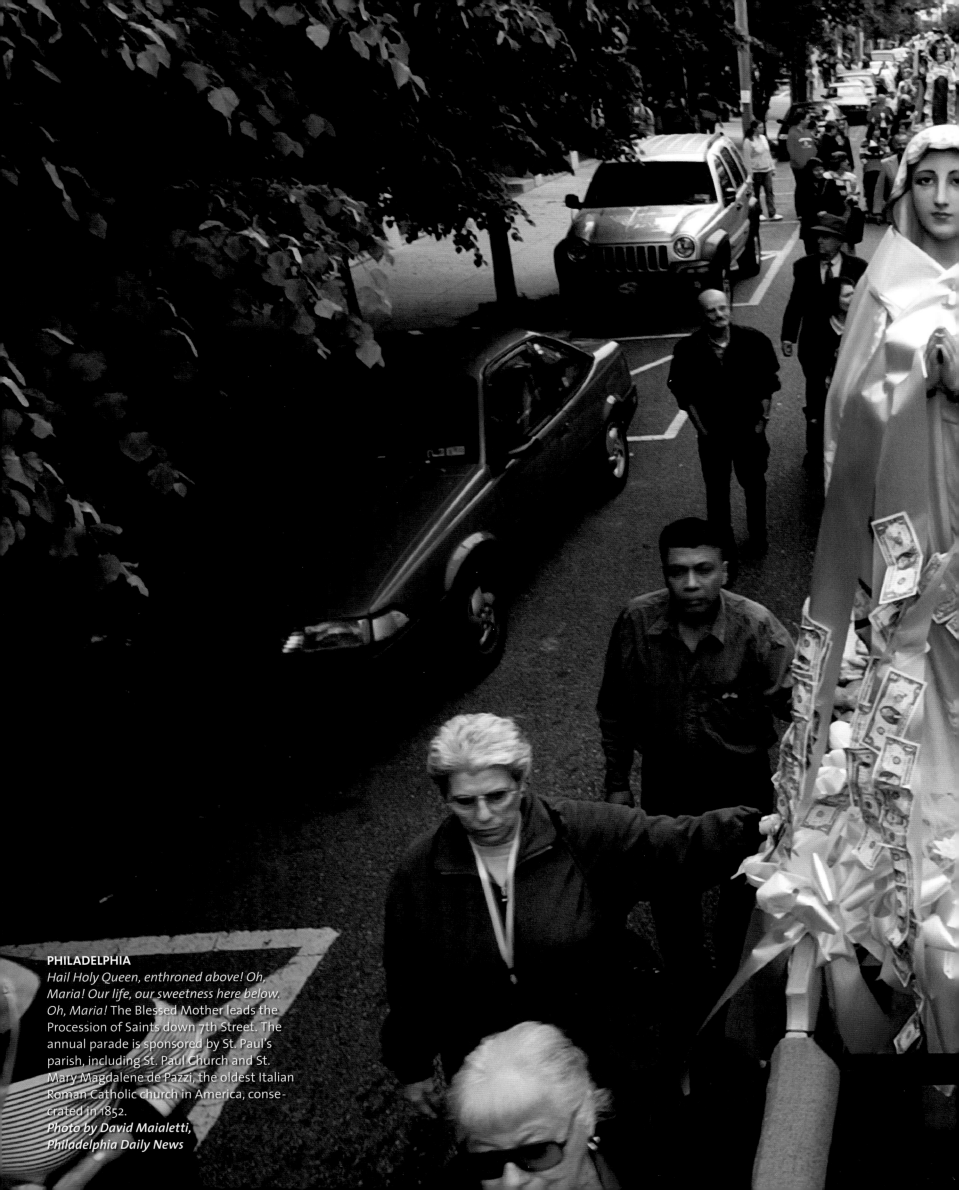

PHILADELPHIA
Hail Holy Queen, enthroned above! Oh, Maria! Our life, our sweetness here below. Oh, Maria! The Blessed Mother leads the Procession of Saints down 7th Street. The annual parade is sponsored by St. Paul's parish, including St. Paul Church and St. Mary Magdalene de Pazzi, the oldest Italian Roman Catholic church in America, consecrated in 1852.
Photo by David Maialetti, Philadelphia Daily News

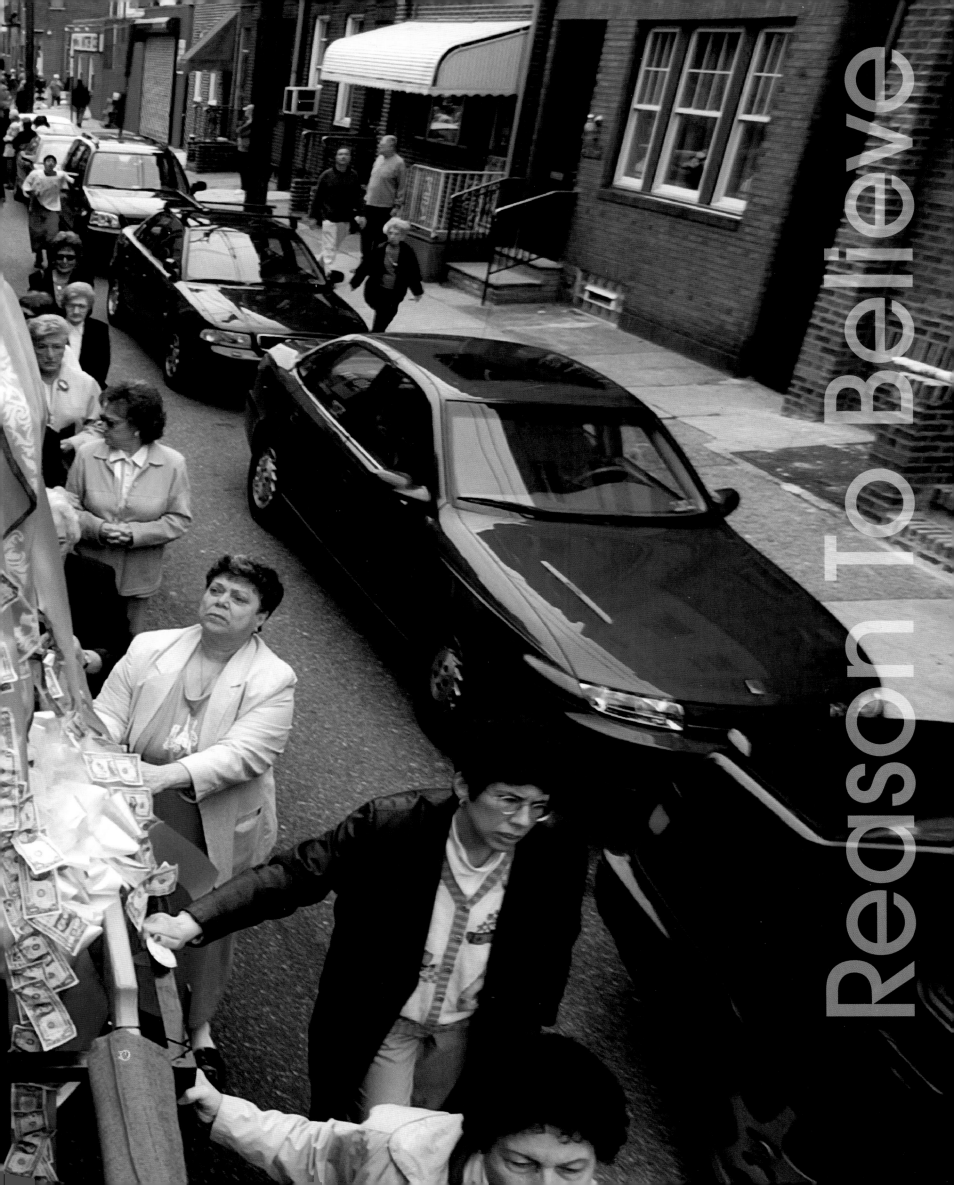

Reason To Believe

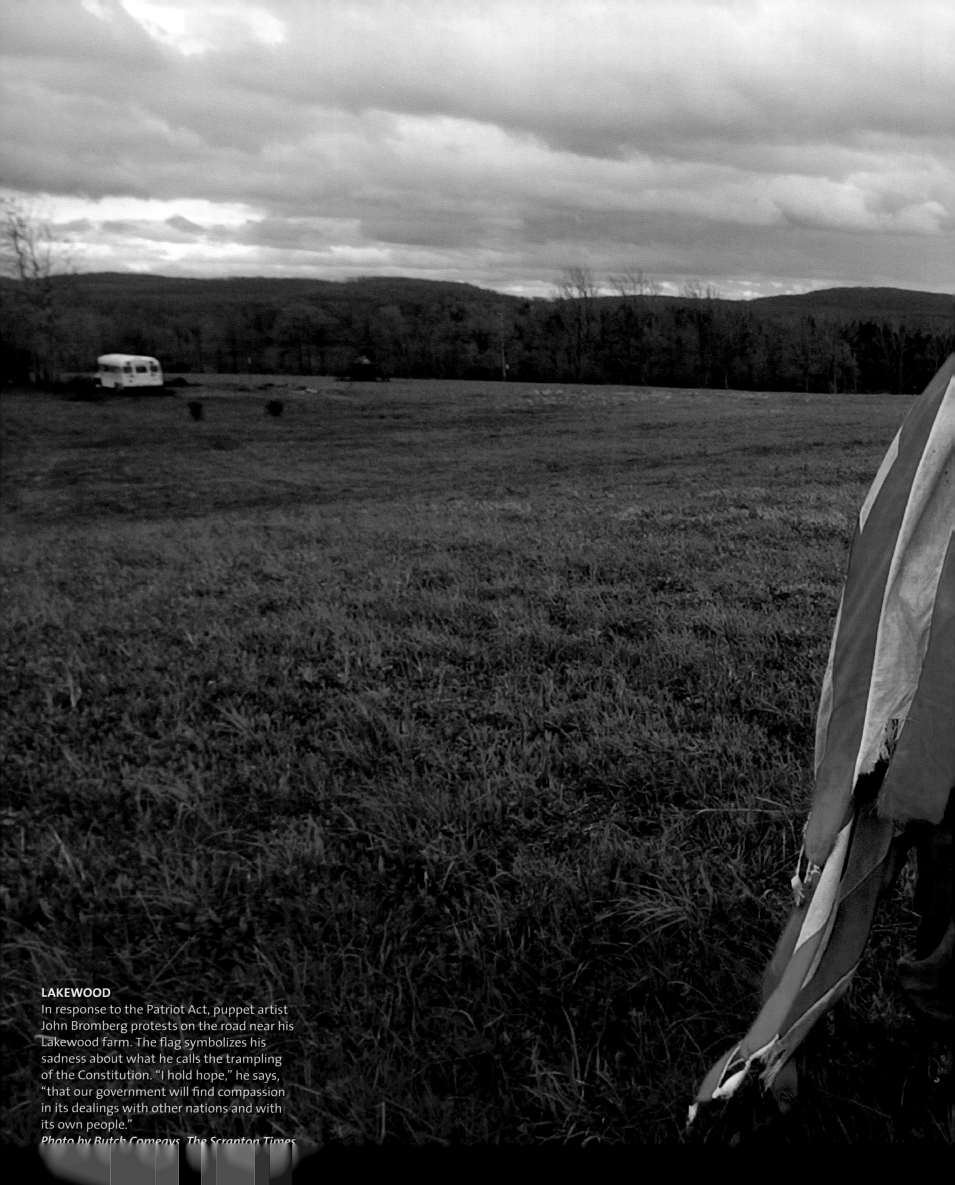

LAKEWOOD

In response to the Patriot Act, puppet artist John Bromberg protests on the road near his Lakewood farm. The flag symbolizes his sadness about what he calls the trampling of the Constitution. "I hold hope," he says, "that our government will find compassion in its dealings with other nations and with its own people."

Photo by Butch Comegys, The Scranton Times

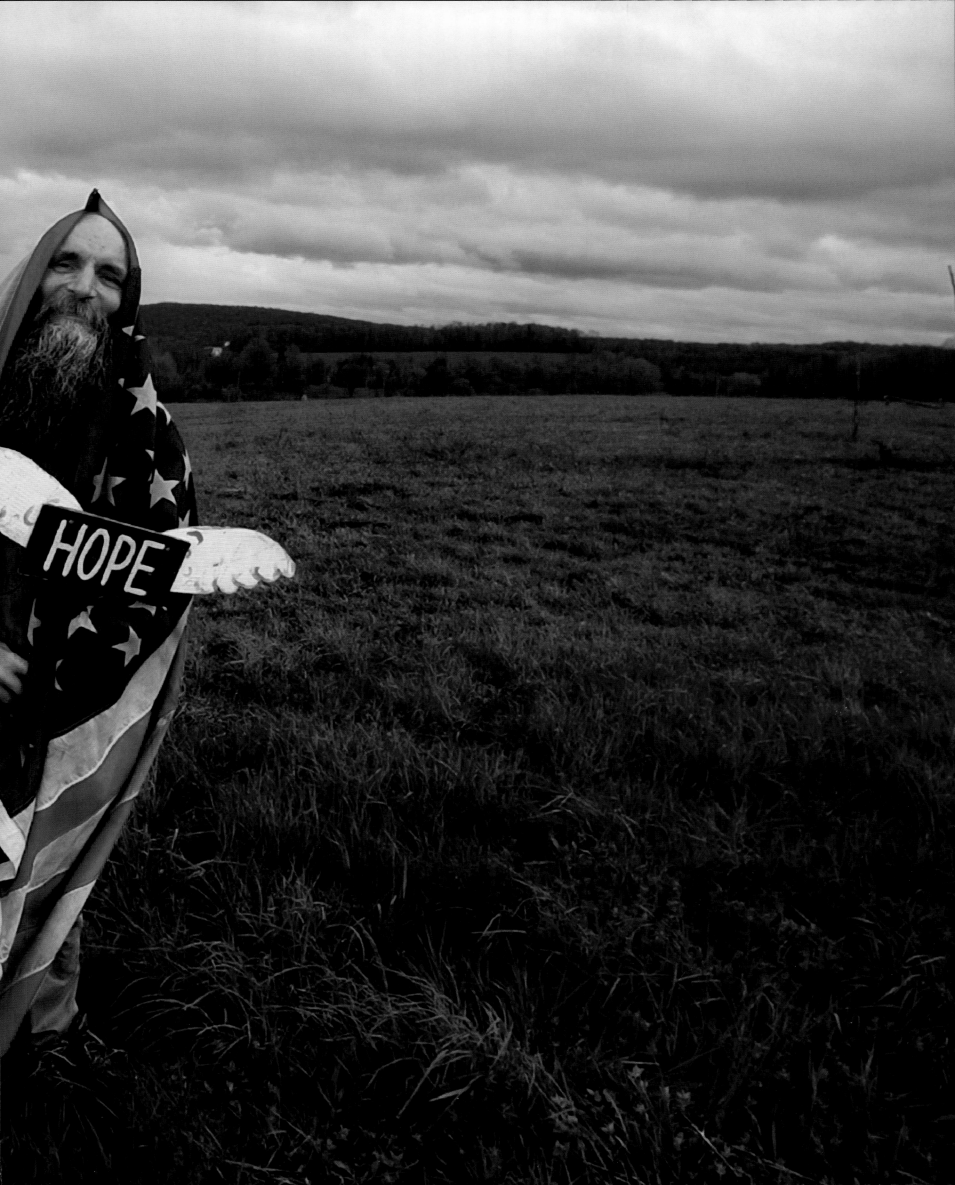

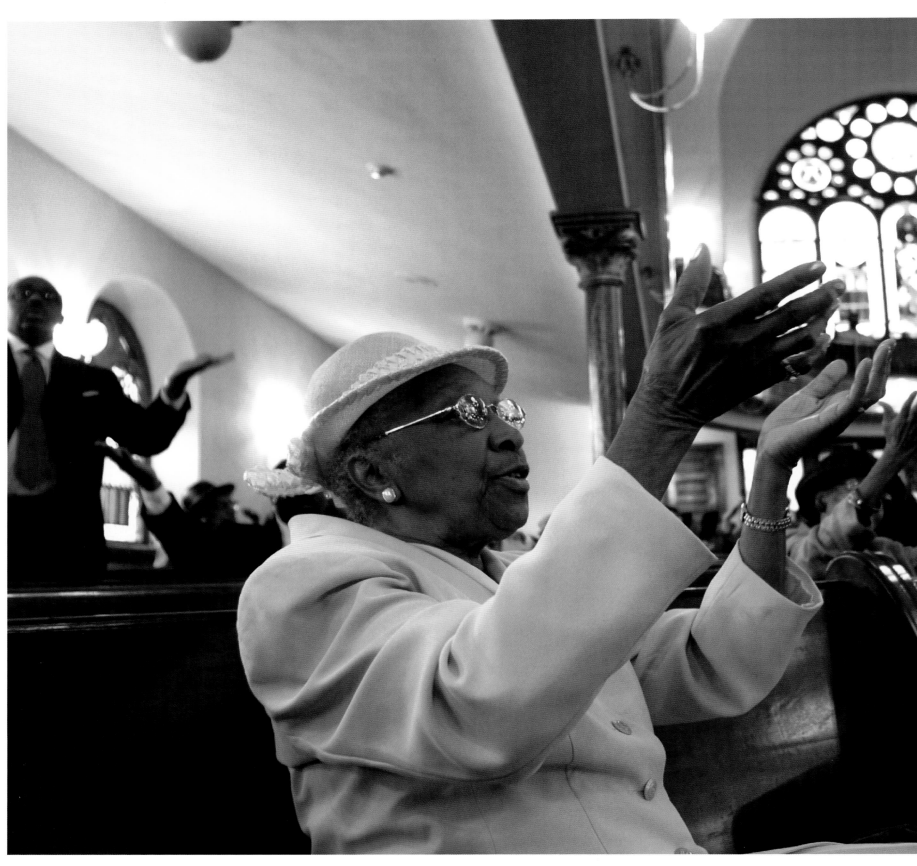

PHILADELPHIA
Since 1794, parishoners have raised their hands in praise at the Mother Bethel African Methodist Episcopal church, which sits on the oldest parcel of land continuously owned by African Americans. Freed slave Richard Allen bought the property on 6th and Lombard streets and founded the country's first A.M.E. congregation.
Photo by E.A. Kennedy 3rd, Image Works

PITTSBURGH

On Wednesday nights in the East End, East Liberty Presbyterian Church holds Taizé Sung Prayer services. As a response to the horrors of World War II, seminary student Roger Schultz founded a prayer community that chanted, prayed silently, and meditated in the Burgundian village of Taizé. Over the past 60 years, the Taizé movement has spread worldwide.

Photo by William D. Wade

WEST CHESTER

First Communion, second grade. St. Agnes School's kids are a wonderfully variegated bunch. From left to right: Kelly Donovan, Theresa Bayer, Andrew Johnson, Tomasz Kazimierczk, Giselle Hernandez, Mackenzie Kelly, Megan Desiderio, Charles Hess, Elaine Byerly, and Brendan Dougherty.

Photo by Vicki Valerio, The Philadelphia Inquirer

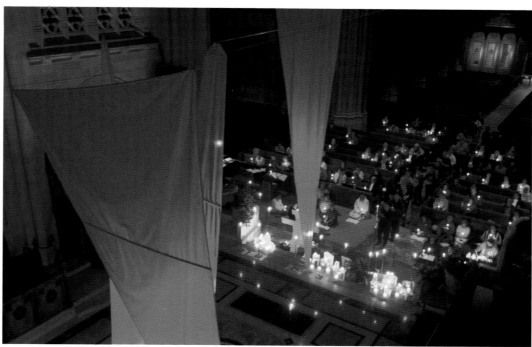

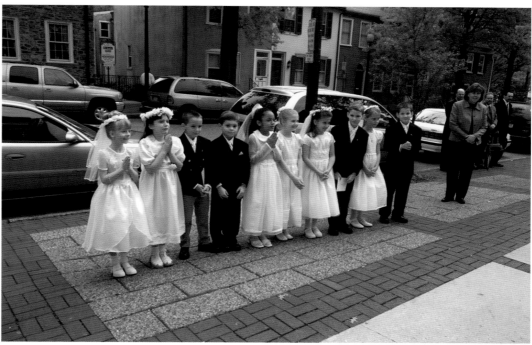

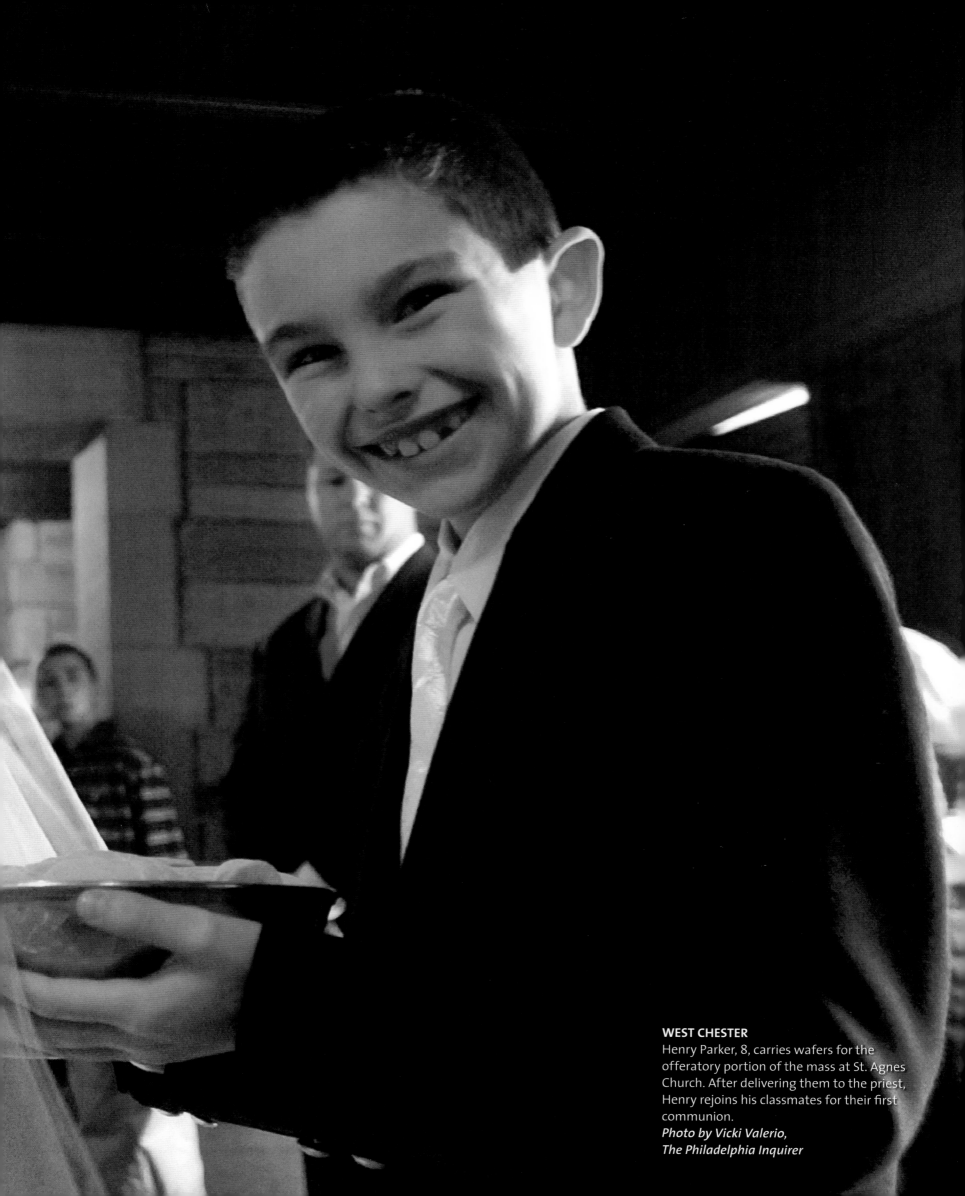

WEST CHESTER
Henry Parker, 8, carries wafers for the offeratory portion of the mass at St. Agnes Church. After delivering them to the priest, Henry rejoins his classmates for their first communion.
Photo by Vicki Valerio,
The Philadelphia Inquirer

GREENSBURG
Noah's Ark Child Center in rural western
Pennsylvania resulted from a need and a battle.
Parents very much wanted a day care center, but
who would organize and run it? Fingers pointed
to local mom Sue Miele, who resisted mightily.
"I fought this tooth and nail with God," she says.
She didn't want to be tied down. Fifty children
later...
Photo by Barry Reeger, Tribune-Review

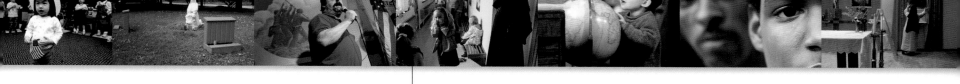

PORTAGE

Sister Maria Anna, 45, of the Congregation of the Sisters Servants of the Most Sacred Heart of Jesus, readies her kindergarten class for pickup at the end of the school day. After six years with Our Lady of the Sacred Heart School, she plans to relocate to Jamaica within the year to do missionary work.
Photo by Sean Stipp

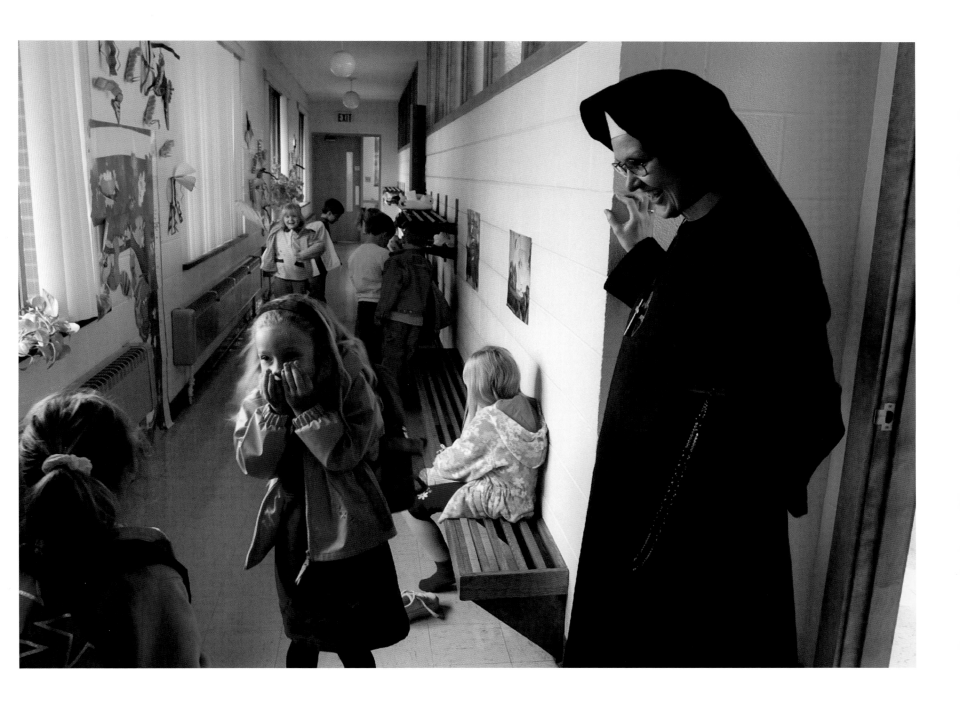

PITTSBURGH
Alexander Gertel and Eliahu Schachter, 11th-grade students at the Yeshiva Boys School, an Orthodox Jewish school in Squirrel Hill, do homework before heading home.
Photo by Scott Goldsmith

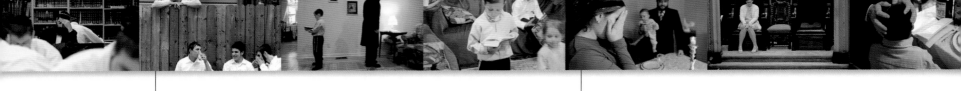

PITTSBURGH

Moshe Ringer, Yisrael Yakov Lokshin, Elisha Naiditch, and Shmuel David Toron of the Yeshiva Boys School in Squirrel Hill hang out during a recess between Sunday studies.
Photo by C. E. Mitchell

PITTSBURGH

Chava Tombosky covers her eyes after lighting the Shabbat candles. Husband Robbie holds their youngest, Meir. Every Friday, 18 minutes before sunset, the Tomboskys, members of the Lubavitch Hassidic sect, welcome the Jewish Sabbath with blessings and prayers. During the next 25 hours, they will not work, cook, or handle any electrical appliances.
Photo by Scott Goldsmith

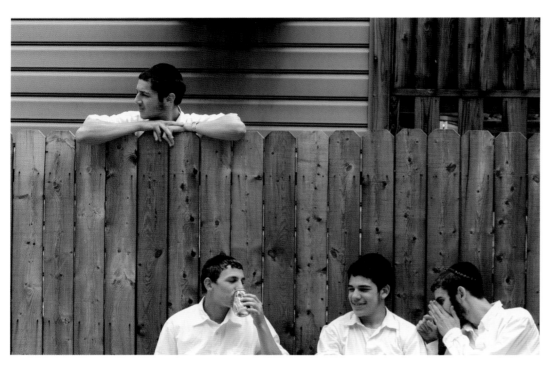

PITTSBURGH
After returning from synagogue on Friday night,
Yitzy Goldwasser and Robbie Tombosky listen as
Mordy Tombosky recites the *maariv*, or evening
prayer, following the lighting of the Shabbat
candles.
Photo by Scott Goldsmith

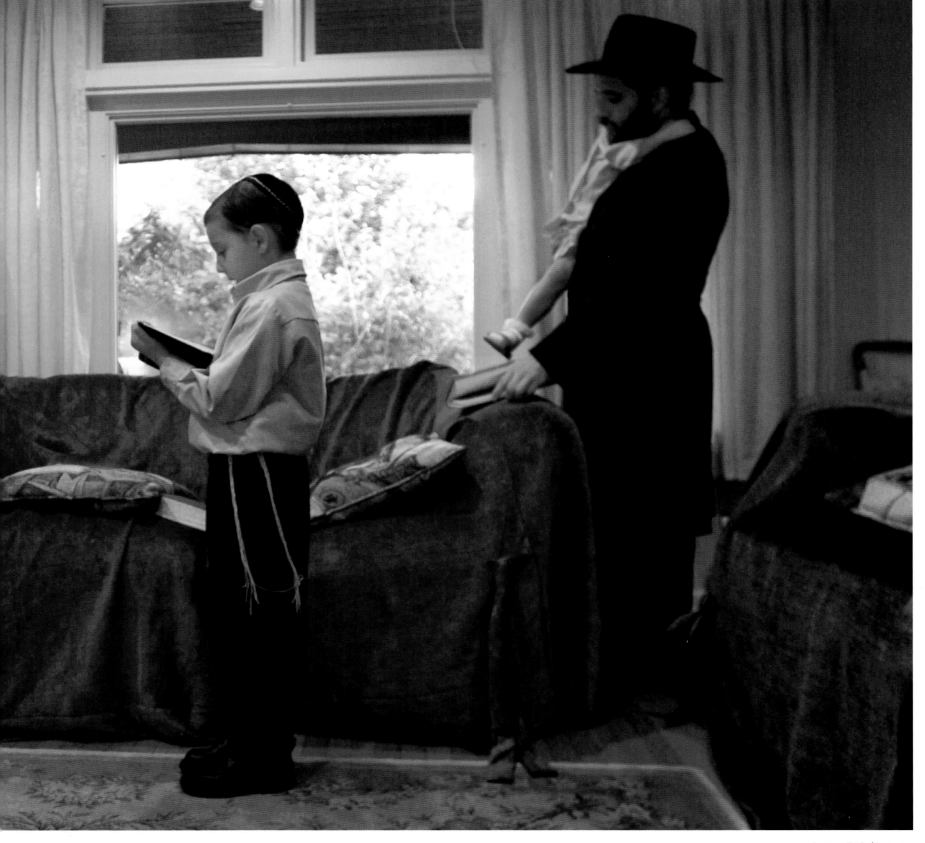

PHILADELPHIA

Lebanese teenagers Sawsan El-Hashash, 18, and Rayyan Shatila, 14, are Arab-American fashion plates. The two friends like to shop at the mall and watch the latest Hollywood movies—but never without their head scarves. "I feel more free here," says El-Hashash. "But I'm still Lebanese and I respect my culture."

Photos by E.A. Kennedy 3rd, Image Works

PHILADELPHIA

In West Philly's shopping district, women draped in the *hijab*, or head scarf, and dressed in Western and Islamic-style clothing reflect the degrees of religious observance of the neighborhood's Ahlus-Sunnah Wal Jama'ah mosque. The city's 85,000-strong Muslim community is divided between African Americans and Middle Eastern immigrants.

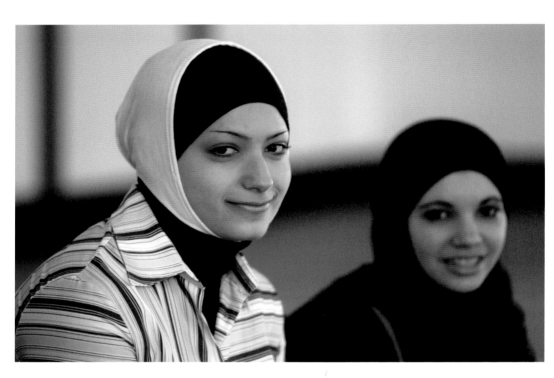

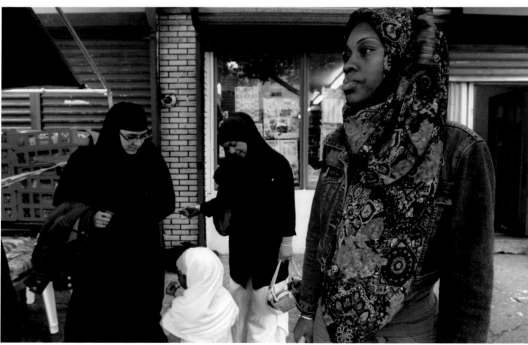

PHILADELPHIA
Full-time high school physics teacher and part-time imam Ali Ghazzawi counsels members of the Ahlus-Sunnah Wal Jama'ah mosque. The West Philadelphia temple's inclusive atmosphere draws a varied crowd of followers, 80 percent of whom are American-born.

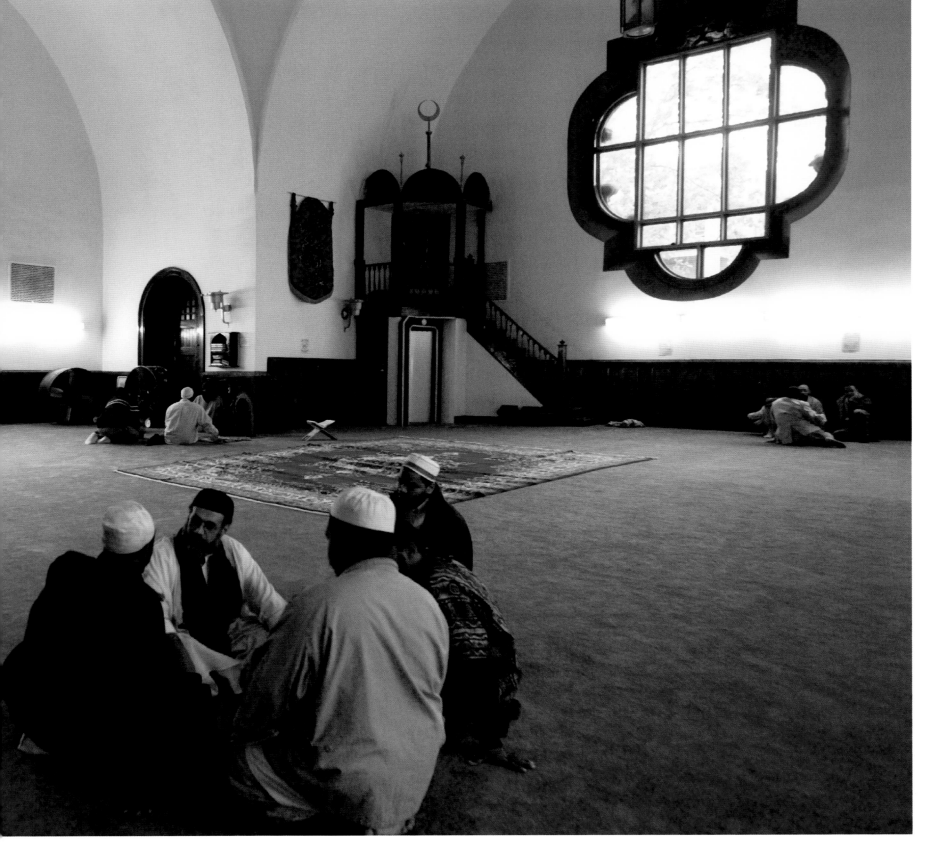

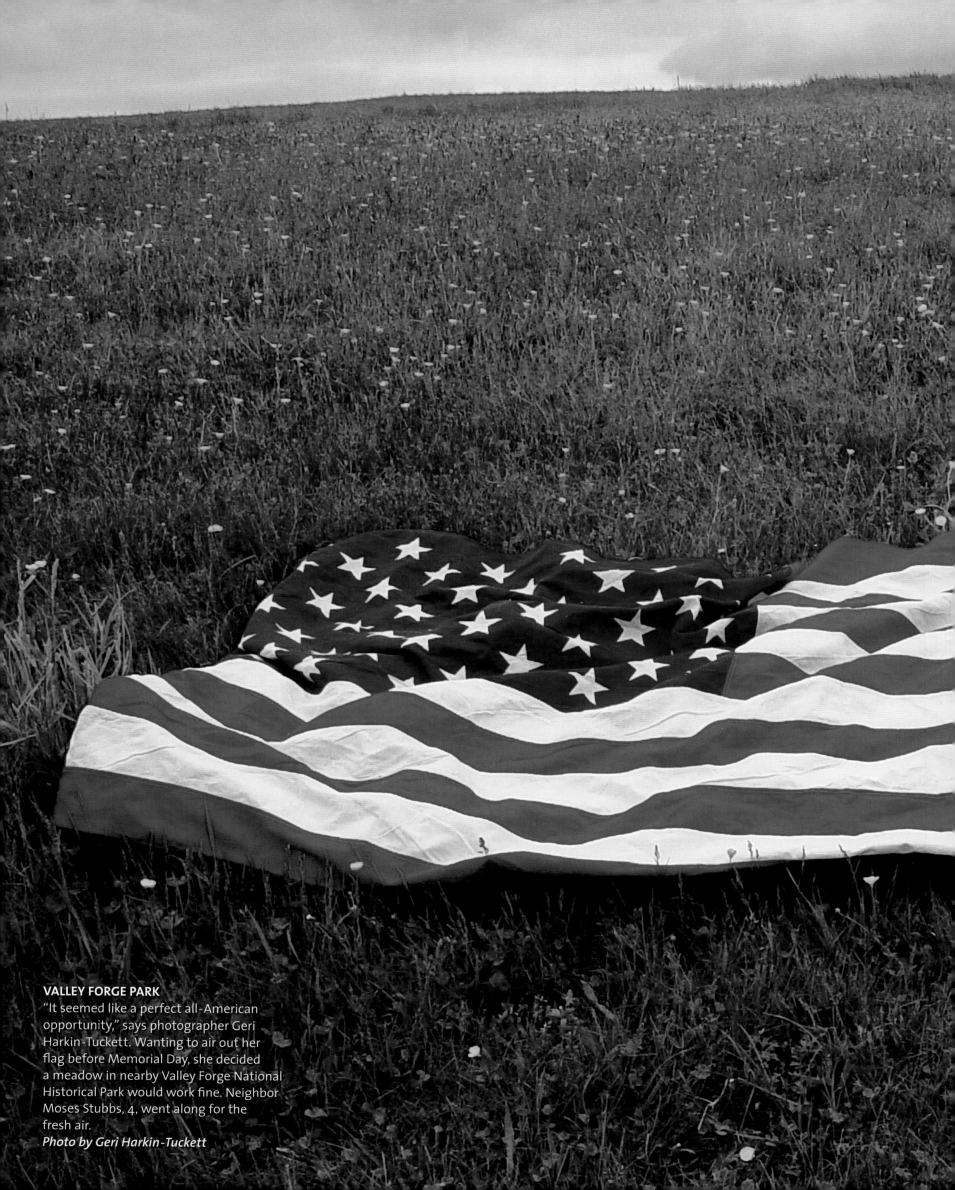

VALLEY FORGE PARK
"It seemed like a perfect all-American opportunity," says photographer Geri Harkin-Tuckett. Wanting to air out her flag before Memorial Day, she decided a meadow in nearby Valley Forge National Historical Park would work fine. Neighbor Moses Stubbs, 4, went along for the fresh air.
Photo by Geri Harkin-Tuckett

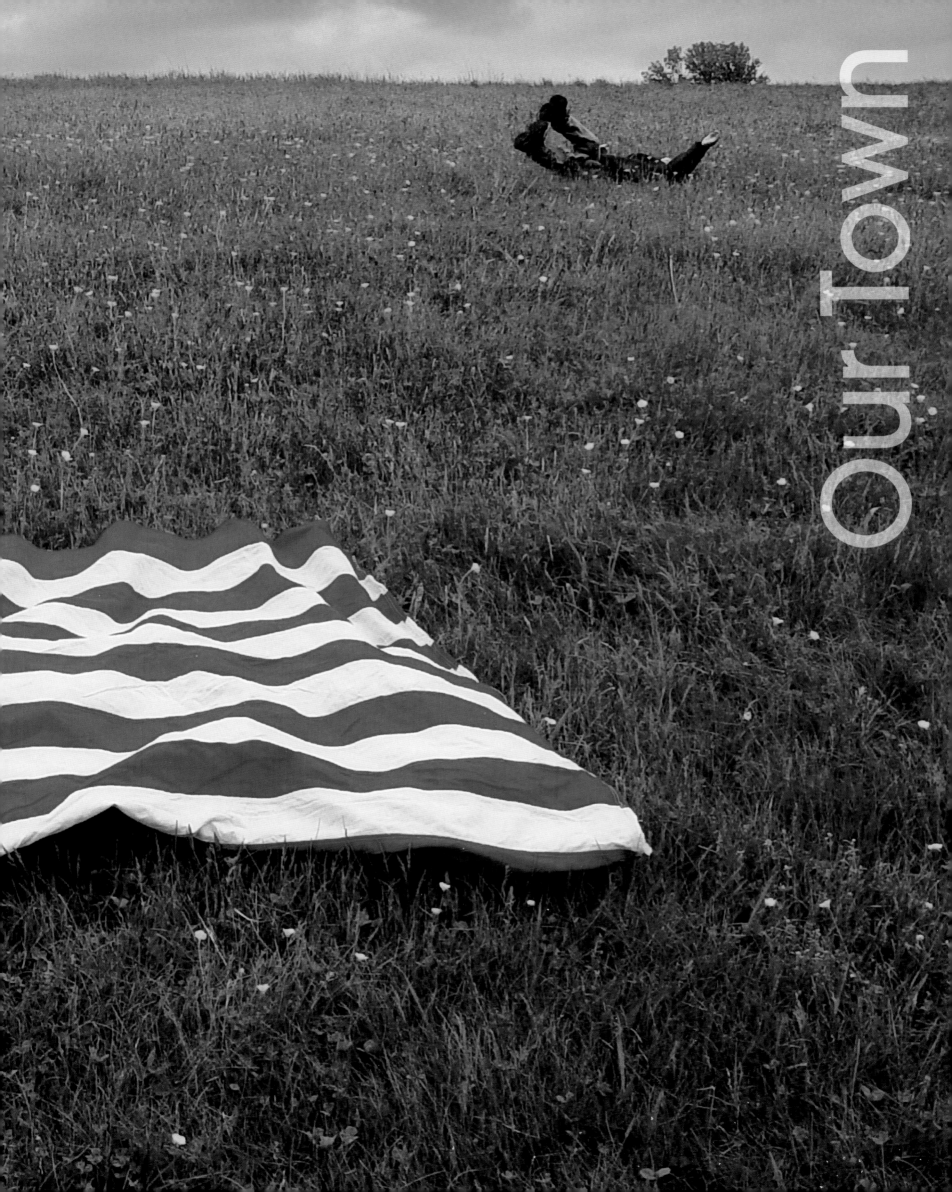

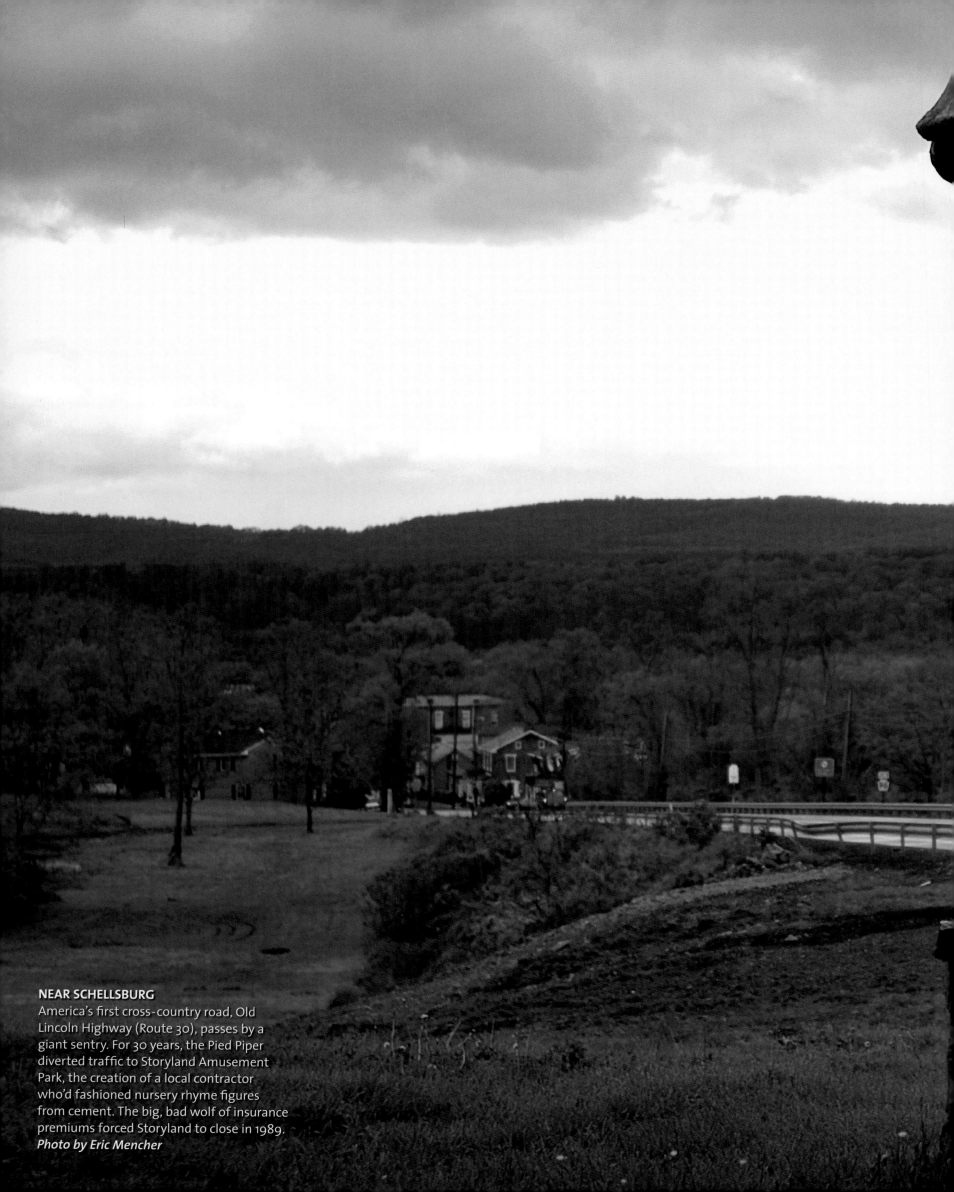

NEAR SCHELLSBURG
America's first cross-country road, Old Lincoln Highway (Route 30), passes by a giant sentry. For 30 years, the Pied Piper diverted traffic to Storyland Amusement Park, the creation of a local contractor who'd fashioned nursery rhyme figures from cement. The big, bad wolf of insurance premiums forced Storyland to close in 1989.
Photo by Eric Mencher

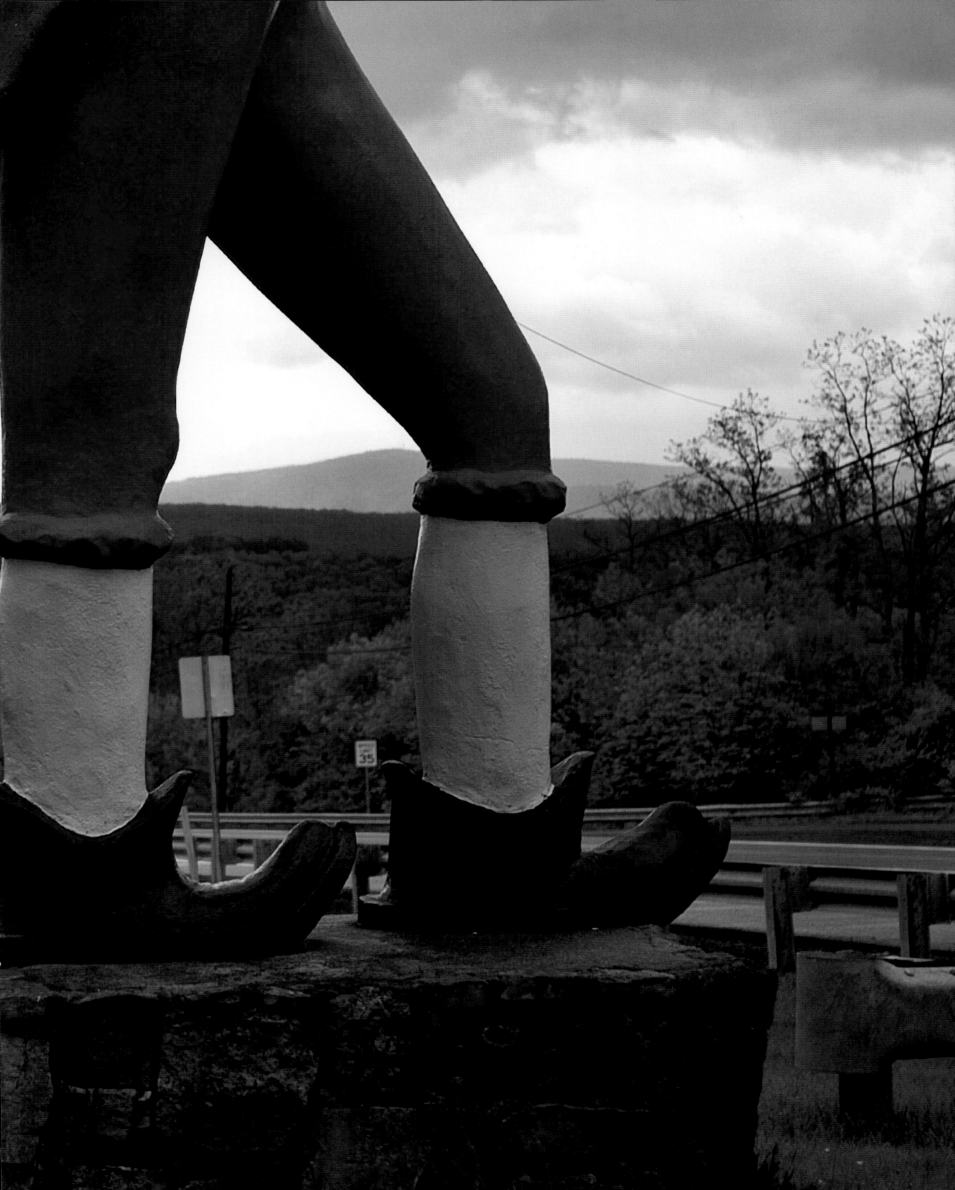

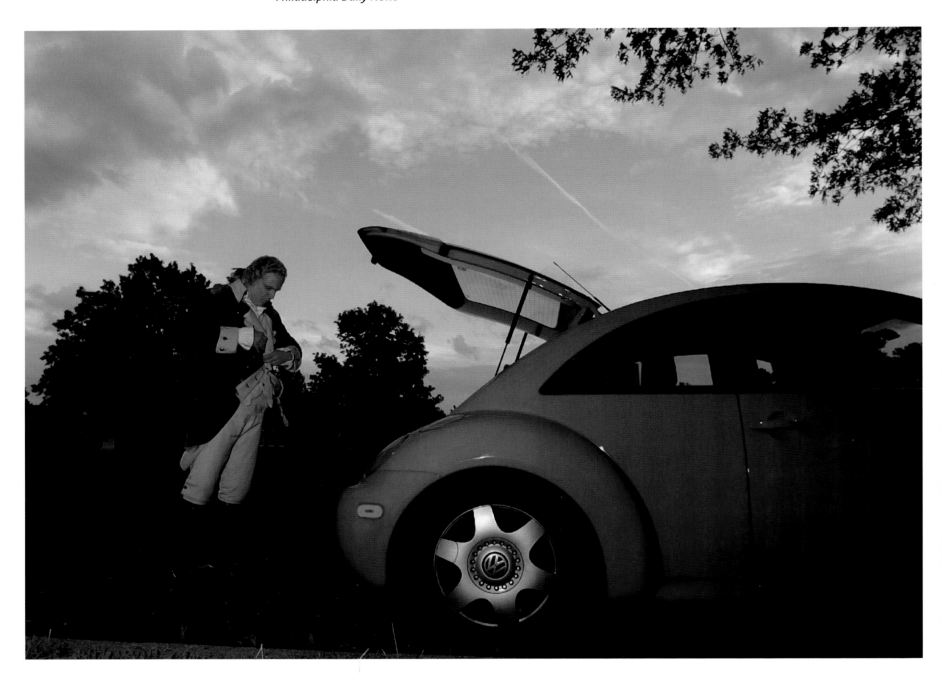

VALLEY FORGE

On his way to address schoolchildren at the Freedoms Foundation, former executive Dean Malissa cannot tell a lie. The Father of Our Country commutes to his scheduled appearances in a cherry red Volkswagen Beetle. No horse, no drum and fife. Malissa dresses before leaving home, but packs his accoutrements—coat, tricorn hat, sword—in the trunk.

Photos by David Maialetti,
Philadelphia Daily News

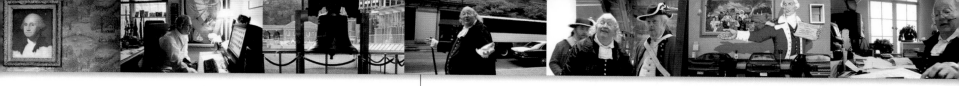

PHILADELPHIA

Ralph Archbold first morphed into Benjamin
Franklin in Michigan but moved to Philadelphia
where he found many more gigs. The full-time
Franklin impostor, caught walking down 12th Street
in downtown Philly, had just addressed the Society
of Cable Telecommunications Engineers convention.
It was an appropriate fit for the Founding Father
whose enlightened curiosity led to numerous
original observations on the nature of electricity.

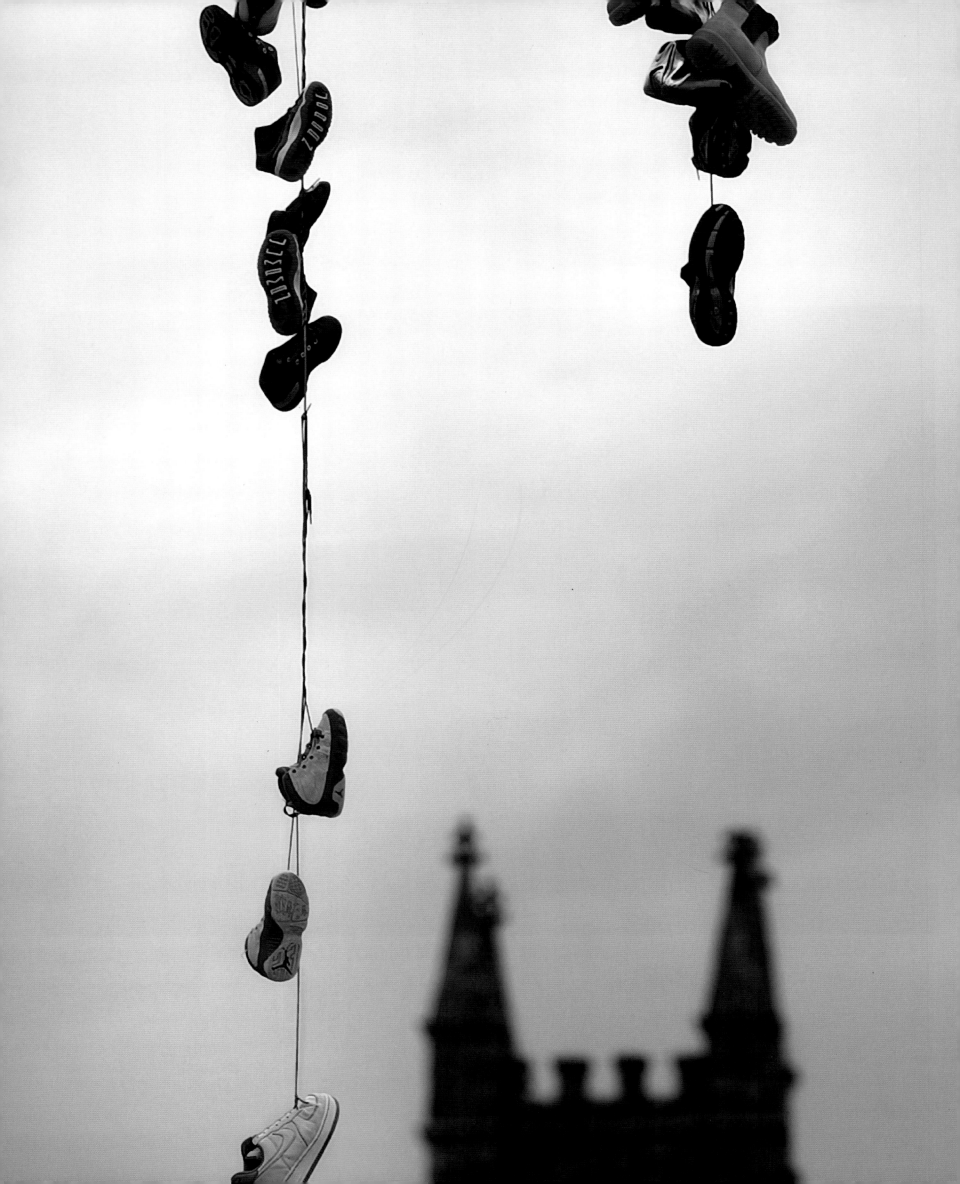

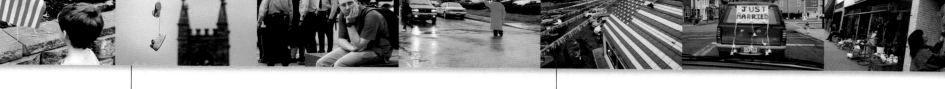

PHILADELPHIA

Saving soles: Lehigh Avenue is ground zero for the 20-year-old local habit of snagging pairs of shoes on overhead lines. Urban anthropologists say the inscrutable ritual celebrates just about anything.

Photo by Eric Mencher

PHILADELPHIA

The roof of Any Auto Outlet was covered in red tiles when Steve Cherkas bought it in 1999. Gazing at it from across the street one day, he realized the rows would lend themselves to an American flag pattern. He wanted commuters on the L-train to get the message that he's proud to be an American.

Photo by Nick Kelsh

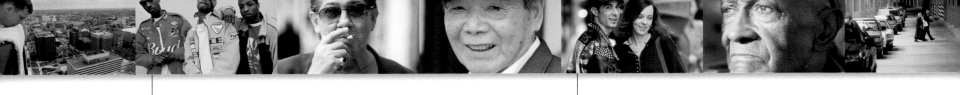

PHILADELPHIA

Members of the Harlem-based rap group
J-Harlem Killa-Dyce G-No flaunt their new Enyce
and Rocawear jackets, which were bought for a
promotional photo shoot in South Philly. After
the shoot, the artists—Raymond Dyson, Eugene
Irby and Jahah Duncan—hung out on South
Street, hoping to attract "some Philadelphia
ladies."
Photo by Jennifer Midberry,
Philadelphia Daily News

PHILADELPHIA

Nori and Heather Wechsler's attire is par for
the course on South Street, Philadelphia's most
colorful boulevard. The newlyweds moved to
the city from New Hampshire so Nori could
study painting at University of the Arts. The
best part about their new home is "hands down,
Philadelphia cheesesteaks."
Photo by E.A. Kennedy 3rd, Image Works

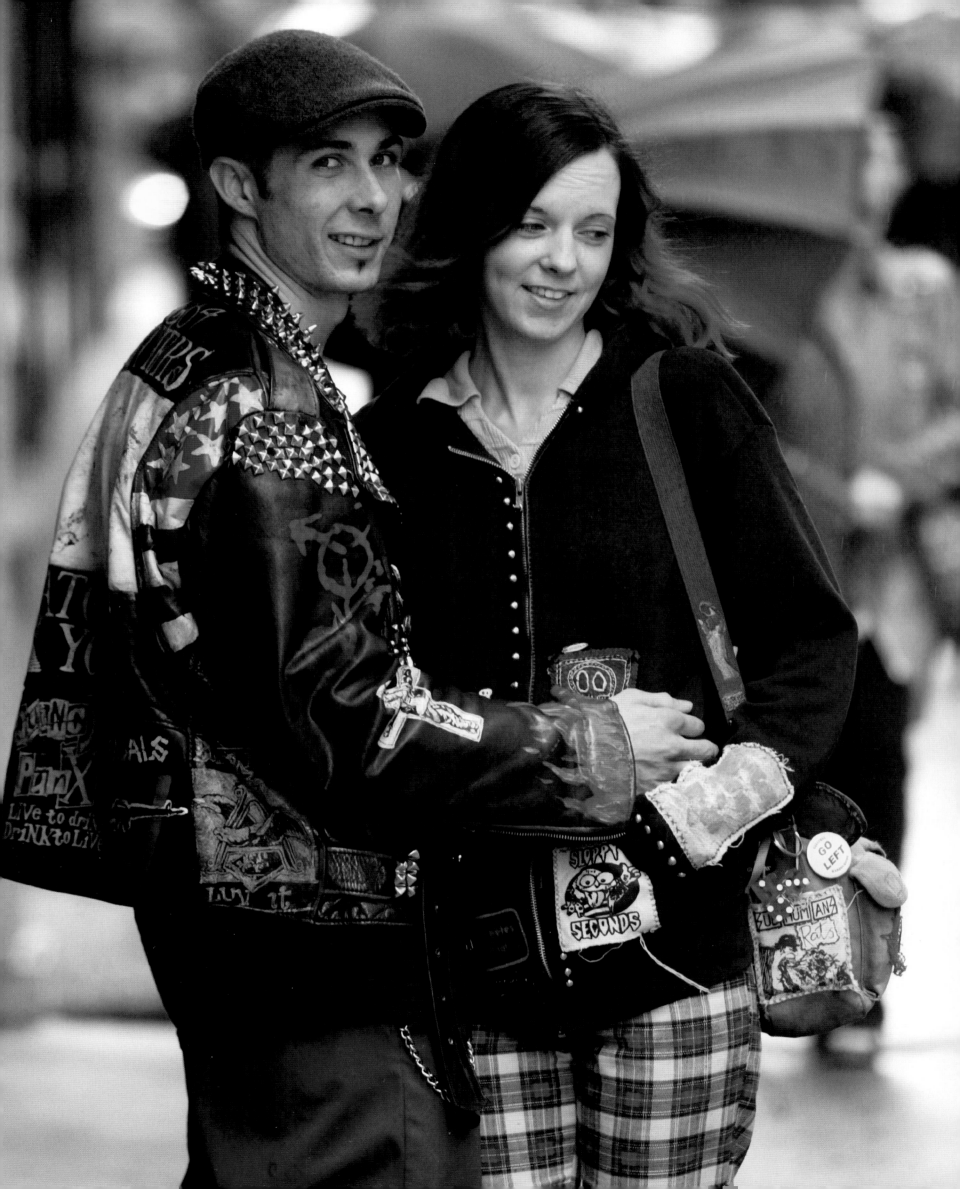

PHILADELPHIA

A mural painted in 1995 after the death of former mayor Frank Rizzo broadcasts his continuing popularity on his South Philly home turf. Mexico-born Ricardo Molanco, who works for Di Bruno Brothers bakery, heard that Rizzo was "fine with everyone." Among friends, the cop turned police commissioner turned mayor (1971 to 1979) was called the Big Bambino.

Photos by David Maialetti,
Philadelphia Daily News

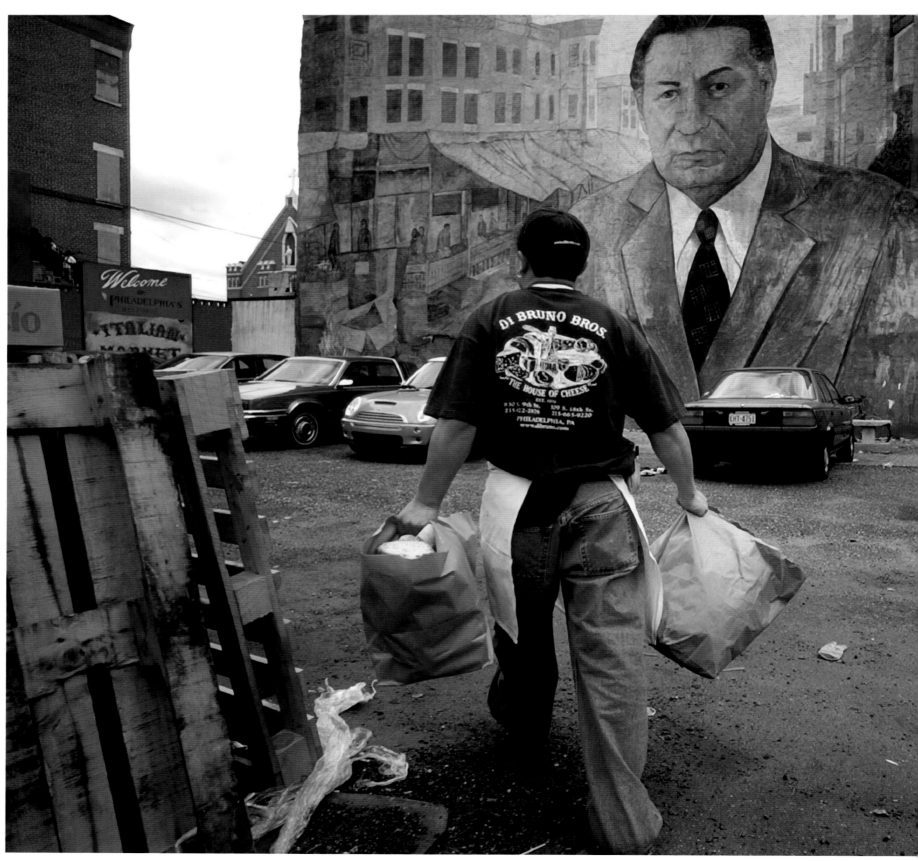

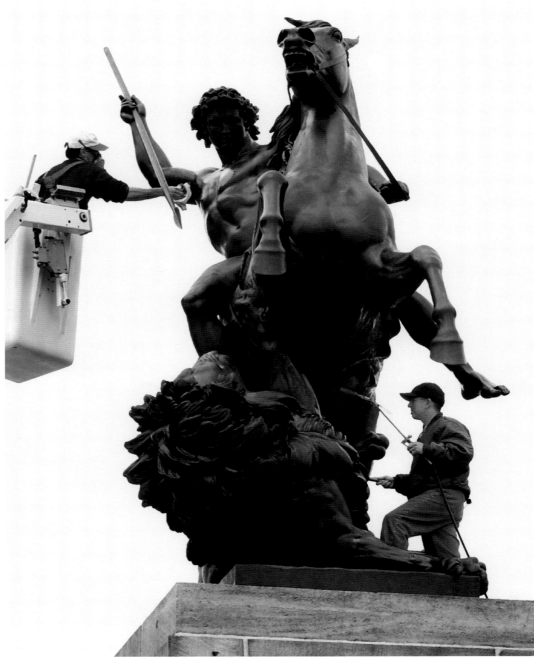

BRADDOCK

U.S. Steel's Edgar Thomson plant, or "ET," was Andrew Carnegie's first steel mill, thrown together in 1875 to feed the American appetite for more railroad tracks. In a bit of Carnegie-style pandering, the mill was named for the president of Pennsylvania Railroad, which five years later would be the largest corporation in the world.
Photo by Steve Mellon, Pittsburgh Post-Gazette

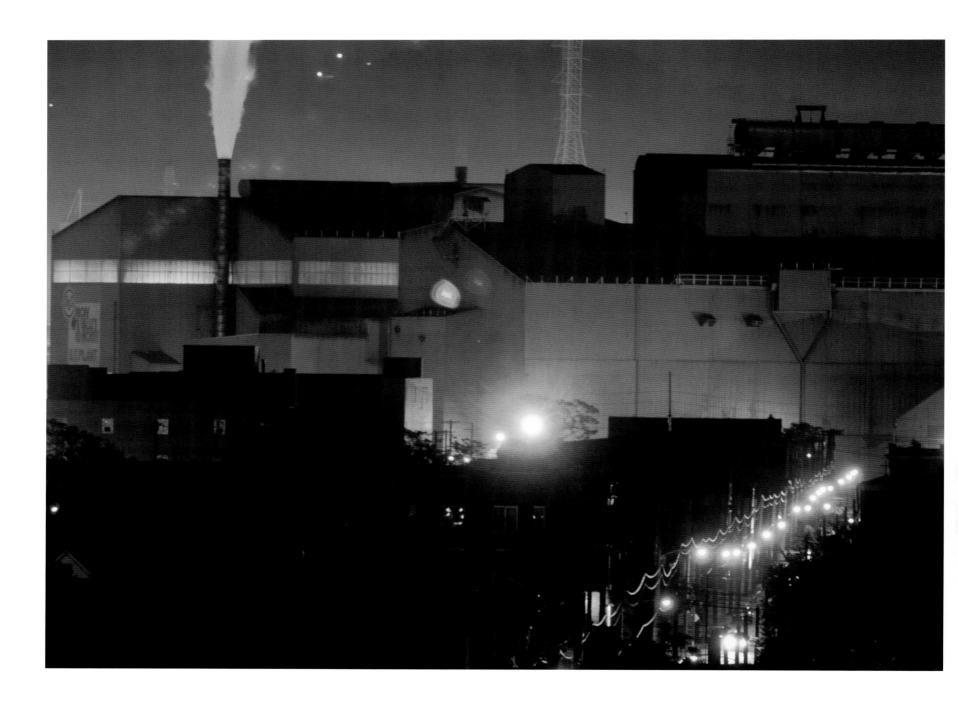

SCHELLSBURG

The Lutheran and Reform congregations who built Schellsburg's Union Church in 1806 must have been a hardy group; for the church's first three years, they had neither a stove nor benches. Worshippers sat on logs. Union is said to be the first Protestant church west of the Susquehanna River.

Photo by Eric Mencher

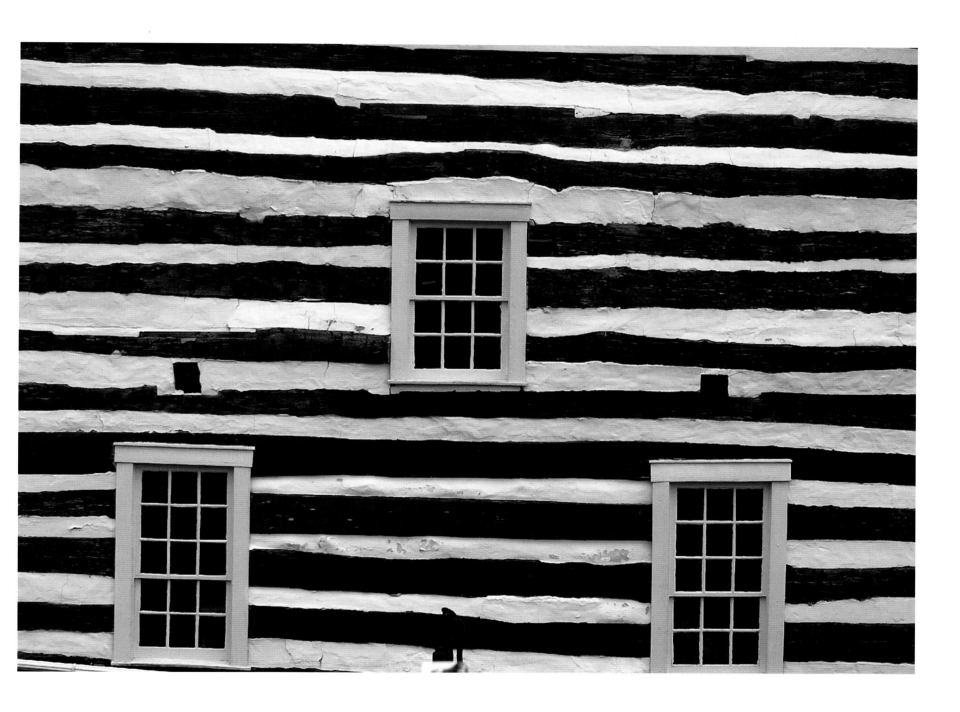

PHILADELPHIA

A restroom designed to look like the bottom of a swimming pool was not enough to keep the restaurant, Trust, afloat. It went out of business a month after this photograph was taken. The announcement of the closure was quickly followed by one of a possible reopening under another name.

Photos by Vicki Valerio, The Philadelphia Inquirer

PHILADELPHIA

Why is my sushi cobalt? Because at Morimoto Restaurant, computer-generated LED lighting constantly changes the wash of light in the dining area. The restaurant is named for its chef, Masaharu Morimoto, who left his home in Hiroshima to seek fortune and fame in fusion cuisine. He succeeded. Morimoto is best known as the Japanese Iron Chef on the television show *The Iron Chef.*

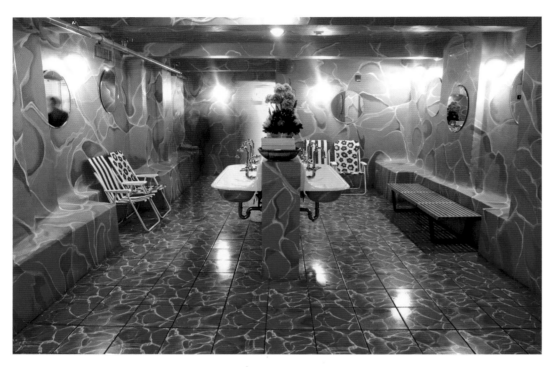

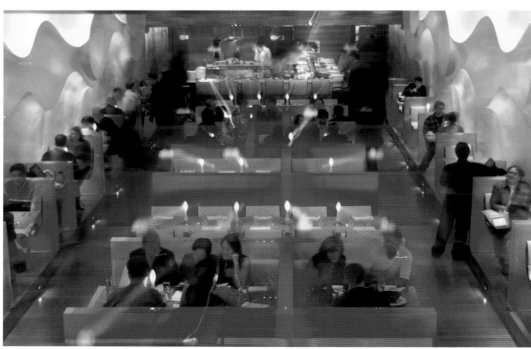

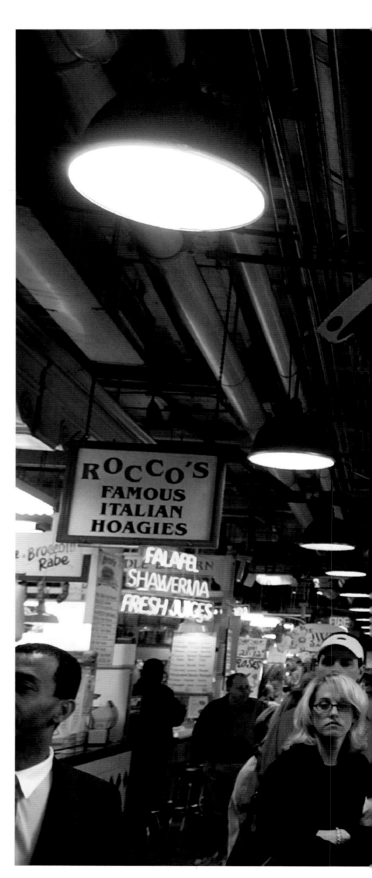

PHILADELPHIA

When Rick Olivieri bought the business his grand-father started in 1932, he changed the name from Olivieri's to Rick's. He added a neon sign and now commits Philadelphia culinary felonies. He makes versions of Philly cheesesteaks for vegetarians and for people on the Atkins or South Beach diets. Traditionalists can still order the standard: beef and Cheez Whiz on a roll.

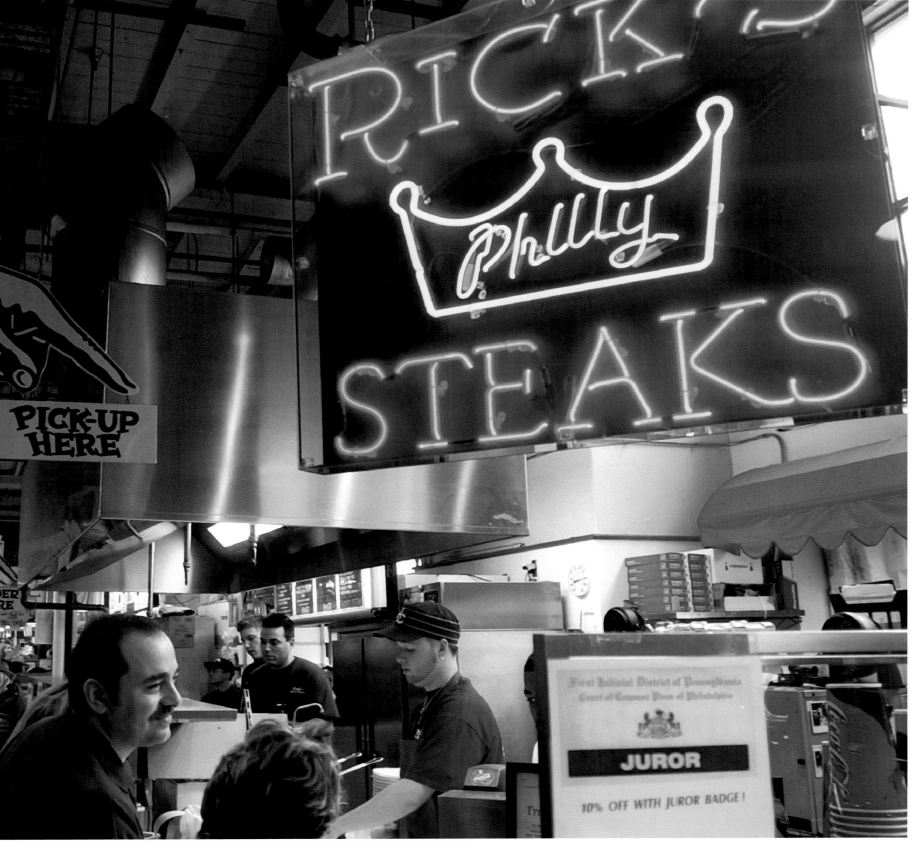

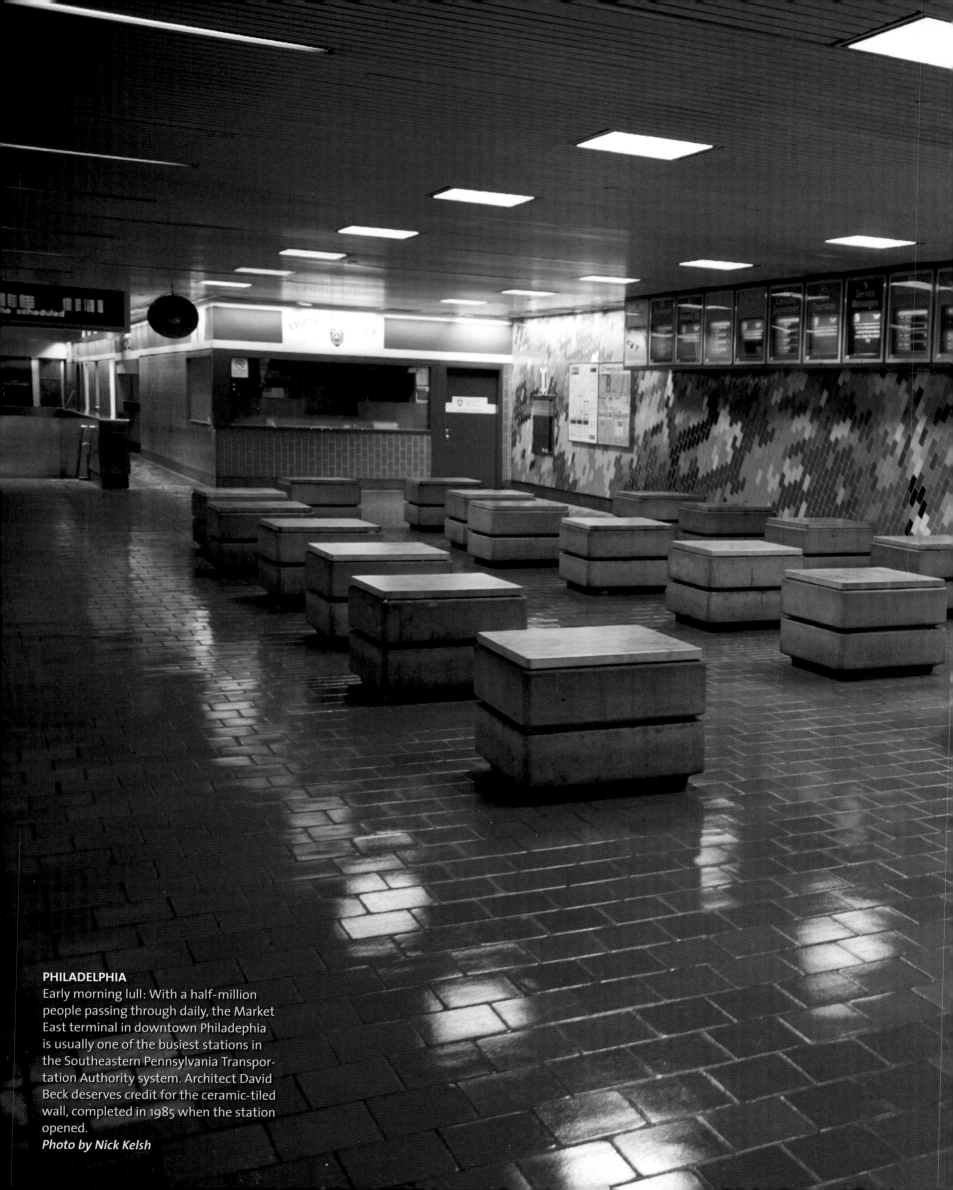

PHILADELPHIA
Early morning lull: With a half-million people passing through daily, the Market East terminal in downtown Philadephia is usually one of the busiest stations in the Southeastern Pennsylvania Transportation Authority system. Architect David Beck deserves credit for the ceramic-tiled wall, completed in 1985 when the station opened.
Photo by Nick Kelsh

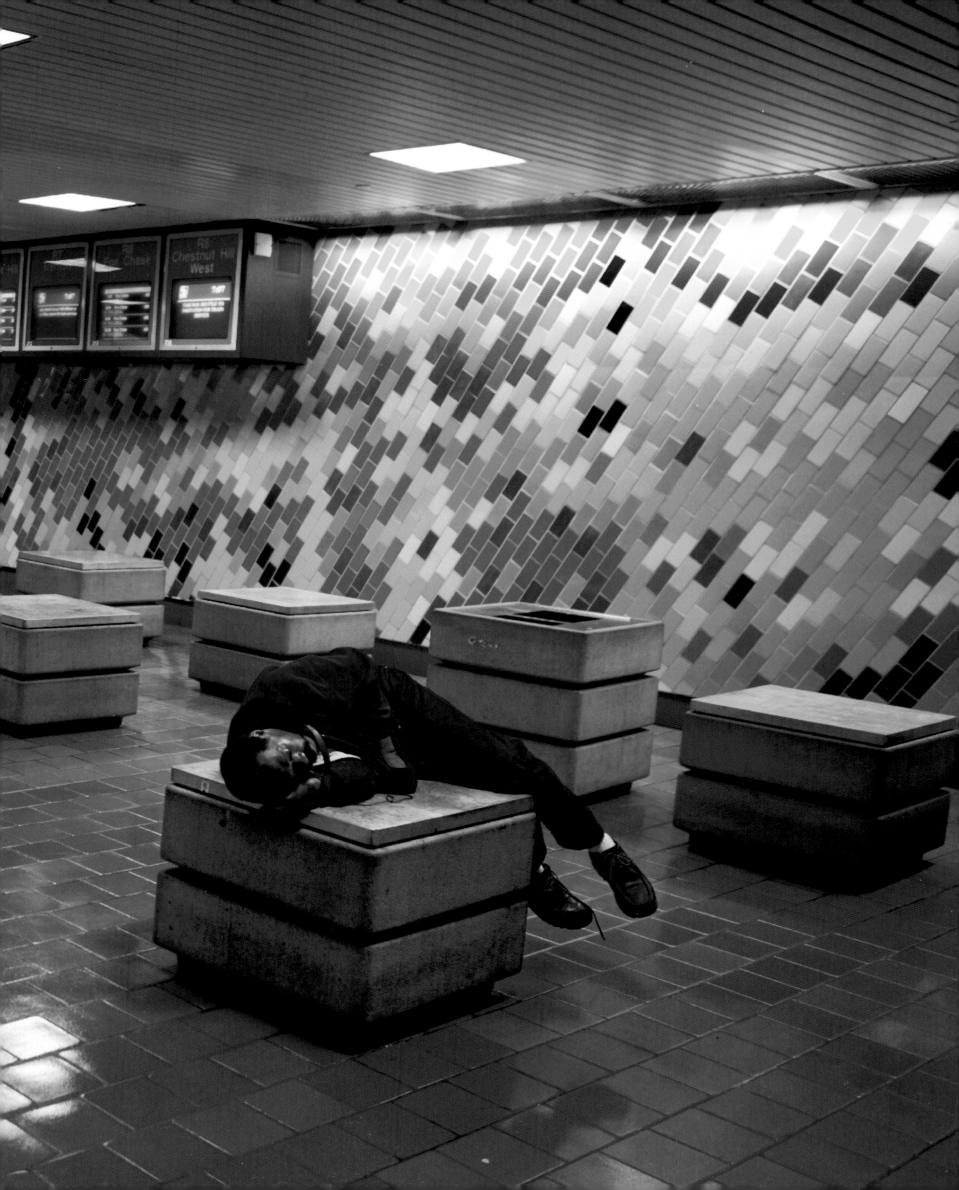

LANCASTER COUNTY

In Churchtown, the lunchtime softball game is a coed affair for a mix of Amish and Mennonite students attending the green schoolhouse. Amish and Mennonite communities usually stay separate, unless their numbers are low or they're both of the Old Order conservative branches.

Photo by Ian Macdonald-Smith

MARTINDALE

And the runners advance. These teenage players come from farms around the predominantly Mennonite town. A few of the boys confided to photographer Scott Goldsmith that they wanted to talk with some of the onlookers but were too nervous.

Photo by Scott Goldsmith

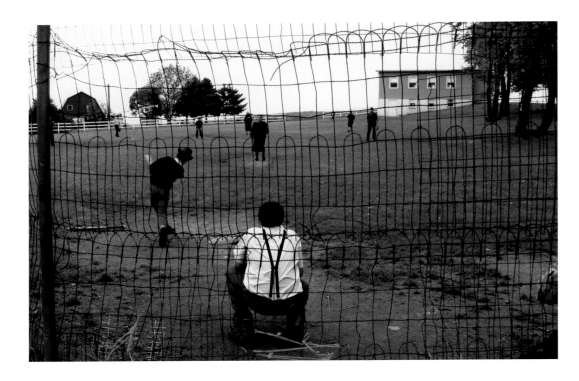

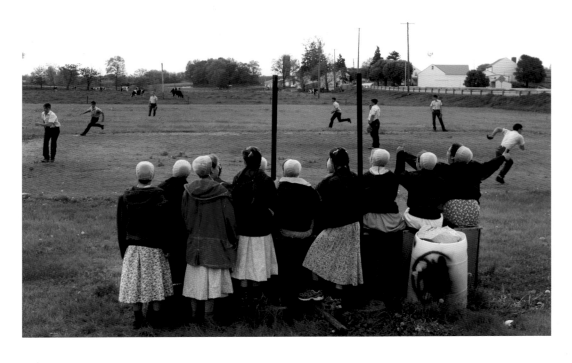

QUAKERTOWN
Rollerblading friends Amanda Bridge, 16, and
Annette Miller, 20, get rolling anytime they can.
Amanda, who received her first blades from her
grandmother, just bought a new pair with money
saved from her weekend job at a nursing home.
She and Annette don't fall much during regular
runs, she says, but jumping "hasn't worked out."
Photo by Yoni Brook

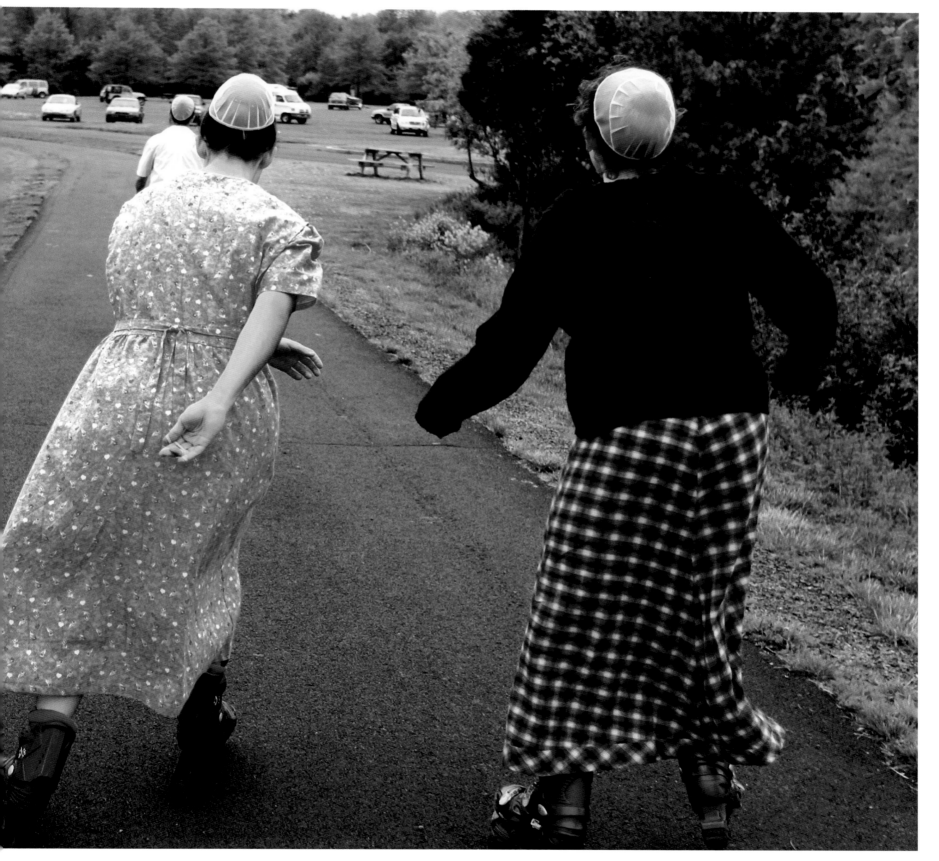

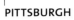

PITTSBURGH
Created for the Mattress Factory Museum by
noted installation artist James Turrell, *Rise*
changes color in a 10-minute cycle. Located in
the Mexican War Streets neighborhood, the
museum attracts 30,000 visitors a year. It was
once the warehouse for the Stearns & Foster
mattress company.
Photo by Annie O'Neill

BREEZEWOOD

Even the most seasoned motorist is challenged by the intersection of Interstate 70, Interstate 76, and the Pennsylvania Turnpike.
Photo by Eric Mencher

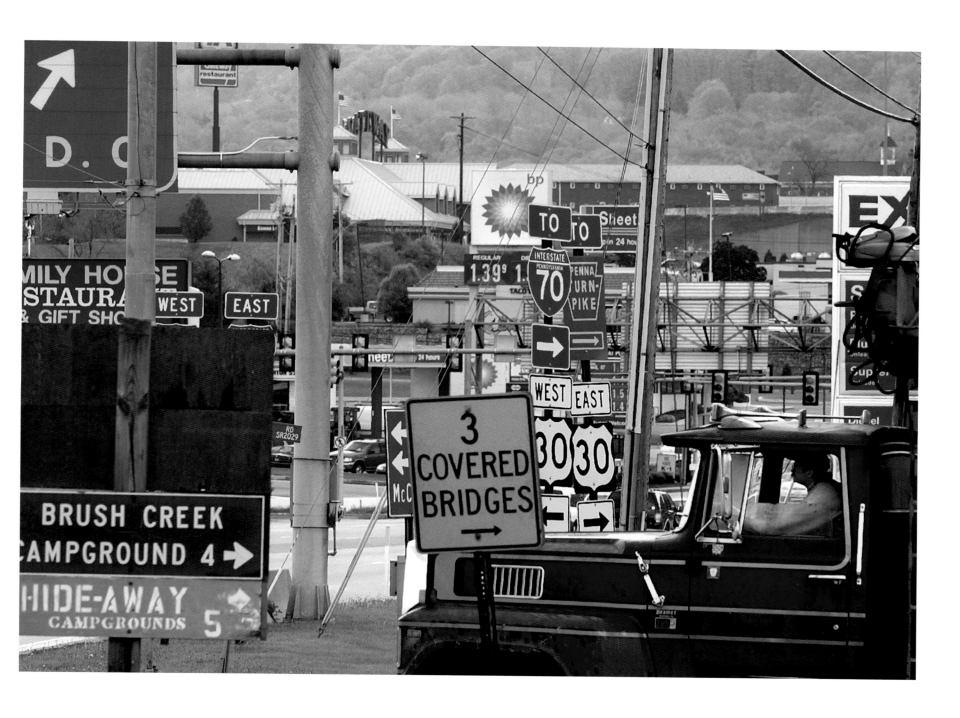

WRIGHTSVILLE

Confederate troops were across the Mason-Dixon Line, heading west to Gettysburg. They planned to cross the Susquehanna at a bridge in the town of Wrightsville. Union troops were ready but outnumbered. The skirmish that ensued gave local carpenters and other townsmen time to reach the bridge and detonate it. A memorial marks their daring.

Photos by Eric Mencher

GETTYSBURG

One among many. The inscription on the battle monument to the 111th New York Infantry volunteers is typically understated. It says the Union soldiers took a position at Ziegler's Grove from the evening of July 2 "to close of battle," two bloody days later. Of the 390 men who fought with the 111th in Gettysburg, 72 were killed or missing and 177 were wounded.

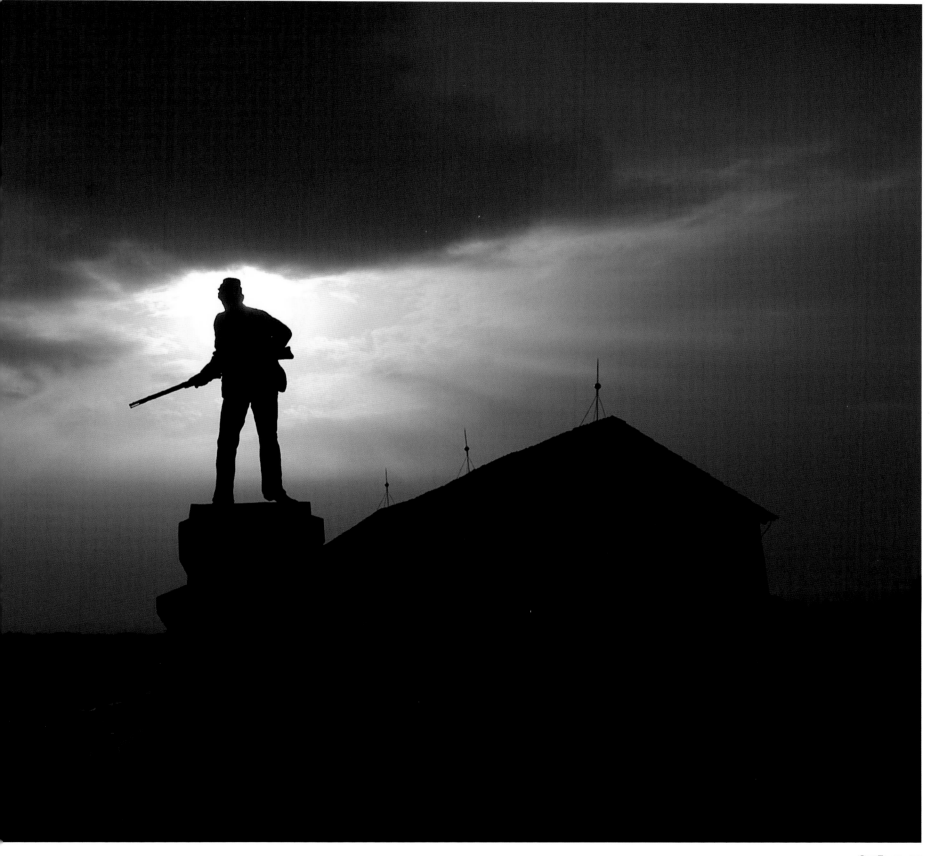

SHARTLESVILLE

Class trip: After a tour of Roadside America's miniature village, first-graders from Perry Elementary School in Shoemakersville reach the finale. Lights dim. A scratchy recording of Kate Smith's "God Bless America" blares. The children stand, put their hands over their hearts, and sing along.

Photo by Frank Wiese, The Morning Call

The week of May 12-18, 2003, more than 25,000 professional and amateur photographers spread out across the nation to shoot over a million digital photographs with the goal of capturing the essence of daily life in America.

The professional photographers were equipped with Adobe Photoshop and Adobe Album software, Olympus C-5050 digital cameras, and Lexar Media's high-speed compact flash cards.

The 1,000 professional contract photographers plus another 5,000 stringers and students sent their images via FTP (file transfer protocol) directly to the *America 24/7* website. Meanwhile, thousands of amateur photographers uploaded their images to Snapfish's servers.

At *America 24/7*'s Mission Control headquarters, located at CNET in San Francisco, dozens of picture editors from the nation's most prestigious publications culled the images down to 25,000 of the very best, using Photo Mechanic by Camera Bits. These photos were transferred into Webware's ActiveMedia Digital Asset Management (DAM) system, which served as a central image library and enabled the designers to track, search, distribute, and reformat the images for the creation of the 51 books, foreign language editions, web and magazine syndication, posters, and exhibitions.

Once in the DAM, images were optimized (and in some cases resampled to increase image resolution) using Adobe Photoshop. Adobe InDesign and Adobe InCopy were used to design and produce the 51 books, which were edited and reviewed in multiple locations around the world in the form of Adobe Acrobat PDFs. Epson Stylus printers were used for photo proofing and to produce large-format images for exhibitions. The companies providing support for the *America 24/7* project offer many of the essential components for anyone building a digital darkroom. We encourage you to read more on the following pages about their respective roles

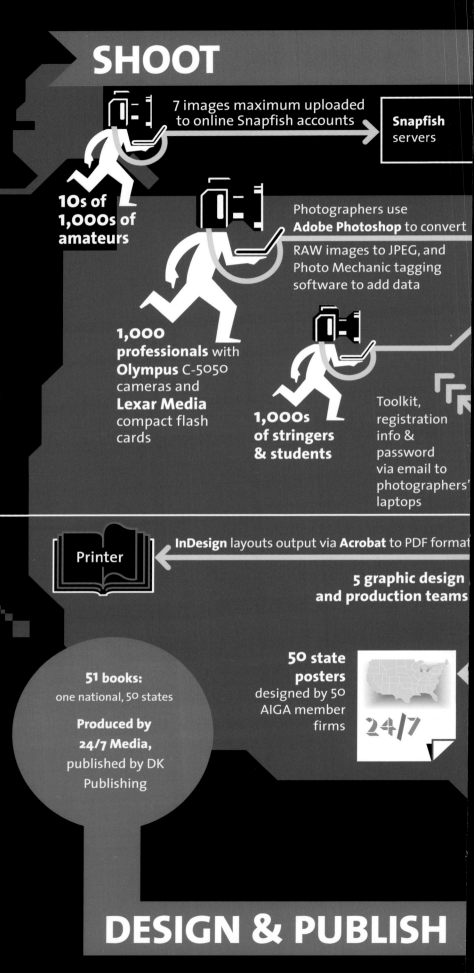

SHOOT

7 images maximum uploaded to online Snapfish accounts → **Snapfish** servers

10s of 1,000s of amateurs

Photographers use **Adobe Photoshop** to convert RAW images to JPEG, and Photo Mechanic tagging software to add data

1,000 professionals with **Olympus** C-5050 cameras and **Lexar Media** compact flash cards

1,000s of stringers & students

Toolkit, registration info & password via email to photographers' laptops

InDesign layouts output via **Acrobat** to PDF format

Printer

5 graphic design and production teams

51 books: one national, 50 states

Produced by 24/7 Media, published by DK Publishing

50 state posters designed by 50 AIGA member firms

24/7

DESIGN & PUBLISH

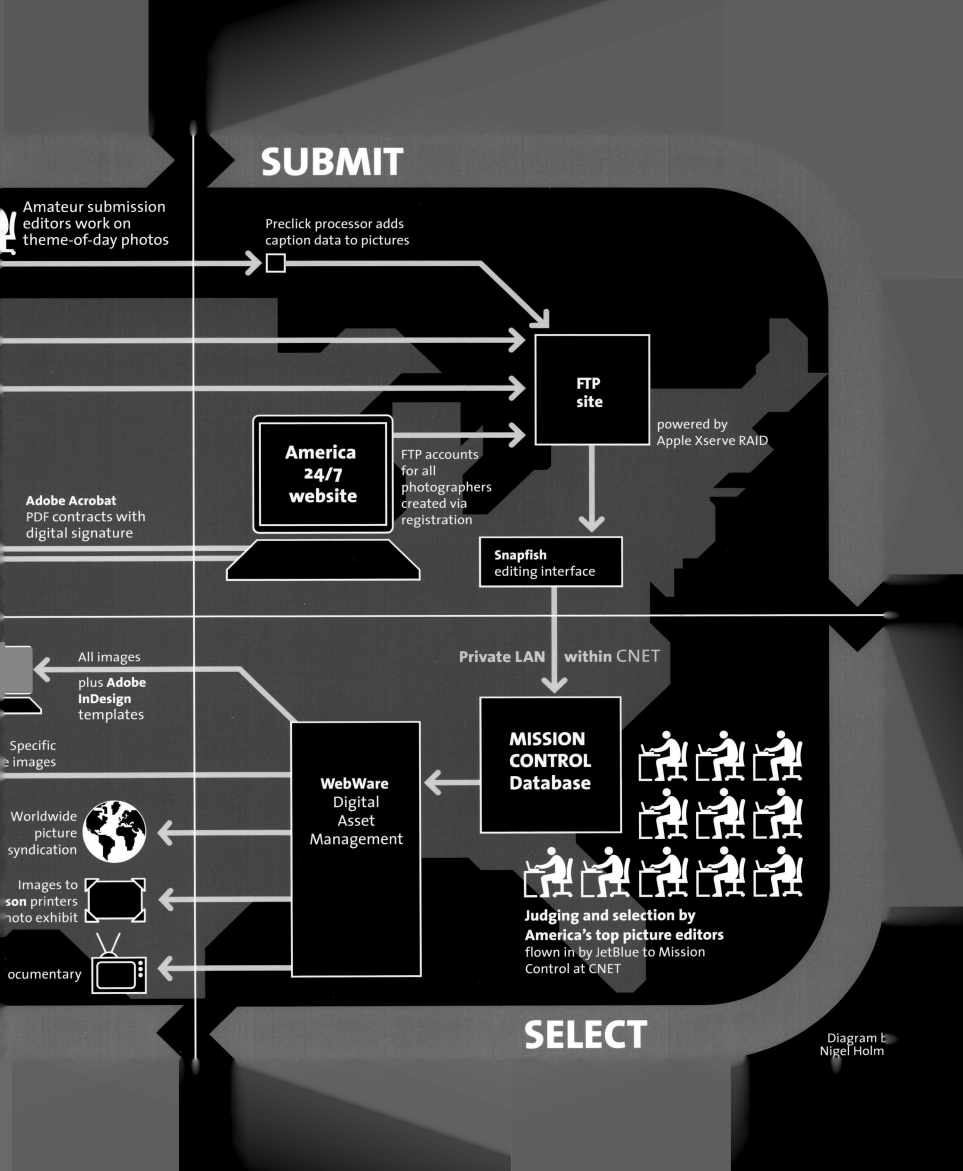

SUBMIT

Amateur submission editors work on theme-of-day photos

Preclick processor adds caption data to pictures

FTP site

powered by Apple Xserve RAID

America 24/7 website

FTP accounts for all photographers created via registration

Adobe Acrobat PDF contracts with digital signature

Snapfish editing interface

All images

plus **Adobe InDesign** templates

Specific e images

Private LAN **within** CNET

MISSION CONTROL Database

WebWare Digital Asset Management

Worldwide picture syndication

Images to son printers noto exhibit

ocumentary

Judging and selection by America's top picture editors flown in by JetBlue to Mission Control at CNET

SELECT

Diagram b Nigel Holm

About Our Sponsors

America 24/7 gave digital photographers of all levels the opportunity to share their visions of what it means to live in the United States. This project was made possible by a digital photography revolution that is dramatically changing and improving picture-taking for professionals and amateurs alike. And an Adobe product, Photoshop®, has been at the center of this sea change.

Adobe's products reflect our customers' passion for the creative process, be it the photographer, graphic designer, layout artist, or printer. Adobe is the Publishing and Imaging Software Partner for *America 24/7* and products such as Adobe InDesign®, Photoshop, Acrobat®, and Illustrator® were used to produce this stunning book in a matter of weeks. We hope that our software has helped do justice to the mythic images, contributed by well-known photographers and the inspired hobbyist.

Adobe is proud to be a lead sponsor of *America 24/7*, a project that celebrates the vibrancy of the American spirit: the same spirit that helped found Adobe and inspires our employees and customers to deliver the very best.

Bruce Chizen
President and CEO
Adobe Systems Incorporated

Olympus, a global technology leader in designing precision healthcare solutions and innovative consumer electronics, is proud to be the official digital camera sponsor of *America 24/7*. The opportunity to introduce Americans from coast to coast to the thrill, excitement, and possibility of digital photography makes the vision behind this book a perfect fit for Olympus, a leader in digital cameras since 1996.

For most people, the essence of digital photography is best grasped through firsthand experience with the technology, which is precisely what *America 24/7* is about. We understand that direct experience is the pathway to inspiration, and welcome opportunities like this sponsorship to bring the power of the digital experience into the lives of people everywhere. To Olympus, *America 24/7* offers a platform to help realize a core mission: to deliver and make accessible the power of the digital experience to millions of American photographers, amateurs, and professionals alike.

The 1,000 professional photographers contracted to shoot on the America 24/7 project were all equipped with Olympus C-5050 digital cameras. Like all Olympus products, the C-5050 is offered by a company well known for designing, manufacturing, and servicing products used by professionals to perform their work, every day. Olympus is a customer-centric company committed to working one-to-one with a diverse group of professionals. From biomedical researchers who use our clinical microscopes, to doctors who perform life-saving procedures with our endo-scopes, to professional photographers who use cameras in their daily work, Olympus is a trusted brand.

The digital imaging technology involved with *America 24/7* has enabled the soul of America to be visually conveyed, not just by professional observers, but by the American public who participated in this project—the very people who collectively breath life into this country's existence each day.

We are proud to be enabling so many photographers to capture the pictures on these pages that tell the story of who we are as a nation. From sea to shining sea, digital imagery allows us to connect to one another in ways we never dreamed possible.

At Olympus, our ideas have proliferated as rapidly as technology has evolved. We have channeled these visions into breakthrough products and solutions to meet the demands of our changing world-products like microscopes, endoscopes, and digital voice recorders, supported by the highly regarded training, educational, and consulting services we offer our customers.

Today, 83 years after we intro-duced our first microscope, we remain as young, as curious, and as committed as ever.

Lexar Media has grown from the digital photography revolution, which is why we are proud to have supplied the digital memory cards used in the America 24/7 project. Lexar Media's high-performance memory cards utilize our unique and patented controller coupled with high-speed flash memory from Samsung, the world's largest flash memory supplier. This powerful combination brings out the ultimate performance of any digital camera.

Photographers who demand the most from their equipment choose our products for their advanced features like write speeds up to 40X, Write Acceleration technology for enabled cameras, and Image Rescue, which recovers previously deleted or lost images. Leading camera manu-facturers bundle Lexar Media digital memory cards with their cameras because they value its performance and reliability.

Lexar Media is at the forefront of digital photography as it transforms picture-taking worldwide, and we will continue to be a leader with new and innovative solutions for profes-sionals and amateurs alike.

Snapfish, which developed the technology behind the *America 24/7* amateur photo event, is a leading online photo service, with more than 5 million members and 100 million photos posted online. Snapfish enables both film and digital camera owners to share, print, and store their most important photo memories, at prices that cannot be equaled. Digital camera users upload photos into a password-protected online album for free. Users can also order film-quality prints on professional photographic paper for as low as 25¢. Film camera users get a full set of prints, plus online sharing and storage, for just $2.99 per roll.

Founded in 1995, eBay created a powerful platform for the sale of goods and services by a passionate community of individuals and businesses. On any given day, there are millions of items across thousands of categories for sale on eBay. eBay enables trade on a local, national and international basis with customized sites in markets around the world.

Through an array of services, such as its payment solution provider PayPal, eBay is enabling global e-commerce for an ever-growing online community.

JetBlue Airways is proud to be *America 24/7's* preferred carrier, flying photographers, photo editors, and organizers across the United States.

Winner of Condé Nast Traveler's Readers' Choice Awards for Best Domestic Airline 2002, JetBlue provides friendly service and low fares for travelers in 22 cities in nine states across America.

On behalf of JetBlue's 5,000 crew members, we're excited to be involved in this remarkable project, and for the opportunity to serve American travelers each and every day, coast to coast, 24/7.

DIGITAL POND

Digital Pond has been a leading creator of large graphic displays for museums, corporations, trade shows, retail environments and fine art since 1992.

We were proud to bring together our creative, print and display capabilities to produce signage and displays for mission control, critical retouching for numerous key images for the book, and art galleries for the New York Public Library and Bryant Park.

The Pond's team and SplashPic® Online service enabled us to nimbly design, produce and install over 200 large graphic panels in two NYC locations within the truly "24/7" production schedule of less than ten days.

WebWare Corporation is pleased to be a major sponsor of the America 24/7 project. We take pride in being part of a groundbreaking adventure that is stretching the boundaries—and the imagination—in digital photography, digital asset management, publishing, news, and global events.

Our ActiveMedia Enterprise™ digital asset management software is the "nerve center" of *America 24/7,* the central repository for managing, sharing, and collaborating on the project's photographs. From photo editors and book publishers to 24/7's media relations and marketing personnel, ActiveMedia provides the application support that links all facets of the project team to the content worldwide.

WebWare helps Global 2000 firms securely manage, reuse, and distribute media assets locally or globally. Its suite of ActiveMedia software products provide powerful media services platforms for integrating rich media into content management systems marketing and communication portals; web publishing systems; and e-commerce portals.

Google's mission is to organize the world's information and make it universally accessible and useful.

With our focus on plucking just the right answer from an ocean of data, we were naturally drawn to the America 24/7 project. The book you hold is a compendium of images of American life distilled from thousands of photographs and infinite possibilities. Are you looking for emotion? Narrative? Shadows? Light? It's all here, thanks to a multitude of photographers and writers creating links between you, the reader, and a sea of wonderful stories. We celebrate the connections that constitute the human experience and are pleased to help engender them. And we're pleased to have been a small part of this project, which captures the results of that interaction so vividly, so dynamically, and so dramatically.

Special thanks to additional contributors: FileMaker, Apple, Camera Bits, LaCie, Now Software, Preclick, Outpost Digital, Xerox, Microsoft, WoodWing Software, net-linx Publishing Solutions, and Radical Media. The Savoy Hotel, San Francisco; The Pan Pacific, San Francisco; Four Seasons Hotel, San Francisco; and The Queen Anne Hotel. Photography editing facilities were generously hosted by CNET Networks, Inc.

Participating Photographers

Coordinator: Clem Murray, Director of Photography, *The Philadelphia Inquirer*

Susan L. Angstadt
Frances Arnold
John Beale, *Pittsburgh Post-Gazette*
Yoni Brook
Michael Bryant, Bryant Photo
Jason Cohn, www.jasoncohn.com
Butch Comegys, *The Scranton Times*
Ed Crisostomo, *The Morning Call*
Joan De Lurio
Anthony DelGandio
Arturo Fernandez, *The Morning Call*
Sharon Gekoski-Kimmel,
The Philadelphia Inquirer
Christopher Glass, *York Daily Record*
Scott Goldsmith
Tom Gralish,* *The Philadelphia Inquirer*
Jack Hanrahan, *Erie Times-News*
Jane Hanstein Cunniffe, SmilingGoat.com
Geri Harkin-Tuckett
Thomas Jenkins
Barbara L. Johnston
Nick Kelsh
E.A. Kennedy 3rd, Image Works
Yischon Liaw

Michael Lightner
Ian Macdonald-Smith
David Maialetti, *Philadelphia Daily News*
June McGaha
Steve Mellon, *Pittsburgh Post-Gazette*
Eric Mencher
Jennifer Midberry, *Philadelphia Daily News*
Gary Dwight Miller
C. E. Mitchell
John S. Needles, Jr.
Annie O'Neill
Christopher Pachuta
Barry Reeger, *Tribune-Review*
Robin Rombach
Sean Simmers, *Harrisburg Patriot-News*
Sean Stipp
Henry Tober
Vicki Valerio,* *The Philadelphia Inquirer*
William D. Wade
Stephen Welsh
Frank Wiese, *The Morning Call*
Michael S. Wirtz, *The Philadelphia Inquirer*

*Pulitzer Prize winner

Thumbnail Picture Credits

Credits for thumbnail photographs are listed by the page number and are in order from left to right.

20 Annie O'Neill
Nick Kelsh
Arturo Fernandez, *The Morning Call*
Don Giles
Gary Dwight Miller
Gerald S. Williams
Michael S. Wirtz, *The Philadelphia Inquirer*

21 Nick Kelsh
Robin Rombach
David Maialetti, *Philadelphia Daily News*
Roger J. Coda
Steve Mellon, *Pittsburgh Post-Gazette*
Steve Mellon, *Pittsburgh Post-Gazette*
Yoni Brook

22 Butch Comegys, *The Scranton Times*
Tony Obfenda
Annie O'Neill
Butch Comegys, *The Scranton Times*
David A. DeNoma
Frank Wiese, *The Morning Call*
Jack Hanrahan, *Erie Times-News*

23 Shari Lee Davis
Steve Mellon, *Pittsburgh Post-Gazette*
Steve Mellon, *Pittsburgh Post-Gazette*
Annie O'Neill
Annie O'Neill
Scott Goldsmith
Yoni Brook

24 Tony Obfenda
Sean Simmers, *Harrisburg Patriot-News*
Butch Comegys, *The Scranton Times*
Jason Cohn, www.jasoncohn.com
Gary Dwight Miller
Jason Cohn, www.jasoncohn.com
Jason Cohn, www.jasoncohn.com

25 Sean Simmers, *Harrisburg Patriot-News*
Jason Cohn, www.jasoncohn.com
Nick Kelsh
Jason Cohn, www.jasoncohn.com

Sean Simmers, *Harrisburg Patriot-News*
Jack Hanrahan, *Erie Times-News*
Sean Simmers, *Harrisburg Patriot-News*

29 Jane Hanstein Cunniffe, SmilingGoat.com
Frank Wiese, *The Morning Call*
Frank Wiese, *The Morning Call*
Jane Hanstein Cunniffe, SmilingGoat.com
Frank Wiese, *The Morning Call*
Yoni Brook
Frank Wiese, *The Morning Call*

32 Annie O'Neill
Arturo Fernandez, *The Morning Call*
Sharon Gekoski-Kimmel,
The Philadelphia Inquirer
Elizabeth H. Field
Jason Cohn, www.jasoncohn.com
Clif Page, *Beaver County Times*
Butch Comegys, *The Scranton Times*

33 Jason Cohn, www.jasoncohn.com
Jason Cohn, www.jasoncohn.com
Jason Cohn, www.jasoncohn.com
Jason Cohn, www.jasoncohn.com
Sharon Gekoski-Kimmel,
The Philadelphia Inquirer
Jennifer Midberry, *Philadelphia Daily News*
Yoni Brook

34 Gerald S. Williams
Nick Kelsh
Frank Wiese, *The Morning Call*
Elizabeth H. Field
Jennifer Midberry, *Philadelphia Daily News*
Mary M. Morgan
Mary M. Morgan

35 Mary M. Morgan
Jack Hanrahan, *Erie Times-News*
Mary M. Morgan
Mary M. Morgan
Sean Simmers, *Harrisburg Patriot-News*
Susan L. Angstadt
Mary M. Morgan

44 Elizabeth H. Field
Butch Comegys, *The Scranton Times*
Jennifer Midberry, *Philadelphia Daily News*
Eric Mencher
Butch Comegys, *The Scranton Times*
Jennifer Midberry, *Philadelphia Daily News*
Steve Mellon, *Pittsburgh Post-Gazette*

45 Scott Goldsmith
Jennifer Midberry, *Philadelphia Daily News*
Butch Comegys, *The Scranton Times*
Jennifer Midberry, *Philadelphia Daily News*
Scott Goldsmith
Butch Comegys, *The Scranton Times*
Yoni Brook

48 Jason Cohn, www.jasoncohn.com
Michael Bryant, Bryant Photo
Michael S. Wirtz, *The Philadelphia Inquirer*
Michael Bryant, Bryant Photo
T. Alan Kirk
E.A. Kennedy 3rd, Image Works
Nhan Tran

49 Jason Cohn, www.jasoncohn.com
Michael S. Wirtz, *The Philadelphia Inquirer*
Michael S. Wirtz, *The Philadelphia Inquirer*
Michael Bryant, Bryant Photo
E.A. Kennedy 3rd, Image Works
T. Alan Kirk
T. Alan Kirk

50 Arturo Fernandez, *The Morning Call*
Michael Lightner
Arturo Fernandez, *The Morning Call*
Barbara L. Johnston
E.A. Kennedy 3rd, Image Works
Butch Comegys, *The Scranton Times*
Arturo Fernandez, *The Morning Call*

51 Nick Kelsh
Robin Rombach
David Maialetti, *Philadelphia Daily News*
E.A. Kennedy 3rd, Image Works
Jennifer Midberry, *Philadelphia Daily News*
E.A. Kennedy 3rd, Image Works
Gary Dwight Miller

52 C. E. Mitchell
Jennifer Midberry, *Philadelphia Daily News*
Jennifer Midberry, *Philadelphia Daily News*
Sean Simmers, *Harrisburg Patriot-News*
Jennifer Midberry, *Philadelphia Daily News*
C. E. Mitchell
Jennifer Midberry, *Philadelphia Daily News*

53 Jennifer Midberry, *Philadelphia Daily News*
Jennifer Midberry, *Philadelphia Daily News*
Jack Hanrahan, *Philadelphia Daily News*
Michael S. Wirtz, *The Philadelphia Inquirer*
Jennifer Midberry, *Philadelphia Daily News*
Jack Hanrahan, *Erie Times-News*
Sean Simmers, *Harrisburg Patriot-News*

58 Anna M. Dill,
New York Institute of Photography
Annie O'Neill
David Maialetti, *Philadelphia Daily News*
David Maialetti, *Philadelphia Daily News*
Michael S. Wirtz, *The Philadelphia Inquirer*
David Maialetti, *Philadelphia Daily News*
David Maialetti, *Philadelphia Daily News*

59 Michael S. Wirtz, *The Philadelphia Inquirer*
Jennifer Midberry, *Philadelphia Daily News*
Jennifer Midberry, *Philadelphia Daily News*
Butch Comegys, *The Scranton Times*
Michael S. Wirtz, *The Philadelphia Inquirer*
David Maialetti, *Philadelphia Daily News*
Nick Kelsh

60 Arturo Fernandez, *The Morning Call*
Mary M. Morgan
E.A. Kennedy 3rd, Image Works
David M Warren

E.A. Kennedy 3rd, Image Works
Gerald S. Williams
Butch Comegys, *The Scranton Times*

61 Frank Wiese, *The Morning Call*
E.A. Kennedy 3rd, Image Works
Jennifer Midberry, *Philadelphia Daily News*
E.A. Kennedy 3rd, Image Works
Jack Hanrahan, *Erie Times-News*
Gerald S. Williams
Yoni Brook

70 Robin Rombach
Robin Rombach
Arturo Fernandez, *The Morning Call*
Arturo Fernandez, *The Morning Call*
Christopher Glass, *York Daily Record*
Robin Rombach

71 David Maialetti, *Philadelphia Daily News*
Robin Rombach
E.A. Kennedy 3rd, Image Works
Robin Rombach
Annie O'Neill
Gary Dwight Miller
Robin Rombach

72 Arturo Fernandez, *The Morning Call*
Vicki Valerio, *The Philadelphia Inquirer*
Frances Arnold
Arturo Fernandez, *The Morning Call*
Arturo Fernandez, *The Morning Call*
Eric Mencher
Arturo Fernandez, *The Morning Call*

73 Mary M. Morgan
Annie O'Neill
Frances Arnold
Jennifer Midberry, *Philadelphia Daily News*
Frances Arnold
Eric Mencher
T. Alan Kirk

74 David Maialetti, *Philadelphia Daily News*
E.A. Kennedy 3rd, Image Works
Michael S. Wirtz, *The Philadelphia Inquirer*
Jennifer Midberry, *Philadelphia Daily News*
Butch Comegys, *The Scranton Times*
Lyle Jones
Vicki Valerio, *The Philadelphia Inquirer*

76 Eric Mencher
Eric Mencher
Scott Goldsmith
Scott Goldsmith
Eric Mencher
Scott Goldsmith
Scott Goldsmith

77 Scott Goldsmith
Scott Goldsmith
Scott Goldsmith
Scott Goldsmith
Scott Goldsmith
Scott Goldsmith
Scott Goldsmith

81 Butch Comegys, *The Scranton Times*
Michael Bryant, Bryant Photo
Jason Cohn, www.jasoncohn.com
Butch Comegys, The Scranton Times
Michael Bryant, Bryant Photo
Jason Cohn, www.jasoncohn.com
Sean Simmers, *Harrisburg Patriot-News*

82 E.A. Kennedy 3rd, Image Works
Yoni Brook
Ed Crisostomo, *The Morning Call*
E.A. Kennedy 3rd, Image Works
Annie O'Neill
Ed Crisostomo, *The Morning Call*
Yoni Brook

83 Yoni Brook
Ed Crisostomo, *The Morning Call*
Ed Crisostomo, *The Morning Call*
E.A. Kennedy 3rd, Image Works
Ed Crisostomo, *The Morning Call*
E.A. Kennedy 3rd, Image Works
Annie O'Neill

86 David Maialetti, *Philadelphia Daily News*
Michael Bryant, Bryant Photo
Michael S. Wirtz, *The Philadelphia Inquirer*
Frank Wiese, *The Morning Call*
Michael Bryant, Bryant Photo
Sean Simmers, *Harrisburg Patriot-News*
Michael Bryant, Bryant Photo

87 Michael Bryant, Bryant Photo
Michael Bryant, Bryant Photo
Michael S. Wirtz, *The Philadelphia Inquirer*
Michael S. Wirtz, *The Philadelphia Inquirer*
Michael Bryant, Bryant Photo
Matt Valentine
Patti Kinlock

88 Christopher Glass, *York Daily Record*
Arturo Fernandez, *The Morning Call*
Butch Comegys, *The Scranton Times*
Butch Comegys, *The Scranton Times*
Jack Hanrahan, *Erie Times-News*
Christopher Glass, *York Daily Record*
Jack Hanrahan, *Erie Times-News*

90 Beverly Logan
Susan L. Angstadt
Nhan Tran
Susan L. Angstadt
Michael S. Wirtz, *The Philadelphia Inquirer*
Susan L. Angstadt
Nhan Tran

91 Susan L. Angstadt
Susan L. Angstadt
Susan L. Angstadt
Eric Mencher
Susan L. Angstadt
Eric Mencher
Steve Mellon, *Pittsburgh Post-Gazette*

94 E.A. Kennedy 3rd, Image Works
Frank Wiese, *The Morning Call*
Frank Wiese, *The Morning Call*
E.A. Kennedy 3rd, Image Works
Jack Hanrahan, *Erie Times-News*
Beverly Logan
David M Warren

95 Matt Valentine
Jack Hanrahan, *Erie Times-News*
Yoni Brook
Eric Mencher
E.A. Kennedy 3rd, Image Works
Jack Hanrahan, *Erie Times-News*
Frank Wiese, *The Morning Call*

96 David Maialetti, *Philadelphia Daily News*
Susan L. Angstadt
John S. Needles, Jr.
David Maialetti, *Philadelphia Daily News*
Jennifer Midberry, *Philadelphia Daily News*
John S. Needles, Jr.
Michael S. Wirtz, *The Philadelphia Inquirer*

97 John S. Needles, Jr.
Michael S. Wirtz, *The Philadelphia Inquirer*
Michael S. Wirtz, *The Philadelphia Inquirer*
Arturo Fernandez, *The Morning Call*
Nhan Tran
Jennifer Midberry, *Philadelphia Daily News*
David Maialetti, *Philadelphia Daily News*

100 E.A. Kennedy 3rd, Image Works
Vicki Valerio, *The Philadelphia Inquirer*
Scott Goldsmith
Vicki Valerio, *The Philadelphia Inquirer*

E.A. Kennedy 3rd, Image Works
Vicki Valerio, *The Philadelphia Inquirer*
Jennifer Midberry, *Philadelphia Daily News*

101 Jennifer Midberry,
Philadelphia Daily News
Robin Rombach
Scott Goldsmith
E.A. Kennedy 3rd, Image Works
Vicki Valerio, *The Philadelphia Inquirer*
Scott Goldsmith
Vicki Valerio, *The Philadelphia Inquirer*

102 E.A. Kennedy 3rd, Image Works
E.A. Kennedy 3rd, Image Works
Jack Hanrahan, *Erie Times-News*
Frank Wiese, *The Morning Call*
Annie O'Neill
E.A. Kennedy 3rd, Image Works
E.A. Kennedy 3rd, Image Works

103 E.A. Kennedy 3rd, Image Works
E.A. Kennedy 3rd, Image Works
Jack Hanrahan, Erie Times-News
Frank Wiese, *The Morning Call*
E.A. Kennedy 3rd, Image Works
Frank Wiese, *The Morning Call*
Matt Valentine

106 Christopher Glass, *York Daily Record*
Yoni Brook
Gerald S. Williams
David Maialetti, *Philadelphia Daily News*
Yoni Brook
Yoni Brook
Eric Mencher

107 David Maialetti, *Philadelphia Daily News*
Yoni Brook
Yoni Brook
Michael S. Wirtz, *The Philadelphia Inquirer*
Yoni Brook
Yoni Brook
Gerald S. Williams

108 Frank Wiese, *The Morning Call*
Yoni Brook
Wade Aiken
Lyle Jones
Yoni Brook
Lyle Jones
Wade Aiken

109 David M Warren
Yoni Brook
Wade Aiken
Jason Cohn, www.jasoncohn.com
Yoni Brook
David M Warren
David M Warren

116 Vicki Valerio, *The Philadelphia Inquirer*
E.A. Kennedy 3rd, Image Works
Vicki Valerio, *The Philadelphia Inquirer*
Vicki Valerio, *The Philadelphia Inquirer*
Eric Mencher
William D. Wade
Susan L. Angstadt

117 Vicki Valerio, *The Philadelphia Inquirer*
William D. Wade
Robin Rombach
E.A. Kennedy 3rd, Image Works
Vicki Valerio, *The Philadelphia Inquirer*
Vicki Valerio, *The Philadelphia Inquirer*
Vicki Valerio, *The Philadelphia Inquirer*

120 Arturo Fernandez, *The Morning Call*
Butch Comegys, *The Scranton Times*
Barry Reeger, *Tribune-Review*
Sean Stipp
Mary M. Morgan
Barry Reeger, *Tribune-Review*
E.A. Kennedy 3rd, Image Works

121 Barry Reeger, *Tribune-Review*
Geri Harkin-Tuckett
Frank Wiese, *The Morning Call*
Sean Stipp
Roger J. Coda
Steve Mellon, *Pittsburgh Post-Gazette*
Sean Stipp

124 C. E. Mitchell
C. E. Mitchell
Scott Goldsmith
Scott Goldsmith
Jennifer Midberry, *Philadelphia Daily News*
Scott Goldsmith

125 Scott Goldsmith
Scott Goldsmith
Scott Goldsmith
Jennifer Midberry, *Philadelphia Daily News*
Scott Goldsmith
C. E. Mitchell
Scott Goldsmith

126 E.A. Kennedy 3rd, Image Works
E.A. Kennedy 3rd, Image Works
Anna M. Dill,
New York Institute of Photography
E.A. Kennedy 3rd, Image Works
Geri Harkin-Tuckett
E.A. Kennedy 3rd, Image Works
Vicki Valerio, *The Philadelphia Inquirer*

127 E.A. Kennedy 3rd, Image Works
E.A. Kennedy 3rd, Image Works
E.A. Kennedy 3rd, Image Works
E.A. Kennedy 3rd, Image Works
Eric Mencher
E.A. Kennedy 3rd, Image Works
Vicki Valerio, *The Philadelphia Inquirer*

132 Tom Gralish, *The Philadelphia Inquirer*
David Maialetti, *Philadelphia Daily News*
David Maialetti, *Philadelphia Daily News*
David Maialetti, *Philadelphia Daily News*
David Maialetti, *Philadelphia Daily News*
David Maialetti, *Philadelphia Daily News*
David Maialetti, *Philadelphia Daily News*

133 Eric Mencher
David Maialetti, *Philadelphia Daily News*
Tom Gralish, *The Philadelphia Inquirer*
David Maialetti, *Philadelphia Daily News*
David Maialetti, *Philadelphia Daily News*
Eric Mencher
David Maialetti, *Philadelphia Daily News*

135 Anna M. Dill,
New York Institute of Photography
Eric Mencher
Michael S. Wirtz, *The Philadelphia Inquirer*
Anna M. Dill,
New York Institute of Photography
Nick Kelsh
Yoni Brook
Steve Mellon, *Pittsburgh Post-Gazette*

136 Barbara L. Johnston
Jennifer Midberry, *Philadelphia Daily News*
David Maialetti, *Philadelphia Daily News*
David Maialetti, *Philadelphia Daily News*
E.A. Kennedy 3rd, Image Works
David Maialetti, *Philadelphia Daily News*
E.A. Kennedy 3rd, Image Works

138 Anna M. Dill,
New York Institute of Photography
David Maialetti, *Philadelphia Daily News*
Annie O'Neill
Archie Carpenter
Arturo Fernandez, *The Morning Call*
Karen Labenz
David Maialetti, *Philadelphia Daily News*

139 Michael S. Wirtz, *The Philadelphia Inquirer*
Michael S. Wirtz, *The Philadelphia Inquirer*
David Maialetti, *Philadelphia Daily News*
Michael S. Wirtz, *The Philadelphia Inquirer*
David Maialetti, *Philadelphia Daily News*
Michael S. Wirtz, *The Philadelphia Inquirer*
Vicki Valerio, *The Philadelphia Inquirer*

140 Ian Macdonald-Smith
Ian Macdonald-Smith
Steve Mellon, *Pittsburgh Post-Gazette*
Arturo Fernandez, *The Morning Call*
Mary M. Morgan
David Maialetti, *Philadelphia Daily News*
Eric Mencher

141 Christopher Glass, *York Daily Record*
Jason Cohn, www.jasoncohn.com
Vicki Valerio, *The Philadelphia Inquirer*
Eric Mencher
Mary M. Morgan
Nick Kelsh
J.D. Small

142 Tony Obfenda
Vicki Valerio, *The Philadelphia Inquirer*
Eric Mencher
Vicki Valerio, *The Philadelphia Inquirer*
Vicki Valerio, *The Philadelphia Inquirer*
Michael S. Wirtz, *The Philadelphia Inquirer*
Scott Goldsmith

143 Vicki Valerio, *The Philadelphia Inquirer*
Scott Goldsmith
Geri Harkin-Tuckett
Scott Goldsmith
Vicki Valerio, *The Philadelphia Inquirer*
Tony Obfenda
Scott Goldsmith

146 Ian Macdonald-Smith
Scott Goldsmith
Scott Goldsmith
Scott Goldsmith
Scott Goldsmith
Yoni Brook
Scott Goldsmith

147 Yoni Brook
Scott Goldsmith
Yoni Brook
Scott Goldsmith
Yoni Brook
Scott Goldsmith
Scott Goldsmith

148 E.A. Kennedy 3rd, Image Works
Annie O'Neill
E.A. Kennedy 3rd, Image Works
Paul Kuehnel, *York Daily Record*
Eric Mencher
Eric Mencher
Gary Dwight Miller

149 Frank Wiese, *The Morning Call*
Annie O'Neill
Michael S. Wirtz, *The Philadelphia Inquirer*
Eric Mencher
J.D. Small
Michael S. Wirtz, *The Philadelphia Inquirer*
Michael S. Wirtz, *The Philadelphia Inquirer*

150 Lyle Jones
Eric Mencher
Eric Mencher
Ian Macdonald-Smith
Eric Mencher
Elizabeth H. Field
Lyle Jones

151 Ian Macdonald-Smith
Frank Wiese, *The Morning Call*
Eric Mencher
Ian Macdonald-Smith
Eric Mencher
Eric Mencher
Mary M. Morgan

Staff

The *America 24/7* series was imagined years ago by our friend Oscar Dystel, a publishing legend whose vision and enthusiasm have been a source of great inspiration.

We also wish to express our gratitude to our truly visionary publisher, DK.

Rick Smolan, Project Director
David Elliot Cohen, Project Director

Administrative
Katya Able, Operations Director
Gina Privitere, Communications Director
Chuck Gathard, Technology Director
Kim Shannon, Photographer Relations Director
Erin O'Connor, Photographer Relations Intern
Leslie Hunter, Partnership Director
Annie Polk, Publicity Manager
John McAlester, Website Manager
Alex Notides, Office Manager
C. Thomas Hardin, State Photography Coordinator

Design
Brad Zucroff, Creative Director
Karen Mullarkey, Photography Director
Judy Zimola, Production Manager
David Simoni, Production Designer
Mary Dias, Production Designer
Heidi Madison, Associate Picture Editor
Don McCartney, Production Designer
Diane Dempsey Murray, Production Designer
Jan Rogers, Associate Picture Editor
Bill Shore, Production Designer and Image Artist
Larry Nighswander, Senior Picture Editor
Bill Marr, Sarah Leen, Senior Picture Editors
Peter Truskier, Workflow Consultant
Jim Birkenseer, Workflow Consultant

Editorial
Maggie Canon, Managing Editor
Curt Sanburn, Senior Editor
Teresa L. Trego, Production Editor
Lea Aschkenas, Writer
Olivia Boler, Writer
Korey Capozza, Writer
Beverly Hanly, Writer
Bridgett Novak, Writer
Alison Owings, Writer
Fred Raker, Writer
Joe Wolff, Writer
Elise O'Keefe, Copy Chief
Daisy Hernández, Copy Editor
Jennifer Wolfe, Copy Editor

Infographic Design
Nigel Holmes

Literary Agent
Carol Mann, The Carol Mann Agency

Legal Counsel
Barry Reder, Coblentz, Patch, Duffy & Bass, LLP
Phil Feldman, Coblentz, Patch, Duffy & Bass, LLP
Gabe Perle, Ohlandt, Greeley, Ruggiero & Perle, LLP
Jon Hart, Dow, Lohnes & Albertson, PLLC
Mike Hays, Dow, Lohnes & Albertson, PLLC
Stephen Pollen, Warshaw Burstein, Cohen, Schlesinger & Kuh, LLP
Rick Pappas

Accounting and Finance
Rita Dulebohn, Accountant
Robert Powers, Calegari, Morris & Co. Accountants
Eugene Blumberg, Blumberg & Associates
Arthur Langhaus, KLS Professional Advisors Group, Inc.

Picture Editors
J. David Ake, Associated Press
Caren Alpert, formerly *Health* magazine
Simon Barnett, *Newsweek*
Caroline Couig, *San Jose Mercury News*
Mike Davis, formerly *National Geographic*
Michel duCille, *Washington Post*
Deborah Dragon, *Rolling Stone*
Victor Fisher, formerly Associated Press
Frank Folwell, *USA Today*
MaryAnne Golon, *Time*
Liz Grady, formerly *National Geographic*
Randall Greenwell, *San Francisco Chronicle*
C. Thomas Hardin, formerly *Louisville Courier-Journal*
Kathleen Hennessy, *San Francisco Chronicle*
Scot Jahn, *U.S. News & World Report*
Steve Jessmore, *Flint Journal*
John Kaplan, University of Florida
Kim Komenich, *San Francisco Chronicle*
Eliane Laffont, *Hachette Filipacchi Media*
Jean-Pierre Laffont, *Hachette Filipacchi Media*
Andrew Locke, MSNBC
Jose Lopez, *The New York Times*
Maria Mann, formerly AFP
Bill Marr, formerly *National Geographic*
Michele McNally, *Fortune*
James Merithew, *San Francisco Chronicle*
Eric Meskauskas, *New York Daily News*
Maddy Miller, *People* magazine
Michelle Molloy, *Newsweek*
Dolores Morrison, *New York Daily News*
Karen Mullarkey, formerly *Newsweek, Rolling Stone, Sports Illustrated*
Larry Nighswander, Ohio University School of Visual Communication
Jim Preston, *Baltimore Sun*
Sarah Rozen, formerly *Entertainment Weekly*
Mike Smith, *The New York Times*
Neal Ulevich, formerly Associated Press

Website and Digital Systems
Jeff Burchell, Applications Engineer

Television Documentary
Sandy Smolan, Producer/Director
Rick King, Producer/Director
Bill Medsker, Producer

Video News Release
Mike Cerre, Producer/Director

Digital Pond
Peter Hogg
Kris Knight
Roger Graham
Philip Bond
Frank De Pace
Lisa Li

Senior Advisors
Jennifer Erwitt, Strategic Advisor
Tom Walker, Creative Advisor
Megan Smith, Technology Advisor
Jon Kamen, Media and Partnership Advisor
Mark Greenberg, Partnership Advisor
Patti Richards, Publicity Advisor
Cotton Coulson, Mission Control Advisor

Executive Advisors
Sonia Land
George Craig
Carole Bidnick

Advisors
Chris Anderson
Samir Arora
Russell Brown
Craig Cline
Gayle Cline
Harlan Felt
George Fisher
Phillip Moffitt
Clement Mok
Laureen Seeger
Richard Saul Wurman

DK Publishing
Bill Barry
Joanna Bull
Therese Burke
Sarah Coltman
Christopher Davis
Todd Fries
Dick Heffernan
Jay Henry
Stuart Jackman
Stephanie Jackson
Chuck Lang
Sharon Lucas
Cathy Melnicki
Nicola Munro
Eunice Paterson
Andrew Welham

Colourscan
Jimmy Tsao
Eddie Chia
Richard Law
Josephine Yam
Paul Koh
Chee Cheng Yeong
Dan Kang

Chief Morale Officer
Goose, the dog